THE NEO-STALINIST STATE

CLASS, ETHNICITY, AND CONSENSUS IN SOVIET SOCIETY

VICTOR ZASLAVSKY

THE NEO-STALINIST STATE

CLASS, ETHNICITY, AND CONSENSUS IN SOVIET SOCIETY

M.E. SHARPE, INC.
THE HARVESTER PRESS

Copyright © 1982 by M. E. Sharpe, Inc.

First published in the United States in 1982 by
M. E. SHARPE, INC.
80 Business Park Drive, Armonk, New York 10504

First published in Great Britain in 1982 by
THE HARVESTER PRESS
Publisher: John Spiers
16 Ship Street, Brighton, Sussex

Library of Congress Cataloging in Publication Data

Zaslavsky, Victor, 1937-
 The neo-Stalinist state.

 Includes bibliographical references.
 1. Soviet Union—Social conditions. I. Title.
HN523.5.Z37 306'.0947 82-5800
ISBN 0-87332-229-0 AACR2

British Library Cataloguing in Publication Data

Zaslavsky, Victor
 The neo-Stalinist state: class, ethnicity and
 consensus in Soviet society.
 1. Soviet Union—Social conditions
 2. Soviet Union—Politics and government
 I. Title
 947.084 HN523
ISBN 0-7108-0419-9

TABLE OF CONTENTS

Herman Ivanovich Iakovlev

IN MEMORIAM

INTRODUCTION

Ever since the Russian Revolution there has been much debate about the nature of the new social system in the USSR, and in particular about the sources of its internal stability. In the past half-century Soviet society has passed from the stage of system building to that of system maintenance; today it is an advanced industrial society whose principles of social organization differ considerably from those of the West.

A common theme in Soviet studies in the West, typical of otherwise very different approaches, has been the idea of internal stability based on coercion and imposed through a terroristic regime. While the left and the right have drawn different conclusions about Stalinism (with the left seeing it as a historical aberration having nothing to do with the validity of Marxism per se, and with the right seeing it as a true expression and decisive indictment of Marxism), they have shared this common tendency. This preoccupation with the "Stalinist state" has led, however, to an underestimation of the degree of consensus-based stability in contemporary Soviet society and has discouraged a realistic examination of the actual functioning of this social system. On the other hand, implicit in official Soviet

ideology is the idea of the "post-Stalinist state." It presents Soviet society as a "mature socialism" that has fully overcome certain excesses of the Stalin period and is supported by the overwhelming majority of the population. The problems here are even more glaring. This view totally glosses over the repressive and even manipulative aspects of Soviet society.

In this collection of essays I attempt to develop an analysis which avoids and goes beyond these limitations, and which recognizes the simultaneously coercive and consensual aspects of the Soviety-type system. That is what I am essentially concerned with in proposing the concepts the "neo-Stalinist state" and "organized consensus" — ideas that are of critical importance in grasping the nature and dynamics of Soviet society in the Brezhnev period.

The Stalinist regime used systematic terror for the mobilization of social resources to accomplish rapid industrialization and property transfers. A centrally administered and planned economy replaced the market economy. Control over social production and distribution was exercised by the highly centralized party-state apparatus, which monopolized political, economic, and ideological power.

The elimination of mass physical terror as a means of government by Stalin's successors signified the transition to a new phase. The new regime still preserves many essential features of the old Stalinist state (notably the centralized one-party-state system). But it has also sought to base internal stability more on consensus and less on sheer coercion; hence the situation during the Brezhnev era may be characterized as one of "organized consensus." This means a political compromise between the state and the people in which basic social groups accept the existing distribution of power and their estrangement from the decision-making process in exchange for job security, some workers' rights, upward mobility, and a slow but steady rise in living standards.

A key question, therefore, is: How is this consensus achieved? How are the essential features of the Stalinist system preserved in a more modern and more pragmatic regime?

What is needed to answer these questions is a close analysis
of the Soviet system in its accumulative, planning, legitimative,
and coercive functions. Through concrete analysis in these
various areas we can arrive at a better understanding of how
social life is planned and controlled in the modern setting, and
how individual members of society are both constrained and
convinced to perform surplus labor.

This requires attention to both the structural and the cultural
aspects of the neo-Stalinist system. The structural aspects
focused on in this book lie mainly in the area of social strati-
fication and social mobility. I seek to show the vital role played
by state-manipulated upward social mobility in the internal sta-
bility and consensus of the USSR. The neo-Stalinist state has
organized new systems of stratification and new channels for
upward social mobility. It uses various mechanisms of social
control and regulation, such as the internal passport system,
and creates privileged sectors and groups in society, such as
"closed" enterprises and certain territorial, occupational, and
ethnic groups. The neo-Stalinist state segments society by
erecting a network of administrative barriers between these
groups. It regulates mobility opportunities through bureau-
cratic restrictions and permits and through rules governing
transfers from one social or territorial group to another. The
book thus focuses on the territorial stratification and two-step
migration which became crucial in maintaining internal stabil-
ity during the Brezhnev period.

Cultural aspects of the neo-Stalinist regime should not be
underestimated. Soviet society is composed of individuals
with specific values and attitudes. The latter are partly in-
herited from the old social order and partly produced by the
present regime, which cultivates its own specific political cul-
ture. A careful scrutiny of this aspect of the neo-Stalinist sys-
tem sheds light on the social processes through which persons
inclined to independent thinking are systematically and effec-
tively marginalized, suppressed, or exiled. It reveals the role
of the "inertia of fear" in Soviet society. Such topics as the
rebirth of the Stalin cult in the USSR and the attitudes of Soviet

workers to the 1968 invasion of Czechoslovakia involve analysis both of traditional features of Soviet political culture and of the role of new social institutions in the dissemination of political views and attitudes favorable to the regime.

The strategy of organized consensus as a social compromise has its limitations. The Soviet leadership in the Brezhnev period has preferred the pragmatic preservation of the status quo to any more radical quest for social transformation. But as Andrei Amalrik has pointed out: "In order to remain in power, the regime must change and evolve, but in order to preserve itself, everything must remain unchanged." [1] Many problems and contradictions have evolved in Soviet society both as a result of and despite the policy of organized consensus, a policy which, for example, requires economic efficiency to be sacrificed for the sake of internal stability. Current economic and demographic problems may well mean that the relative success of the policy of organized consensus in the 1970s is of a temporary character.

The options open to the future leadership are, however, contingent on the present state of Soviet society, with its various conflicts and compromises. The road of technocratic reform and economic liberalization promises improvements in labor productivity and living standards, but only at the price of basic de-Stalinizing modifications of the economic and political structure of Soviet society. The ominous events in Poland remind us of the continuing appeal, for the Soviet leadership, of the old Stalinist model of a terroristic and politically imperialist state, even if this model has to take a neo-Stalinist form. A key question of the 1980s will thus continue to be how the irrepressible forces of change will be politically adapted to and bureaucratically modified by social forces highly resistant to any radical change. By exploring how this process has actually worked in the recent period, the essays here will, I hope, render the unfolding future somewhat more intelligible.

ACKNOWLEDGMENTS

Between 1956 and 1975 I participated in various working groups
and seminars, both official and unofficial, organized by social
scientists in Leningrad and Moscow. My intellectual debt to
some of my Soviet colleagues and friends is immense. I deeply
regret that under the present conditions, I cannot thank them here
by name. For useful discussion of the relevant topics I would like to
thank Zygmunt Bauman, Wlodzimierz Brus, Robert Brym, Juan
Corradi, Olimpiad Ioffe, Alastair McAuley, Mary McAuley, Gian-
franco Poggi, and Vladimir Shliapentokh. I am agrateful to Maria
Fabris, Eleni Mahaira-Odoni, Peter Sinclair, and Alexander
Zaslavsky for their help in preparation of the manuscript. My
special thanks are due to Frederick Johnstone, Volker Meja,
and Paul Piccone, whose criticisms and intellectual stimulation
were of particular importance for my work.

Some of these chapters have appeared, in earlier versions,
as articles in the following journals:

"The USSR and the Working Class," Telos 42 (Winter 1979-
80).

"The Ethnic Question in the USSR," Telos, 45 (Fall 1980).

"Socioeconomic Inequality and Changes in Soviet Ideology,"

Theory and Society, 9 (1980).
"Adult Political Socialization in the USSR: A Study of Attitudes of Soviet Workers to the Invasion of Czechoslovakia," Sociology, 15:3 (1981).
I am grateful to these journals for granting permission to publish revised and elaborated versions of these articles.

THE NEO-STALINIST STATE

CLASS, ETHNICITY, AND CONSENSUS IN SOVIET SOCIETY

THE REBIRTH OF THE STALIN CULT IN THE USSR

"Stalin? he (Brecht) exclaimed contemptuously in answer to my objection; — fifty years from now the communists will have forgotten who Stalin was." Henry Pachter.[1]

Some fifty years have passed since the day of that conversation, and Brecht has proved a poor prophet. Khrushchev too, shortly before dying, regretted not having dared publish, while still in power, a series of documents on Stalin's crimes and, particularly, the reports of the inquiry commission on Kirov's assassination. Khrushchev claimed that had he done so, the Stalin cult in the twentieth century would have been a closed chapter. Actually, it is unlikely that the publication of the documents would have changed anything. Today the Stalin cult is thriving, and its restoration is one of the distinctive traits of Soviet society under Brezhnev.

For the Soviet citizen the rebirth of the Stalin cult is a fact of life. There is hardly a worker who has not had to attend either open or closed meetings where local party officials explicitly exalt Stalin while explaining his "minor" violations of legality during his last years in terms of the difficulty of the

political situation — something which cannot possibly affect the overall evaluation of his role as wise leader and brilliant military commander. Similarly, Moscow intellectuals have also had to endure the same treatment from higher-ranking officials.[2]

A definitive judgment about Stalin has recently been published by the authoritative journal Kommunist:

...he never opposed Lenin, invariably considering himself Lenin's pupil and follower. Stalin did not introduce anything into Marxist-Leninist teaching which was not essentially in harmony with its basic conclusions....

During Stalin's years our party steadily and unswervingly followed the basic Leninist course, always turning to the masses and regarding their support as essential to the viability of its policies.[3]

The Stalinist Cult in Literature

In any case, students of Soviet society need not focus exclusively on information accessible in the USSR only to specialists, party functionaries, or dissidents. To grasp a political idea's ideological value it is necessary to examine how it becomes transformed by the mass media and popular stereotypes. Because of its sensitivity to changes in mass political attitudes and because of its traditionally important function within Soviet society, literary narrative is an irreplaceable indicator of mass political orientations. The centralization of all activities, including literature, makes possible a first evaluation of how far the restoration of the Stalin cult has progressed, even if only on the basis of a limited number of examples.

Consider Ivan Stadniuk's novel The War, of which several million copies were published in 1974. When describing an unexpected appearance by Stalin and his "comrades in arms," the author emphasizes that all those present "were left petrified in solemn silence, unable to believe they were facing the Chief and his comrades in arms in the flesh and blood." The comrades are Molotov, Malenkov, and Beria, in that order. How could even the possible publication of new documents adding another couple of million people to the number of victims of

Stalin's and Beria's camps inhibit official writers from describing "the sincere love, the faith and deep devotion of the people who, like a resplendent wave, are drawn to the Mausoleum" where Stalin stood, he "who completely dedicated himself to the building of socialism"? Even during Stalin's lifetime, when he was not known for excessive modesty, it was hard to find him represented as an intellectual Titan who, "pen in hand, sits at the table and writes, plunging his gaze into the granary of his own wisdom, freely and generously shaping his lucid thoughts, filling them with energy, passionately blending new principles and new ties with the multiformity of scientific concepts and with the manifestations of reality, carrying each phrase to the finish with crystalline clarity."[4]

One could also refer to the novel The Siege, of which several million copies were also published. Of course, the author, Aleksandr Chakovskii, Literaturnaia gazeta's editor, did not need to change his personal convictions. In his first novels, Morning Has Already Come and Cvan Cher Goes on Watch, published when Stalin was still alive, Chakovskii was already singing high praise of the People's Leader and Guide. The twenty-fifth anniversary of the dictator's death was celebrated by serializing The Siege in several full-length movies and by awarding Chakovskii the Lenin prize.[5]

Two Levels of Mystification

Two kinds of attitudes toward the victims of Stalinist terror can be identified in official Soviet literature. According to the first, there were no innocent victims, and therefore Stalin is praised for "not having spared the people's enemies." Thus in a recent publication by Pravda's well-known foreign politics commentator, Iurii Zhukov, Stalin was eulogized for having made "the only correct choice under the tragic conditions of his time." To avoid any ambiguity concerning the times in question, Zhukov's memoirs are subtitled "Pages from a Chronicle of the 1930s."[6] And the poet Sergei Smirnov, one of the

supporters of this approach, has depicted Stalin's funeral in the following lines: "And so, as he rises above the crowds, Our Own, He did not go alone: The souls of the down-trodden citizens like a funeral wreath follow on."[7] Striking here is the analogy with Eichmann, who reputedly said: "When I die, six million Jews will lie with me in the grave."

The other approach to the victims of the terror seeks to provide an "objective" evaluation of Stalin's role. While praising the dictator's performance in creating the Soviet state and annihilating both real and imaginary opposition to the authorities, these authors still disapprove of Stalin's deeds in 1937-39 when many honest comrades were also eliminated. They explain, however, that these were excusable errors. They allegedly were caused by lack of information and the personal weaknesses of a leader encumbered by the "supreme historical responsibility" that fell on him. In any case, they argue, innocent victims were rehabilitated (although posthumously), justice has been done, and all must be forgotten. In the history of Soviet society "there are no negative pages."

Pardon and forgetfulness are recurring themes in Iurii Bondarev's recent works. His previous novel, The Silence, was originally a major event in the struggle against the Stalin cult. Having in the meantime become secretary of the writer's union and been honored with all possible awards, Bondarev today narrates a parable of two old pensioners about to share a two-room apartment provided by the state. To celebrate the event, the pensioners drink a toast in the kitchen, "staring fixedly into each other's eyes, then fall silent for a moment, and suddenly both burst into tears. One had been the inquisitioner and the other his victim, condemned to many years in the camps."[8] Another example can be found in the recent memoirs of Kalinin's son, where Enukidze, Postyshev, Stalin, and the other Soviet leaders are depicted as a single large family.[9] The difference between butchers and victims seems so negligible that the author does not even mention it to avoid casting a shadow over the friendship and compatibility of the group.

Many of the survivors of the Stalinist Gulag never really

believed in the miracle of their own liberation and often predicted "Stalin's return." But to many Russians born during the 1930s, such a return seemed unlikely. Many of them listened to Khrushchev's 1956 report and afterwards destroyed the huge plaster statues of Stalin decorating every public place. Later, in 1961, some of them stood watch night and day in Red Square, afraid to miss the removal of Stalin's remains from the mausoleum. So why is a figure so compromised rehabilitated so readily? What has made possible the rebirth of the Stalin cult during the Brezhnev period?

The Cult within the Apparatus

It is widely accepted that the rebirth of the Stalin cult is due to the emotional attachment of the present leaders. In fact, many of today's leaders started their political careers during Stalin's time. He made Brezhnev a member of the Central Committee; it was in Kosygin's company that he was last seen in public; Gromyko, subsequently the minister of foreign affairs, was then a vice-minister; Epishev, subsequently the chief of the Central Political Directorate of the Armed Forces, was then in charge of the vice-ministry of state security; Ustinov, now defense minister, was then minister of armaments. The list could go on. It is well known, however, that gratitude to dead leaders is a rare quality among politicians and hardly influences the course of events. Many members of the group in power are indebted even more to Khrushchev, but this has not stopped them from prohibiting the mention of his name in the press even today. The current leaders' sympathy and approval of many of Stalin's policies have favored, but not determined, the rebirth of the ex-dictator's cult.

What has happened becomes much more intelligible when seen within the context of the organization and the structure of power in the Soviet Union. Soviet society has been correctly described as a mono-organizational system.[10] This fact is codified in the Constitution, which designates the CPSU as "the

force directing and guiding society." This means that the
party's bureaucratic apparatus, which has become one with
state power, dominates society by organizing and directing the
activity of otherwise totally atomized individuals. The party
apparatus is in no way equal to the sum of individuals carrying
out various tasks at any given moment. The apparatus consists
of the totality of social roles, norms, relations, and laws, in-
cluding the laws of self-reproduction and self-preservation.
In turn, the functioning principle of this system — democratic
centralism — inevitably leads to domination by the highest,
"personified" echelon over the entire party apparatus.[11]

The birth of the personality cult — through the concentration
of power in the hands of a restricted number of people who
choose the Leader and ascribe to him an artificial charisma —
is the natural result of the operation of the single-party system.
The Leader's personal qualities and good intentions do not
change the situation. Despite Lenin's personal opposition, his
cult was born and gained strength during the last years of his
life, reaching its peak in the unprecedented decision to erect
a mausoleum to preserve his embalmed remains. The history
of the Stalin, Khrushchev, and Brezhnev cults shows how these
mechanisms of cult manufacture work and are likely to develop.
The apparatus's absolute power finds its most adequate em-
bodiment in the Leader's personal power acting in the name
of the apparatus and executing its will.

Elevated to power by the apparatus, Khrushchev subsequently
betrayed its interests by attempting to limit its power by intro-
ducing the principle of regularly rotating cadres. Thus he fully
deserved his fate, i.e., to be forgotten. Relieved of his duties
and reduced to the status of a nonperson while still alive, even
after his death he remains "untouchable" in today's Soviet
press and literature. In effect, the restoration of the Stalin
cult was not caused primarily by the desire of the apparatus
to destroy all traces of the main achievement of Khrushchev's
life — the denunciation of Stalinist crimes — but by the need to
reinforce its own hegemonic position, which had been partially
shaken under Khrushchev.

By demystifying Stalin, Khrushchev cleverly exploited the identification of the apparatus with the sum of individuals constituting it. Honestly or not, he equated Stalin's repression of certain apparatus members with repression of the party itself; this gave him the practical advantage of attributing responsibility for these events entirely to Stalin. In any case, to maintain with Khrushchev that Stalin "broke the back of the Party, eliminated it as a living political organism and ruling class,"[12] inevitably psychologizes the historical process by blaming Stalin for the main social transformations in the Soviet Union. Whatever Stalin's personal interest in wiping out this or that stratum of the apparatus, his regime enormously strengthened the role of the party as a socially dominant force with legislative, executive, and control functions firmly in its hands.

Stalin reinforced all these fundamental structures of power, and they have remained unchanged even after his death. Consequently the apparatus could never renounce Stalin's authority and cult, with the result that today it is logical for official authors to interpret the critique of the personality cult as an "undue preponderance of moral problems over national and state problems."[13] In effect, every attack on the Stalin cult and on its role in the creation of the Soviet state carries a call for democratization and challenges the monopoly of the apparatus. If the attempt to escape the apparatus's control is considered an extremely dangerous crime, the demolition of Stalin's cult can only result in an increase in this type of crime. As a Soviet criminologist put it: "The liquidation of the consequences of the Stalin cult and the desecration of state power have given rise among the young to a negative attitude toward all authority, have produced false opinions with respect to discipline and democratic institutions, and have sanctioned demagoguery; in the last analysis this could only translate into forms of indifference and nihilism toward the state, into morally dubious actions, and into open violations of legality."[14]

To preserve society's organizational structures and the existing system of power distribution, the apparatus is forced to adopt stabilizing measures, such as the restoration of the Stalin

cult.[15] In explaining the behavior of the Soviet apparatus, it
is not necessary to resort to sentimentalisms, such as the per-
sonal devotion of some leaders to Stalin's memory, or to ideo-
logical arguments. Faced with a predicament similar to that of
their Soviet colleagues, Western bureaucrats are likely to act
in the same manner.

Whatever the Soviet leaders' politics, they are not determined
by purely egoistic motives for self-preservation. The Soviet
leaders also endeavor to use their power for certain positive
ends. In principle, relations between the party-state and society
at large cannot be analyzed on the basis of the interests and ac-
tions of one segment alone. It would be simplistic to explain
the rebirth of the Stalin cult only in terms of an apparatus im-
posing its will on the population. How Soviet people and workers
in particular react to this policy must also be taken into
consideration.

The Myth of the Good Tsar

Like The War and The Siege, numerous other novels praising
Generalissimo Stalin have been also published in large editions
that immediately sold out. Chakovskii's novel is available only
on the black market at a price much higher than the original.
To obtain these works from a lending library, one must be on
a waiting list for several months. Almost everywhere the film
The Siege broke box-office records. No doubt many people
were still "morbidly curious about the recluse in the Kremlin,"
as Nadezhda Mandelstam put it.[16] Yet a very large number of
Soviet workers have a very positive opinion of Stalin and his
record. This is not only common knowledge but is also con-
firmed by the enormous success of pro-Stalin literary and cin-
ematographic works, as well as by some unpublished surveys
by Soviet sociologists.

There is little doubt that the intense propaganda of the Stalin
cult through the mass media has produced results. Still, it
would be wrong to explain the political orientation of a social

group by relying exclusively on the intensity of the ideological influence to which it is subjected. An ideology that effectively molds the political consciousness of a social group cannot be totally autonomous from, and unconnected with, some real social experience of this group. The roots of Stalin's vast popularity can be understood only in terms of the experiences of Soviet workers.

Thanks to official Soviet sources (Khrushchev's report to the Twentieth Congress and some early 1960s publications), Western radio broadcasts, and samizdat, the extent of Stalinist terror, however incomplete or distorted, is well-known by the Soviet population. This does not change the fact that many workers and peasants have an image of Stalin as a disciplined yet kind leader who sought, sometimes with cruel means, to create an egalitarian and just society, even though his will may have often been distorted by his collaborators. It is not difficult to recognize in this attitude a residue of the faith in the "good tsar" — the cornerstone of the Russian peasant's traditional political culture. This is hardly surprising when one considers that much of the Soviet working class is composed of "first-generation" workers. More important is the fact that the image of Stalin as the initiator of a policy that has led to full and steady employment and to massive promotion of workers and peasants to nonmanual and supervisory positions can be confirmed by the personal experiences of many representatives of these classes. The following passage by Aleksandr Zinoviev illustrates the point:

Why did my mother keep Stalin's portrait? She was a simple peasant woman. Before collectivization our family lived fairly well, but at what price! Backbreaking work from dawn to dusk. And what was the future of the children (there were eleven in the family)? To become peasants or, at best, tradesmen. Then collectivization came; villages were ruined, plundered, and many escaped to town. And what happened as a result? In my family one son became a university professor; another a manager of a factory; yet another a colonel; and three others became engineers. Something like this happened to millions of families. I do not want to pass value judgments, to claim that it was good or bad. I only want to say that at the time, an advancement unparalleled in human history took place in the country, an advancement which promoted many millions

from the lowest of social classes to the status of industrial worker, engineer, teacher, doctor, artist, officer, writer, scientist, etc. Perhaps it could have happened without Stalinism, but that is irrelevant. The protagonists of the process knew that it did happen under Stalin and, so it seemed, because of him.[17]

Research on the role played by mass terror in the industrialization process, in the struggle against unemployment, and in the growth of workers' social mobility remains among the most urgent objectives for students of Soviet society. It must be noted that in addition to millions of victims, the terror produced millions of individuals who derived advantages from it.[18] Thus the annihilation of the kulaks as a class was carried out with the help of the peasants themselves, who received for collective use the possessions of the exiled kulaks. One of the main economic and sociopsychological aspects of the terror was its leveling character, which greatly contributed to strengthening the legitimacy of the Stalinist regime.[19] Of course, the greatest weight of terror was borne by the peasants and workers who were deprived of their freedom and used as a quasi-slave labor force. Much more openly, however, the terror struck both the population's richer strata (well-to-do peasants in the early 1930s) and, later, privileged groups (party functionaries in the mid-1930s). The terror increased social mobility, eliminated reemergent class barriers, and functioned as a sociopsychological mechanism by creating the sensation of a "negative" equality, or even of protection for individuals against the arbitrariness of local authority. At the end of the 1960s, when various enterprises began massive layoffs of superfluous workers in order to carry out economic reforms, workers often had fond recollections of Stalin's "justice," when factory administrators "lived in fear" — in contrast to this new period, when they could "do as they pleased."

This type of reaction should not be surprising. With the atomization of the working class and in the absence of any workers' democracy, of rights to association and strike, a strong central power comes to be seen as a guarantee of workers' economic rights against the arbitrariness of local administration. Therefore the support of the Stalin cult by specific

sectors of the working class, especially those less skilled, is not only a result of the romantic cult of state power but also of the quite rational understanding of their own interests and position within the existing power structure.

Closed Enterprises and Working-class Chauvinism

The rebirth of the Stalin cult among workers is also connected with certain recent structural modifications within society and, in particular, with the rapid increase in the number of so-called "closed" enterprises. The Soviet regime has found in these enterprises an extremely effective means for combating dissatisfaction among skilled workers.[20] Closed enterprises dispel the danger of a workers' movement forming during the present phase when terror can no longer be widely used. This, however, reinforces society's militaristic and chauvinistic tendencies.

The mechanism is simple. When joining a closed enterprise, workers realize that they are voluntarily renouncing their already scarce sociopolitical rights (including the right to quit their jobs at will). Even though workers exchange their rights for concrete material advantages, a step of this kind still requires some self-justification. It is not hard to find. In fact, whatever they may produce, the real raison d'être of these closed enterprises lies in their genuine or fictitious participation in secrets of capital importance to the state. Working at a closed enterprise, workers fulfill their duty to defend their country from potential aggressors and receive supplementary compensation due to the "particular importance" of their work for the Soviet Union's existence. This situation, reminiscent of wartime, justifies limitations imposed on workers' rights and induces them to accept these limitations willingly. It is fairly easy for workers to identify with such convictions insofar as the memory of the anti-Nazi war, which cost innumerable lives, has been exploited by the mass media in order to continue feeding the sense of danger allegedly still confronting the Soviet Union.

This explains the phenomenon poignantly described by Hedrick Smith in a chapter entitled "World War II Was Only Yesterday" in his book The Russians.[21] In fact, even after thirty-five years, the war continues to be the main theme in Soviet literature, film, and television. By this time, however, the concatenation of images of "war–victory–Generalissimo Stalin" is spontaneously generated. Ruthlessly distorting historical facts, pro-Stalinist literature depicts Stalin as the wise commander who, after preparing the country for war, led it to victory. It exploits the myth of national grandeur and the cult of the hero. The quintessence of such stereotypes reappears in the following verses, published in 1968, in which the author proposes to build an immense World War II museum: "Oh visitor, experience your dependence on the country, on everything Russian. There, in the middle, lies our Generalissimo, with all his great marshals."[22]

Thus the objective position of closed enterprise workers within Soviet society, their work, the subjective evaluation of their own possibilities and goals, all determine their "predisposition" to accept willingly and to internalize the stereotypes of chauvinist propaganda.

The Cult among the Young

Stalin's popularity among younger workers requires some explanation. The history of Soviet society can be characterized by two successive phases: one of social revolution ending in the late 1950s and another stationary one (system-maintenance) whose beginning coincides roughly with Brezhnev's rise to power. Many important transformations, however, are still taking place during this stationary phase. Many changes in people's values may be attributed to the fact that the older vision of a final social goal has obviously been lost. In the ideology of the revolutionary period, this goal was industrialization and the construction of a classless society; the determination of the regime to achieve at least the first of these goals

was one of the main elements of massive popular consensus during Stalin's period. In 1920 Lenin had already envisioned the possibility of building communism within two decades.23 After him, Stalin pledged the advent of communism as soon as the Soviet economy was capable of producing certain quantities of steel and oil. In the Stalinist period the average person's outlook was equally conditioned by fear of the present and faith in a happier future. The sense of rapid transformation during this period of social revolution made such predictions appear realistic.

The promise contained in the party's ambitious 1961 program, adopted under Khrushchev — to build communism by 1980 — was nothing but a clumsy attempt to resurrect the romantic spirit of the revolutionary phase at a moment when, having reached relative maturity, society was entering a phase of maintaining the status quo. The adoption of so concrete a program contributed significantly to discrediting the idea of communism as a practically realizable objective.

Anatolii Levitin-Krasnov has described the mood of Soviet young people as a "profound disillusionment with the idea of communism, in which three former generations had faith. The young neither fight against communism, argue against it, nor curse it; something much worse has happened to communism: they laugh at it." 24 In the eyes of young workers who started working in the 1960s, the country's future appears to be a monotonous chain of five-year plans: the ninth and tenth have already passed, while the eleventh has just started. And while through the early 1970s some slow improvement in living conditions may have been noticeable, there followed stagnation, if not deterioration, in living standards. The loss of the final objective becomes all the more painful when individual consumption cannot compensate for it by gradually transforming Soviet citizens into satisfied consumers.

Under these circumstances many young people long for a meaningful life with some goals. But in a society lacking positive programs, where individual creativity is repressed by the regime, the young look back nostalgically to the period of social

revolution inseparably linked with Stalin's name. The tragic
paradox of Soviet society lies in the fact that Stalinism has co-
incided historically with a period of social revolution. The
idealization of this period, reinforced by the memory of real
opportunities for rapid social mobility for workers, provides
fertile ground for the rebirth of the Stalin cult among today's
young workers.

The Dependence of Intellectuals

The problem of the intelligentsia's position with respect to the
rebirth of the Stalin myth must also be analyzed. It is well
known that in the second half of the 1960s, part of the intelli-
gentsia was opposed, individually as well as a group, to all at-
tempts to rehabilitate Stalin. At times actions taken by spe-
cialists caused repeal or modification of measures already ap-
proved by the Central Committee — an extraordinary fact, never
to recur after the initial years of Soviet rule. For example,
the ninetieth anniversary of Stalin's birth was not celebrated,
the order to publish reports on it in newspapers was revoked,
and the provision designating Stalin's theoretical works as uni-
versity-level subject matter was abrogated.[25] Symbolic of
this period was an article written for the fifteenth anniversary
of Stalin's death by Lydia Chukovskaia and distributed in sam-
izdat. It demanded public condemnation of informers, assas-
sins, and provocateurs of the Stalin period for, as she con-
tended, the "complicity of silence" had come to an end.[26]
 Today, when Stalin's reputation has reached dimensions un-
imaginable at the end of the 1960s, the opposition has consider-
ably weakened. What has happened in the interim to Soviet
specialists, many of whom by the very nature of their work
cannot help but oppose Stalinism as a system repressing free-
dom and individual initiative? The most serious change of re-
cent years consists in the overproduction of specialists who,
at the beginning of the 1960s, made up 10 percent of the Soviet
population, while today they represent almost 20 percent — far

above the number of peasants.[27]

Thus the new middle class is the fastest growing group in Soviet society. This inevitably leads to the devaluation of diplomas and an increase in competition made harsher by the unbalanced territorial distribution of specialists, itself a consequence of the internal passport system operating in the country. This kind of situation generally results in the weakening of the new middle class's radicalism, insofar as specialists gradually find themselves highly dependent on the dominant class.[28] In the Soviet Union the state is the only employer and can deny professional work to anyone who is politically disloyal. This practice has been facilitated by the overproduction of specialists. In recent years there have been numerous instances of internationally known scientists stripped of their jobs, their titles, and their academic appointments.

However, overproduction of specialists and increased competition for adequate jobs have another consequence. A significant number of scientists are likely to accept the new Stalin cult because of their sympathy with the anti-Semitism that Stalin elevated to state policy by the late 1930s. As Mikhail Agurskii has observed, "in the eyes of most people, Stalin is the one who fought for the national Russian cause, against all alien influence."[29] Pragmatic anti-Semitism, as a means to slow down competitors, has become one of the distinctive traits of Soviet specialists of the 1970s. Under Stalin employment within the party apparatus, the armed forces, state administration, the diplomatic service, foreign trade, and various other sectors was closed to Jews. Therefore they became overconcentrated and highly visible in other available sectors, particularly in the theoretical sciences, education, culture, and the medium-level management of some branches of industry. This fact is now turning them into a prominent and convenient target.

In today's USSR it has become very hard to distinguish where official anti-Semitism ends and the pragmatic anti-Semitism of specialists fighting their rivals begins. It is not surprising, therefore, that as these strata of specialists find expression through their own "organic ideologists," the latter should rapidly

rise to careers within the country's highest ideological in-
stitutions. This is exactly how Vasilii Mishin, a philosophy in-
structor in a provincial city, became one of the highest direc-
tors at the Philosophy Institute of the Academy of Sciences. He
published a book theoretically justifying the need to reduce the
percentage of Jews working in the science, technology, educa-
tion, and cultural sectors. Similarly, Petr Palievskii, founder
of "The Fatherland," a cultural circle open only to individuals
of "pure Russian origin" and one that defined Osip Mandelstam's
poetry as "a Jewish abscess on the pure body of Russian po-
etry,"[30] has recently become one of the directors of the In-
stitute for World Literature.

Submission and Repression

There is little doubt, however, that a significant number of in-
tellectuals still follow the internationalist, democratic tradi-
tions of the old Russian intelligentsia and continue to feel his-
torically responsible for what happens in the country. In their
case neither spontaneous, pragmatic anti-Semitism nor official
support for it are in any way involved. The exaltation of a ty-
rant who, beyond the destruction of liberties and democratic
ideals, was also responsible for so many massacres can only
fill them with moral indignation.

Nonetheless, in the 1970s, among these intellectuals dissat-
isfaction and protest went hand in hand with social passivity
and political conformism. Clearly, age and health conditions
do not permit the few surviving intellectuals of the older gen-
eration the intensive social activism of the past. It is not dif-
ficult to imagine the sentiments stirred by the current pro-
Stalinist campaign in, say, the well-known international journal-
ist Ernst Henri, who dealt the first blow at the most vulner-
able point of the myth of Stalin-the-Brilliant-Commander: in
a famous 1965 letter to Ilya Ehrenburg distributed throughout
the country in thousands of copies, Henri demonstrated the dic-
tator's responsibility for the defeat of the German workers'

movement, for the destruction of the Soviet leadership, for the
USSR's failure to prepare for war, and for the colossal war
losses. The sense of futility and hopelessness among the older
generation and, quite simply, human weariness are easily under-
standable. But the fact that the social activism of the interme-
diate and younger generations of Soviet intellectuals has weak-
ened so much since the middle 1970s has gradually stirred
thoughts of a return to "the complicity of silence." In order
to grasp how and why this incongruence between the emotions
and the mass behavior of a social group arises and is consoli-
dated, it is necessary to evaluate realistically the regime's
present capacity to limit political activity by the population.
In this connection it must be noted that the position of Brezhnev's
regime on intellectual dissidence has today grown increasingly
harsher. The overproduction of specialists, which generates
a form of hidden unemployment, provides the leading group with
an effective means for silencing dissenters.

In the 1970s, however, newer and more effective means be-
came available. The first of them, well-known in the West, is
the voluntary and/or forced emigration of many active intellec-
tual critics who were catalysts in the democratization move-
ment and the anti-Stalinist struggle. The fate of the noted So-
viet historian Aleksandr Nekrich, whose work June 22, 1941,
was banned from all USSR libraries and who lost his job and
was practically expelled from the country, is one of the most
telling examples.[31] Lev Kopelev has compared the current
"cultural landscape" of Soviet society to a moonscape strewn
with sterile, cavernous craters or gaps left behind by the flight
of emigrants.[32]

The second means for exerting pressure on the intellectual
opposition has gone almost unnoticed in the West. According
to a 1976 regulation, any specialist under fifty years of age
can be recalled to serve as a reserve officer for a period of
up to two years. In practice this amounts to a form of exile
since, following a few days of preparations, these people are
usually sent to some remote spot in Siberia where they spend
two years under rigid military discipline, isolated from family,

friends, work, and hometown. This is a very effective tool be-
cause arbitrariness is couched in the absolute "legality" of
military authority actions, and it eludes negative reactions from
Western public opinion, which becomes mobilized only when a
dissident is brought to trial.

Finally, the peculiar social-psychological climate of Soviet
society from the middle 1970s on was marked by the gerontocratic
character of its leadership. In the last years not one month
has gone by without the habitual Western press release on the
"serious illness" of one or another Soviet leader. In fact the
average age of Politburo members today hovers around sev-
enty. Moreover, two newcomers to the Politburo joined at
the ages of sixty-seven and seventy-seven, which is even more
absurd for a country where retirement is generally obligatory
between the ages of fifty-five and sixty. Faced with this state
of affairs, Soviet intellectuals can easily arrive at two conclu-
sions. First, it is clear that the present leadership can only
initiate policies for maintaining the status quo and is prepared
to adopt any available means to this end. Second, in all prob-
ability a change of guard within the leadership will not occur
in stages but, instead, all at once. Under the circumstances
the belief in the futility of immediate opposition has gained
ground among intellectuals, for it would be very dangerous and
promises few possibilities for success; hence the necessity of
wait-and-see tactics. In this context the pro-Stalinist campaign
is commonly attributed to the "hard" wing of the leadership and
is equated somewhat with the actions of the Chinese "gang of
four" faction in the wake of Mao's death.

It is hard to say to what extent hopes for a sudden change in
the present leadership might be justified. The history of coun-
tries with one-party systems provides examples of extremely
stable and durable leadership groups. Theoretically nothing
prevents Brezhnev from reaching Tito's age, for example,
while still holding his position. In any case, we can state that
the rebirth of the Stalin cult must not be attributed only to the
actions of a single group or even of the party bureaucracy as
a whole to maintain their monopoly on power. The origins of

re-Stalinization must be located in the peculiar structure of Soviet society, in the social psychology of the groups constituting it, and in the particular historical moment that forges temporary coalitions among groups of diverse interests to support, or at least not to obstruct, specific policies. The present historical moment can be defined as one of "organized consensus." While the leading group tries to consolidate and intensify the atomization of society, other social groups, unable to see different prospects or possibilities for opposition, accept this atomization in exchange for a few real or even illusory privileges. The rebirth of the Stalin cult is a logical aftermath of Soviet social evolution in the Brezhnev era.

2

ADULT POLITICAL SOCIALIZATION:
SOVIET WORKERS AND THE INVASION OF CZECHOSLOVAKIA

Alexis de Tocqueville's well-known observation[1] that there
is a considerable degree of continuity between pre- and post-
revolutionary societies certainly applies to Russia. Indeed,
some social scientists go so far as to postulate the existence
of unchangeable traditions which allegedly can be shaken neither
by a revolution nor by the emergence of a new type of industrial
society.[2] Proponents of this view seem to disagree only on the
question of how far back in the history of Russia one should
date the origins of that society's dominant political culture.
White cautiously suggests that the USSR's ruling political ideas
"were inherited from the prerevolutionary period"; LaPalombara
asserts that the widely accepted legitimacy of the Soviet state
"is fundamentally owing to a history of authoritarianism that
is rooted in traditional and medieval Russia"; and Conquest re-
cently reiterated the view that "the roots of Russian political
attitudes derive from the time of the Mongol invasion."[3]

This article was co-authored by Z, whose name for obvious reasons cannot be
given. He had no opportunity to take part in the actual writing of this article, but
he shared with me all the work of interviewing, discussing, and interpreting the
data obtained.

22

Whatever the merits of such arguments — and we do not for
a moment deny that they are considerable — it must be empha-
sized that they have the undesirable consequence of diverting
attention away from those structural arrangements which en-
courage the persistence of ideas over time. The transmission
of political culture requires that institutions effectively social-
ize members of society; otherwise there exists no mechanism
which can ensure the kind of continuity discussed by White,
LaPalombara, Conquest, Brzezinski,[4] and others. It is the
aim of this paper to discuss some of the major institutional
supports of Soviet political culture today.

At the end of August 1968, two Soviet social scientists, in
response to the invasion of Czechoslovakia by troops of the
Warsaw pact countries, decided to interview Soviet workers
about their attitudes toward this invasion. The findings reported
here, in spite of data incompleteness occasioned largely by the
restrictions unavoidable in such a clandestine sociological study,
shed some light on the process of adult political socialization in
Soviet society.

Methodology

Our findings are based on a survey we conducted from Septem-
ber 1968 to March 1969 in the USSR. Three hundred fifty-two
male workers employed as drillers in the geological industry
were interviewed. The five geological parties from which our
sample was drawn were located in three different regions des-
ignated here as Far Northern, Northern, and Central. In the
Far Northern and Northern regions we were able to work on
"open" and "closed" parties; the difference between them will
be explained below. In the Central region we studied only an
"open" party.

We conducted our interviews while we worked on setting pro-
duction norms for drilling. Each drilling unit consists of three
workers: a master (a highly skilled worker, classified as cat-
egory V or VI according to the six-category scale of qualifica-

tions widely used in Soviet industry); a senior operator (a skilled worker, category III or IV); and a junior operator (a semiskilled worker, category I or II). Each unit was observed during one to three eight-hour shifts. The interviews were conducted at the workplace and while walking to and from it; they were informal, lasted from one to two hours each, and were arranged with each worker separately. Also, the interviewers normally had a group conversation with all the workers in the unit. In about 50 percent of the cases we could check the data obtained at workplaces by repeating interviews in the respondents' homes.

Ranking of Responses

We ranked the responses of the workers interviewed in this survey according to the following scale. The first group unreservedly approved the invasion and completely identified themselves with this decision by the Soviet leadership. This attitude was defined as "strong support." These respondents also condemned the actions of the Czechs and expressed often undisguised hostility toward them. Criticism of the Soviet government, if any, on the part of these highly motivated supporters consisted in disapproval of its leniency and excessive liberalism in the treatment of "Czech traitors."

We defined as "weak support" the position of those who agreed with the invasion but with considerably less certainty; one might even say they saw it as the lesser evil. They were much less critical of the Czechs: rather than viewing them as traitors, to be subjected to martial law, they excused their pardonable human weaknesses. Their criticism of the Soviet leadership was noticeable: for example, a considerable number of the respondents from this second group disapproved of even symbolic participation on the part of East German troops in the operation. They implied that perhaps the invasion was a premature act, and other alternatives could have been tried first. Nevertheless, they assumed that the Soviet government

had weighed the consequences and come to the conclusion that it was the only thing to be done. Characteristically, some of these "weak supporters" refused to discuss the situation that might have arisen in the case of armed resistance by the Czechs. Their response was that no one could oppose the decisions of the Soviet government.

The attitude of those workers who neither supported the decision to invade nor opposed it was defined as "undecided." A typical respondent from this third group considered the existing information too ambiguous to come to any definite conclusions. Usually these respondents felt a certain sympathy with the Czechs but reproached the Czech government for the political awkwardness of its leadership.

Respondents from the fourth group expressed disapproval of the invasion, considering it as morally and/or politically unjustified. They were in sympathy with the Czechs, but this did not prevent them from criticizing the Czech government as well. We classified this attitude as "opposition."

Finally, some respondents not only expressed dissatisfaction with the Soviet government's action in this situation but also revealed opposition to the Soviet regime as a whole. It was clear that these respondents identified themselves with the Czech side in this conflict and perceived its defeat as their own. This fifth group of workers was in "strong opposition" to the invasion.

Before beginning the survey, we naively felt that the assertions of the Soviet mass media about the "unanimous approval given by the Soviet population" to the occupation were the usual propagandistic bluff. The data reported in Table 1 show that Soviet propaganda was closer to reality than we expected: 76.1 percent of all respondents supported the decision to invade, 14.6 percent opposed it, and 9.3 percent were undecided. Our experience in interviewing Soviet workers, however, has led us to the conclusion that the clearly distinguishable difference between the attitude defined as "strong support" and that designated as "weak support" is a qualitative one. In the case of "strong support," we were dealing with devoted followers whose active, highly motivated approval of the invasion differed

Table 1

Attitudes toward the Invasion of Czechoslovakia by Age
(%)

Age	Strong opposition	Opposition	Undecided	Weak support	Strong support	Total
51-60	14.3(3)	9.5(2)	4.8(1)	23.8(5)	47.6(10)	100(21)
41-50	5.6(3)	7.4(4)	3.7(2)	33.3(18)	50.0(27)	100(54)
31-40	2.5(2)	3.7(3)	6.2(5)	45.7(37)	42.0(34)	100(81)
21-30	—	11.8(11)	6.5(6)	46.2(43)	35.5(33)	100(93)
<21	—	30.8(16)	26.9(14)	34.6(18)	7.7(4)	100(52)
Total	(8)	(36)	(28)	(121)	(108)	(301)

$\chi^2 = 78.21$; 16df; P <.005　　　　　　$\gamma = .32$

Note. N's in parentheses.

qualitatively from the position of "weak supporters," who ac-
quiesced simply out of habit or resignation. The first group
considers the Soviet regime the most appropriate system for
society. The second is not particularly happy with the regime
but goes along with it, being unable to imagine any practical
alternative to it.

It is well known that Soviet propaganda is an omnipresent
and powerful pressure in the direction of conformity to, and
acceptance of, the regime. In the case of the occupation of
Czechoslovakia, the effort to manipulate public opinion was
extraordinary even for the Soviet propaganda machine. This
activity was greatly facilitated by the immediate resumption
of Western broadcast jamming with an intensity exceeding that
of the Stalin period. That is why not only those who opposed
the invasion but also those who weakly supported it, by demon-
strating so much variance with officially decreed opinions, rep-
resent a failure of the far-flung system of indoctrination.

Singling out the group of "strong supporters" (35.9 percent
of the sample) and setting it off from the rest of the workers
interviewed helped us to discover differences in the life

experience of these two categories of people with regard to the number and strength of their ties to the existing order. The dichotomization of our sample into "strong supporters" and others serves as a starting point for the analysis of specific social institutions responsible for manufacturing and perpetuating Soviet political culture. In this article we concentrated our attention on three social institutions — the army, the party, and the closed enterprises — whose role in the process of adult socialization, especially political socialization in Soviet society, appears to be crucial.

The Army Experience

The greatest difference in attitudes toward the invasion was observed between the teenager group (16 to 18 years old) and the rest of the sample. As Tables 1, 2, and 3 show, the youngest workers produced the smallest proportion of strong supporters and the largest proportion of those in opposition. In order to understand the sources of this "youthful idealism," to weigh and evaluate the role of various socializing agents that shaped the political attitudes of these young workers, we had to appeal to our own experience as members and participant-observers in Soviet society.

Table 2

Attitudes toward the Invasion of Czechoslovakia by Age
(%)

Age	Less than strong support	Strong support	Total
21-30	64.5(60)	35.5(33)	100(93)
< 21	92.3(48)	7.7(4)	100(52)

$\chi^2 = 13.63$; 1df; $P < .005$ $Q = +.74$; $P < .005$ one-tailed test

Note. N's in parentheses.

First of all, a first-generation worker's family does not or-
dinarily play a significant role in the transmission of political
beliefs to children. Women in this social group are usually
apolitical, i.e., have no clearly expressed political interests
and orientations at all. There are normally no political dis-
cussions within the family. Such discussions are an integral
part of the conversation of circles of male friends. We repeat-
edly observed cases in which a master in the unit expressed
strong support for the invasion of Czechoslovakia while his
son, who worked in the same unit as a junior operator, ex-
pressed opposition to it. This did not provoke any political
conflict because of the absence of political communication be-
tween generations within the family.

It should, however, be noted that during the period under dis-
cussion, this situation was beginning to change. Shortly before
Khrushchev's fall, the jamming of Western broadcasts in Rus-
sian had been stopped, and since the second half of the 1960s
the ownership of shortwave radios has become widespread
throughout the country. The Western broadcasts are not only
a major source of alternative information and entertainment;
they have also introduced politics into the working-class family.
This development occurred, however, too late to have affected
our respondents.

Table 3

Attitudes of Nonmembers of the CPSU toward the Invasion
by Age and Type of Enterprise (%)

Age	Type of enterprise	Less than strong support	Strong support	Total
21-30	closed	64.3(9)	35.7(5)	(14)
	open	77.2(44)	22.8(13)	(57)
< 21	closed	80.0(8)	20.0(2)	(10)
	open	95.2(40)	4.8(2)	(42)

$\chi^2 = 8.92$; 3df; $P < .05$ Partial Q = +.39; $P < .075$ one-tailed test

Note. N's in parentheses.

From our experience we judge that the major part in the moral-political socialization of working youth was played by the school (with its youth organizations), where Russian classical literature, which traditionally took sides with the "humiliated and offended," and basic Marxism, with its ineradicable ideas of egalitarianism and social justice, were essential elements of the curriculum.[5]

Most striking is the dissimilarity in attitudes between the age group under 20 and the contiguous age cohort (21-30) shown in Tables 2 and 3. While only 7.7 percent of teenagers strongly supported the invasion, the number of strong supporters among the respondents in the 21-30 age group reached 35.5 percent. How could the difference of a few years between these groups produce such a radical change in political views? Our first hypothesis was that adolescent workers are not sufficiently embedded in the political regime in the sense that they have fewer and/or weaker ties than older workers to those institutions which can — and, in the Soviet case, do — place conservative limits on political thought and action.[6] Younger workers have no family of their own, often consider their job a temporary occupation before the call to military service, and are generally free from responsibilities; as a result they are, we hypothesized, more radical in their political views. We found that the adolescents were in fact not as embedded as older workers — but for reasons other than those we had originally assumed: when only jobs and family are considered, workers in their twenties appear hardly more embedded in the political regime and adult life than do teenagers.

That jobs and family are not primary factors in accounting for degree of embeddedness in the existing structure of political authority can be seen, first of all, in the fact that those in the 35-45 age group are usually just as inclined as younger workers to leave their jobs because the right to quit one's job at will is the major bargaining resource of all workers.[7] Moreover, young workers in our sample did not feel any resentment because of their subordinate position as junior operators. They considered it a natural consequence both of the

requirements of technological process and of their lack of
practical experience.

The married workers in our sample cannot be considered as
more embedded in the political regime either. Due to the spe-
cific conditions of employment in geology, the members of
married workers' families often have no opportunity for em-
ployment at the geological work site and are forced to live sep-
arately from the male head of household. More importantly,
family life among first-generation Soviet workers is a very
fluid and unstable arrangement owing to a large proportion of
marriages of convenience.[8] It was very difficult to obtain re-
liable information concerning the marital status of young peo-
ple in this social group. But comparison of the attitudes of
respondents in the 21-30 age group who had children with those
of single respondents in the same age cohort produced no sig-
nificant association between marital status and political attitudes.

The only plausible explanation of the differences in political
views between teenage respondents and those in the 21-30 age
group seems to be the impact of the Soviet army as a socializ-
ing agent. Ever since the first years of Soviet power, the army
has been considered a major instrument of socialization and
mental transformation. "The Red Army, which is largely made
up of peasants," wrote Bukharin, "is one of the greatest possi-
ble cultural machines for imbuing with a new mentality the
peasant who passes through its ranks."[9]

Goffman could have used the Soviet army as a perfect exam-
ple of a total institution.[10] The army, with its enforcement of
complete conformity and absolute submission to a superior,
is a model of Soviet society as a whole. It creates one of the
basic ties to the existing political order. The army experi-
ence — and here lies its salience — structures the political
consciousness of both peasants and workers[11] by establishing
two models of thought and behavior or, more precisely, by
forming two conditioned social reflexes: the reflex of unques-
tioning submission to authority and the reflex of automatic di-
chotomization of the world into "ours" and "theirs."

Recruits develop a strong affective relationship with the army

which undoubtedly favors the process of adult socialization.[12] Our respondents in the 21-30 age group recalled the army with a peculiar mixture of gratitude and aversion. This affective relationship was partly sustained by patriotism and deliberately propagated "militolatry," defined by Andreski as "adulation of military virtues."[13] More importantly, service in the Soviet army is highly instrumental for the achievement of peasants' personal goals. The army is the main channel for leaving the collective farm. The evidence that we have shows that at the end of the 1960s, 30 percent of the peasant youth at most returned to their villages after military service.[14] Hardly any of our respondents in the 21-30 age group did so. Getting a passport and the consequent mobility from peasant to worker status became their main social achievement, inseparably linked with service in the armed forces.

Some respondents had additional grounds to be grateful to the army. The role of the army as a socializing agent is enhanced by the fact that it is a major reservoir from which young candidates for party membership are recruited. The army is a very convenient place for the early selection of the most active and ambitious members of the younger generation, who could become potential grass-roots leaders of the working class, and for drawing them into the ranks of the party, the most privileged and controlled group in the society. In our sample fourteen of the twenty-two party members in the 21-30 age cohort joined the party during military service.

Entry into the party during military service is deliberately facilitated by the authorities. This is explained by the close integration of both social institutions as well as by the extreme similarity in the way they function. The party principle of "democratic centralism" fully corresponds to the army principle of unquestioning obedience to anyone higher in rank, while the principle of the "only true ideology" and unceasing struggle between Soviet and bourgeois ideologies is quite analogous to the military dichotomization of the world into "us" and "enemies."

The Party

One of the characteristic consequences of political and societal change in the USSR in the 1960s is the change in the way party membership is viewed. In the Stalin period party membership not only entailed obvious social privileges and increased chances for upward social mobility but was also characterized by basic insecurity and the need to be ready to sacrifice one's personal interests. At that time, correspondingly, making a decision to join the party involved some elements of personal initiative and choice.

In the 1960s the gap between party members and the rest of the population became more pronounced. Since the advent of "de-Stalinization" and the reduction of the role of organs of coercion, the advantages of being a party member are no longer "balanced" by the risk and restrictions under which party members lived during the years of terror. Today party membership, particularly for young workers, is a prerequisite for rapid promotion. It represents a significant increase in job security, important in the case of an attractive job, and it augments the chances for obtaining other social and psychological benefits.[15] On the other hand, joining the party is no longer a matter of personal choice but a result of official recruitment policy. An invitation to join the party, made by a local party committee after scrutiny of possible candidates, is a long-wished-for event for one who is chosen. It signifies substantial upward mobility. The findings reported in Table 4 — that a majority of party members in our sample fully identify themselves with the regime and strongly support all government actions — are, therefore, to be expected.

Members of the party represent the most homogeneous subsection of the Soviet working class. Table 4 shows, nevertheless, that there were significant differences in attitudes among party members related to the type of enterprise in which they were employed. We consider this to be the most important finding of our study.

Table 4

Attitudes toward the Invasion for Members and Nonmembers
of the CPSU by Type of Enterprise (%)

Age	Party membership	Type of enterprise	Less than strong support	Strong support	Total
21+	yes	closed	20.5(8)	79.5(31)	100(39)
	yes	open	39.5(17)	60.5(26)	100(43)
		Total	(25)	(57)	(82)
21+	no	closed	60.0(30)	40.0(20)	100(50)
	no	open	76.9(90)	231.(27)	100(117)
		Total	(120)	(47)	(167)

$\chi^2_{(1)}=$ 38.69; 1df; P $<$.005 Q_1 = +.71; P $<$.0025 one-tailed test

$\chi^2_{(2)}=$ 3.51; 1df; P $<$.1 Q_2 = +.43; P $<$.005 one-tailed test

$\chi^2_{(3)}=$ 4.97; 1df; P $<$.05 Q_3 = +.38; P $<$.005 one-tailed test

Note. (1) — party membership and level of support.
 (2) — type of enterprise for party members and level of support.
 (3) — type of enterprise for nonmembers of the party and level of support.
 N's in parentheses.

"Closed" Enterprises and Political Attitudes of Workers

A closed enterprise, as opposed to an open or normal enter-
prise, is in principle one which produces something falling into
the very vague category of military or state secret. Specific-
ally, in the geological industry closed parties are allegedly
those either located in territory adjacent to the state border
of the Soviet Union or prospecting for "strategically important"
resources. Such undertakings are officially called "regime
enterprises" because all workers and employees are subject
to special conditions of secrecy (rezhim sekretnosti). To join
such an enterprise a worker must get a security clearance and
commit himself to special obligations. Workers in closed

enterprises are under permanent and strict control; they no longer have the right to change jobs at will, or this right is severly truncated; they are responsible for the political behavior of their relatives and close friends. These constraints, nevertheless, do not prevent the emergence of strong competition among workers for jobs in a closed enterprise.

The attractions stemming from a closed enterprise are as follows. Workers' wages are significantly higher (in our study the basic wages of workers in closed geological enterprises were 30-40 percent higher than those in open enterprises located almost next door). The wage differential is due largely to the higher productivity achieved which, in turn, is caused by the use of more advanced technology and better labor discipline. Various fringe benefits are exceedingly important in the Soviet economy, with its intrinsic shortage of goods; and whereas workers in closed enterprises benefit from these "perks," workers in open enterprises do not.[16] Workers in closed enterprises are treated as especially trusted individuals, and this entails more than just psychological advantages. Security clearance normally adheres to the worker for life, considerably increasing his job security.[17] But psychological benefits are also significant because all the material benefits are justified and sanctified by the special importance of the work for the very existence of the Soviet state, thereby fostering sentiments of social superiority. These advantages of work in a closed enterprise — together with the fact that workers in such parties are, more than anybody else, subject to concentrated and intensive indoctrination — all help explain the high correlation shown in Tables 4 and 5 between type of enterprise and level of regime support. Both party and nonparty members in closed enterprises are more inclined to be strong supporters. Such enterprises are one of the most important institutions of adult political socialization which tie a worker to the existing regime.

During the years that elapsed since the completion of this study, we continued our participant observation and collected information on the functioning of closed enterprises. This led us to conclude that such enterprises are becoming one of the

Table 5

Attitudes toward the Invasion of Czechoslovakia
by Type of Enterprise (%)

Type of enterprise	Strong opposition	Opposition	Undecided	Weak support	Strong support	Total
Closed	2.0(2)	7.1(7)	8.1(8)	29.3(29)	53.5(53)	100(99)
Open	3.0(6)	14.4(29)	9.9(20)	45.5(92)	27.2(55)	100(202)
Total	(8)	(36)	(28)	(121)	(108)	(301)

χ^2 = 20.57; 4df; P < .005 γ =.38

Note. N's in parentheses.

fastest growing social institutions in the USSR. Not only have new closed factories and plants emerged, but closed branch offices or workshops have also appeared inside traditional open plants. The concept of "military secret" has been greatly inflated. More and more managers try to transform their open enterprises into closed ones as a way of solving their labor-turnover problem.

Regime enterprises have also become an important means of neutralizing the dissatisfaction of highly skilled workers. Soviet sociologists have repeatedly drawn attention to the "low ceiling" of social promotion for skilled workers.[18] By creating a new group of privileged workers, the Soviet regime produces new opportunities for upward social mobility. The manpower of closed enterprises is often very skilled because it uses advanced technology. Indeed, it is sometimes "overqualified," owing to the common practice of accepting a lower position in order to join such an enterprise. In our sample this phenomenon of overqualification was not noticeable because of special conditions in the geological industry and a corresponding policy of hiring and promoting personnel. However, a majority of the masters in open geological parties acknowledged that they would seize the first opportunity to accept a senior operator position in a closed party.

Conclusion

Each of the three social institutions which have been discussed, different as they may be in function and in the spheres of human activity they organize, contributes to the process of adult political socialization. Supplementing and overlapping each other, they are important components in the highly integrated system of adult socialization in the USSR.

Our analysis of the attitudes of Soviet workers toward this one specific event thus has more general implications. It suggests that an understanding of the socializing activity of these key institutions gives us important insights into the nature of the stability of the Soviet regime. All of them — the army, the party, and the closed enterprises — took their present shape during the predominantly coercive and regimentative stage of the development of Soviet society; indeed, closed enterprises are the direct offspring of the reign of terror. In the contemporary period these three institutions are more important in preserving the structure of power in Soviet society, now characterized by a developmental stage in which terror has lost its former efficacy. Each of them is carefully designed so that the entrance and gradual advance of workers through them entails a corresponding increase both in control over thought and behavior and in rewards and benefits obtained, thus helping to forge new and stronger ties between the individual and the regime — ties that are all the stronger since they are not directly coercive.

The subjective experiences and aspirations of Soviet workers need to be understood and explained within this institutional context, as must be their evaluations of, and attitudes toward, these institutions. The consciousness of a member of a social group reflects both his objective social position and his experience in attempting to change that position. Success in passing through the army, success in joining the party, and success in entering into and advancing in a closed enterprise represent sequential stages of an individual's self-realization and thus evoke a sense of accomplishment and satisfaction. The degree of personal initiative involved in joining these organizations

becomes progressively greater as one proceeds from one to
the next. Whereas there is virtually no opportunity to avoid
military service, entering the party does require some sort
of personal initiative and commitment. A worker consciously
controls his behavior, conforming to today's requirements and
simultaneously trying to draw the attention of the local party
leadership to himself. Nevertheless, factors that are beyond
his control, such as the number of candidate positions at the
disposal of a local party committee or some of his background
characteristics, may play a far greater role in determining
his success or failure. In contrast, obtaining a job in a closed
enterprise may depend more on the individual traits of the
worker, such as his qualifications and his ambition.

As we have seen, each of the institutions discussed can se-
cure for its members a degree of social mobility, thereby bind-
ing them more closely to the regime. This illustrates the im-
portance of the concept of "embeddedness in the regime," which
refers to the number and strength of social ties between an in-
dividual or a group and the existing political regime, as a the-
oretical tool in the analysis of Soviet society. Each social
class — indeed, each stratum of a class — within Soviet society
is characterized either by its own set of socializing institutions
that produce and determine various degrees of embeddedness
in the regime or, at least, by a different relative weight and
specific configuration of such institutions. To be sure, these
secondary socializing agencies do not have an unlimited forma-
tive influence on a personality, and a contradiction can arise
between an individual's attitudes and perceptions and the image
the political system presents of itself.

A major task for students of Soviet political culture is, there-
fore, to identify and analyze the specific set of institutions
through which a particular social group in the Soviet Union is
socialized — as well as to analyze the limitations on the
power of these institutions and the social roots of noncon-
formity. Such investigation of Soviet political culture is
vitally important for the understanding of current changes
in Soviet society.

The Problem of Methodology

In describing a study of this type it is appropriate to address two questions: (a) How are unofficial sociological surveys in the USSR at all possible? (b) To what degree can one rely on the sincerity of responses to such politically sensitive questions as those concerning the invasion of Czechoslovakia?

Regarding the first question, we can assert that if the history of the Soviet oppositional intelligentsia in the 1960s and 1970s were someday to be written, it would include, in addition to samizdat activities, unofficial sociological investigations. Normally any empirical sociological research in the Soviet Union may be conducted only under the aegis of an official institution and after approval of the research program by a party committee at the corresponding level. But a sociologist can exercise his own initiative in two ways: first, he can, at his own risk, extend the authorized program to include the questions he is interested in; second, because the Soviet population is quite unfamiliar with sociological studies, while the sociologist is gathering authorized information (for example, participating in census work), he can simultaneously conduct interviews for his own personal use. In either case he is unable to choose the informants most appropriate for his purposes. He has to seize the opportunities available.

In our case the reason for drawing the sample from workers in the geological industry was that one author, who also holds a degree in mining engineering, was at that time in charge of the production norms department (the department that supervises the fixing and changing of levels of productivity) in one of the Soviet geological directorates.

This study of workers' attitudes toward the invasion of Czechoslovakia entailed a certain risk for its authors. It would be taken for granted by any "officially thinking" person that there were no differences of opinion among workers. The proper place for a sociologist so engaged would be a mental hospital, a punishment not unheard of in the Soviet Union. On the other hand, the detection of such activity would be unlikely

since, in the eyes of officialdom, the sociologist's only incentive for "looking for trouble" — Veblen's "idle curiosity" — would not justify the risk involved. Small, friendly circles, a traditional form of organization among members of the Russian intelligentsia, also reduce the danger by providing practical help and moral support.

Respondents' Frankness

A central problem in any study of political attitudes in a closed society is the question of the respondents' frankness. It is well known that Soviet population surveys are an extremely unreliable source of information. Yakushev, a Soviet sociologist now working in the West, asserts with some justification that the sociological techniques connected with opinion surveys are, in many cases, not effective under Soviet conditions.[19] This is not only because many sociological institutions aiming at self-preservation program ideologically and politically favorable findings in advance. More importantly, a typical Soviet respondent, as Dadamian and Dondurei acknowledge, always "seeks to show himself in a good light," thereby "shifting all estimates significantly to the positive part of the scale."[20] As a rule the respondents "see no reason to distinguish sociological questionnaires from official forms, sociological interviews from testimony given, say, in court or at the police station."[21]

What permits us to assert that our respondents answered with candor, revealing their actual opinions? First, after the drastic weakening of the coercive apparatus during the Khrushchev period; after the reintroduction of the right to quit one's job at will; and without sufficient incentives, Soviet workers are the least intimidated persons in Soviet society. The famous motto of Soviet workers — "They can send us no further than our machines" — characterizes the situation succinctly. Second, after being associated for more than ten years with the same geological directorate, one of the authors had several close friends and good acquaintances among the workers

of each party observed. These friends and acquaintances
were used in a dual role: they served as a link between in-
vestigators and the rest of the workers; and as a group of per-
sons whose frankness was to a significant extent guaranteed,
they provided a kind of control group. Moreover, the relation-
ships between interviewers and respondents were extensive
and not merely formal or official. The authors participated in
the everyday life of the group for several months. There was
not a single case in which opinions expressed in respondents'
homes contradicted those obtained during the interview at the
workplace. On numerous occasions workers told us about lis-
tening to Western radio and constructing antijamming devices.
This served as additional evidence that we enjoyed their con-
fidence. Third, respondents did not consider that they were
being interviewed or observed or that any conversation out of
the ordinary was occurring. This raised certain ethical prob-
lems for the authors, but for obvious reasons it was a conditio
sine qua non in a study of this sort. Finally, our role was un-
usual, in some respects, for sociologists. Due to our associa-
tion with the production norms department, we were welcomed
and trusted with an openness that would not normally be shown
to a social scientist.[22] It was mainly this atmosphere of mu-
tual assistance and cooperation that allowed us to discuss freely
the most sensitive political questions and to obtain reliable in-
formation on workers' political attitudes.

Limitations of Our Sample

We had absolutely no choice in the construction of our sample,
the major limitations of which are as follows:
 1) Our sample did not reflect the multiethnic character of
Soviet society. The harsh climate of the Far Northern and
Northern regions is not attractive to people from southern
parts of the Soviet Union, while the Central region provides
no special incentives for migration. Some of the respondents,
about 14 percent, were, according to their internal passports,[23]

of non-Russian origin (mainly Ukrainians). But all non-Russians in our sample were completely Russified, and we knew of no one who used a non-Russian language or read non-Russian literature. So our findings reflect only the attitudes of workers of Russian nationality.

2) We did not succeed in interviewing female workers. In the units under observation there were 41 female workers, all employed as junior operators. Typically they were the wives of masters or senior operators and, in the absence of other jobs, worked with their husbands on drilling machines. Among Soviet workers, especially those of the first generation, political interests are traditionally considered a male prerogative. Women are fully responsible for household chores and children and, under the weight of the "double shift" of occupational and familial work, ordinarily have neither time for nor interest in political discussions.

3) Practically all our respondents were first-generation workers. Those young workers who were formally second-generation workers, i.e., sons of drillers, had frequently spent their childhood with relatives in the countryside. Two specific factors explain the concentration of former peasants and children of peasants in the geological industry. First, drilling work is physically hard labor usually in remote parts of the country where standards of living are exceptionally low and, therefore, completely unattractive to more urbanized ("cadre") workers. Second, the geological industry represents one of the most convenient channels of escape from collective farms because the requirements for obtaining internal passports have been deliberately softened for peasants going into that industry.

Our sample, therefore, cannot serve as a basis for characterizing opinions and attitudes of fully urbanized Soviet workers, who are concentrated mainly in large industrial cities. Nevertheless, we would argue that the political views and opinions shared by the workers interviewed were representative of a significant part of the Soviet working class. We think that our study provides information not only about workers employed in the mining and geological industries but, more

generally, about first-generation workers. The latter today represent a significant subset, if not a numerical majority, of the Soviet working class.[24]

The Problem of Nonrespondents

About 5 percent (16 out of 352) of the workers in our sample declined indirectly to discuss the invasion of Czechoslovakia, and 10 percent (35) declined directly. The latter explained their unwillingness to discuss this political question by a complete absence of interest in politics, or they did not provide any explanations. Those workers who expressed their unwillingness indirectly exemplified a development in the Russian language which, extending the concept suggested by Ferguson,[25] can be called "political diglossia." There is an "official political code" used to discuss the problems of politics and power in all spheres directly controlled by the party-state.[26] Outside these official domains a Soviet citizen normally uses a "private language" without resorting to the clichés and stereotypes of the official political code. When some of our respondents fell back on official political language, this served as an unmistakable indicator of their simulation of prescribed thinking. They defined the situation as an official one and made this clear to the interviewers. In these cases we promptly switched the topic. We checked our initial hypothesis — that the language consciousness of these workers had been blurred by the mass media to the extent that they had no other linguistic resources for the discussion of political problems — and found it to be invalid. These nonrespondents could use private language, but they were indirectly telling us that they did not wish to express their opinions.

The relatively high proportion of nonrespondents may cast doubt on our ability to achieve an atmosphere of trust and candor. Also, one might interpret the nonresponse as a sign that the nonrespondents disapproved of the official policy but feared to say so. One must take into account, however, that nonre-

sponse was closely related to the worker's age and to the type of geological party he worked in. Among workers over 40, 31.2 percent declined to discuss political topics, while among younger workers this figure came to 8.2 percent. Among workers at "closed" enterprises 22.7 percent appeared unwilling to respond, while this figure dropped to 10.0 percent among workers in open parties in the same regions. Workers at closed enterprises are subject to far more rigid control and expect more informers among their number. The overcautiousness of older workers, who grew up and whose characters were shaped during the Stalin epoch, when silence and the lack of interest, sincere or pretended, in political matters were necessary to survive, is all too understandable. We noticed that among the nonrespondents an abnormally high proportion of persons had been imprisoned at various periods during their lives.[27]

Our experience forces us to assume that nonresponse in this survey must be interpreted neither as mistrust of the interviewers nor as evidence of disagreement with the regime's policy. It indicates the colossal "inertia of fear" existing in Soviet society among the older generations and provides evidence that the closed enterprise system of control is in many respects a continuation of the system of total control from the Stalin period.

3

THE REGIME AND
THE WORKING CLASS

Why is there no workers' movement in the USSR today? Why
do Soviet workers hardly ever undertake organized actions?
Some authors find easy answers to these questions in the theory
of the terroristic totalitarian state — especially in the analyses
of Carl Friedrich, Zbigniew Brzezinski, and Hannah Arendt.[1]
According to this theory the powerful repressive apparatus of
the totalitarian state would nip any real or potential workers'
opposition in the bud.

 Today, however, reliance on the totalitarian state model
amounts to a mechanistic extension of Stalinism to Brezhnev's
regime and ignores the enormous changes that have taken place
during the last twenty-five years. In Soviet history the post-
Stalinist period has been one of "peaceful" development, unin-
terrupted by wars, purges, or revolutions either "from below"
or "from above." During these years the USSR has been trans-
formed into an advanced industrial society — even if one quite
different from the Western model. If there is still an "inertia
of fear"[2] in this society and the repressive apparatus retains
considerable power, they function in a qualitatively different
way than during the Stalinist era and cannot explain the relative

consensus emerging between the working class and the ruling apparatus.

Social Atomization

The problem must be posed differently. A direct consequence of Soviet ideological dictatorship and of the one-party system has been the atomization of society. All social activity remains the prerogative of the neo-Stalinist state. No individual or group initiative is possible without party-state mediation. For example, a group of painters attempting to organize an independent exhibition will be considered subversive not so much for the "ideologically negative" influence that art might have — rulers are usually more pragmatic than painters and do not overestimate the potential of art — but because the regime restricts the dangerous emergence of any initiative as well as any solidarity among individuals.

The absence of organized workers' action in the USSR effectively demonstrates the persistence of social atomization. What mechanism guarantees its perpetuation and what leads workers to give up organized action? These questions require a thorough analysis of Soviet working-class conditions during the post-Stalinist period.

In recent years Soviet sociology has documented the heterogeneity of the Soviet working class. Social researchers have studied the working class's internal structure in terms of recruitment, diverse employment categories in different industrial sectors, workers' stratification, as well as the character of work.[3] Empirical data clearly demonstrate that workers' strata are differentiated in terms of interests, motivations, and behavioral patterns. Contrary to official rhetoric about growing social homogeneity and progress toward the final overcoming of all social differences, intraclass differences in the Soviet Union are becoming far more substantial that interclass ones.[4]

Thus the Soviet working class can be divided into two main

groups: the first includes relatively unskilled workers mainly engaged in manual labor (about 79 percent of all workers by the midseventies); the second is formed by highly skilled workers who do both manual and intellectual labor (the remaining 21 percent of the working class).[5] The two groups differ in many respects, including their attitudes toward the regime.

From Forced Labor to Voluntary Unemployment

In Soviet society trade unions have no real power, and with rare exceptions, strikes are unknown. Yet Soviet workers cannot be considered deprived of rights because Western criteria for trade union effectiveness are simply inapplicable to Soviet society. Thus an essential feature of the Soviet economy is the right of workers to quit their jobs at will.

The extensive development of Soviet industry, combined with low labor productivity and poor work organization, generates a chronic labor shortage. Considering that by 1970, 90 percent of the entire working-age population was already employed, by now the USSR's labor power reserves have been practically exhausted. The Soviet Union is probably the only country in the world where instead of unemployment subsidies, there is a law against "social parasitism" that makes it an offense not to work for more than three consecutive months.

Still, the right to quit one's job at will is a rather recent development. Immediately after the October Revolution, Bukharin claimed that a planned economy was making forced labor inevitable. Since free labor could not really fit into a planned, rationally organized economy, it should be replaced by a regime of obligatory labor and by state distribution of the work force.[6] But by definition, forced labor is possible only if there is a powerful repressive apparatus. The Soviet workers' right to freely choose their work was liquidated in 1940, only after the Stalinist regime had consolidated its coercive apparatus. A June 26, 1940, law froze all workers in the jobs they held at the time. "Voluntary retirement from work" was prohibited

as a criminal offense. Absenteeism from work for less than
compelling reasons was to be punished by "corrective" labor.
Tardiness of more than twenty minutes counted as a day's ab-
sence.[7] It took only a little over twenty years to devolve from
the October Revolution, which declared factories to be the prop-
erty of the workers, to Stalin's decree, which reduced workers
to property of the factories.

This system of forced labor lasted from 1940 to 1956. In the
last years of Stalin's regime, terror, as a method of govern-
ment, had already begun to threaten the social system's very
existence. Terror had also become ineffective in the economic
sphere, since it destroyed the human will to work. Therefore
Khrushchev's attempts to curb the repressive apparatus and
the political police, to rehabilitate surviving prisoners from
labor camps, and to abrogate the law prohibiting voluntary
change of one's workplace were interrelated.

A year after the law was revoked, about 50 percent of all
workers had changed jobs. The well-known phenomenon of la-
bor turnover had begun. Soviet statistics define it as the num-
ber of workers who quit their jobs voluntarily or who are dis-
missed by the administration for violations of work rules.
Since 1959 the annual rate of labor turnover has fluctuated be-
tween 19 and 22 percent. Moreover, as Murray Feshbach has
pointed out, "these rates understate the actual rate of turnover
because they exclude, by definition, certain acceptable reasons
for departure, such as being drafted into the armed forces, sep-
aration on old-age and disability pensions, and termination of
temporary work assignments. Inclusion of these causes raises
the turnover rate in industry by one-half, up to 30 percent
annually."[8]

Under these circumstances the workers' right to voluntarily
quit their jobs is a powerful means to pressure management.
As pointed out in samizdat, the characteristic feature of the
Soviet worker is his "awareness of his social role (being a
worker) and the consciousness of the difference between his
and management's interests."[9] Within the Soviet economic
system the firm director's salary and career depend on fulfill-

ing the production plan for the firm. Forced to meet the plan
under conditions of chronic labor shortage, management tries
all means to keep workers in place. As a rule, management
seeks to win respect for its regulations and maintain needed
productivity by improving the bonus system or providing better
working conditions than those in neighboring enterprises.
Hence there is a "spontaneous" increase in wages thanks to the
workers' legal right to move to factories that pay them better.

Keeping this fundamental right involves a permanent struggle.
Under Khrushchev the regime considered issuing "work pass-
ports" to limit labor's freedom of movement; but this in-
itiative was rejected. There have been similar attempts under
Brezhnev. For example, in the early 1970s the job placement
bureaus in various cities were given more control over new
employment; all workers fired for an infraction of labor dis-
cipline are required to report to a special public commission
on job placement for assignment to new jobs. Moreover, a
1974 provision stipulates that any worker who quits his job at
his own request loses his right to cultivate the garden plot
granted to him by the factory — which is important for the
family economy. Finally, immediately after the invasion of
Afghanistan, the Central Committee approved a decree con-
cerning "The Further Strengthening of Discipline at the Work-
place and the Reduction of Labor Turnover in the Country's
Economy" that limits the right of workers to leave their jobs
at will.[10] Yet Soviet leadership has avoided resorting to radi-
cal administrative measures. For instance, the attempts by
some factory administrators to evict workers who have left
their jobs voluntarily from apartments owned by the enterprises
have not been supported by the central authorities.[11] There-
fore the right to change jobs remains. Its elimination through
administrative means may result in workers' protests whose
impact would be hard to evaluate.

The Rejection of Economic Reforms

In order to understand the sources of support for, and satis-

faction with, the current regime on the part of unskilled and semiskilled workers, it is necessary to examine one of the most peculiar incidents in recent Soviet history — the 1960s economic reforms. Initially the reforms were presented to the population as a way to revolutionize the Soviet economy. After several years, however, the Soviet mass media stopped mentioning them, in spite of the fact that the leadership which initiated them remained in power. Today economists explain the failure of the 1960s economic measures in terms of their inconsistency, inefficiency, and conservatism.[12] Without denying the importance of this economic explanation, one should also pay attention to the reforms' social impact, which was immediately felt and contributed significantly to their eventual rejection.

The object of the reforms was to reduce the role of centralized planning and to strengthen the initiative of each individual enterprise by making economic efficiency (profitability) the criterion for the firm's proper functioning. Before the reforms the enterprise received a production plan, the financial means for paying workers, and a work plan establishing the exact number of workers that ought to be employed. After the reforms, while plans remained firm with respect to production volume and salary floors, enterprises could autonomously determine the number of workers and wage levels. Any money saved could be transferred, in the form of production premiums, to administrative personnel and to workers.[13]

The "reformed" enterprises all behaved the same way. They drastically reduced the number of workers (at times by as much as 50 percent), improved work organization, and stimulated the economic interest of the remaining workers enough to realize the plan while achieving a considerable increase in labor productivity and reducing production costs. But with an increase in "reformed" enterprises, the social consequences of the reforms became clear: in the first place, the reforms threatened two important social groups — the lower and middle bureaucracy and semiskilled workers — whose status, privileges, and life style were endangered. The economic reforms led to

greater emphasis falling on technicians, engineers, and specialists whose competence, together with their ability to exploit actual resources, was decisive for the successful operation of an enterprise. Control over production and distribution was beginning to change hands. The large intermediate bureaucracy (mainly local party functionaries and industrial ministry officials) that had held industry under its tutelage became useless or even harmful. In fact, it was an obstacle to enterprise development, and it began to run into growing opposition. Thus it is not surprising that the party apparatchiks and the ministry bureaucrats began to resist reforms in all possible ways, to the point of discrediting their most active supporters — some of whom were even imprisoned for "economic crimes."[14]

But far more important was the strong opposition the reforms encountered among semiskilled workers. As a result of the reforms, not only did economic stratification begin to rapidly develop within the working class, but the workers' right to quit their jobs at will was checked by incipient unemployment and the growing "reserve army" of labor. And the workers' right to change workplaces at will was their only recourse, since they lacked the right to strike or engage in collective bargaining.

Under the conditions of labor scarcity threatened by the reforms, relatively unskilled workers could maintain their long-run security, fight for individual wage increases, and achieve them.[15] The following is an account of a typical work situation in parts of the construction industry: "The amount of completed work reported is greatly in excess of what has actually been done; the cost of materials is set at a level almost two times higher than state prices; the workers receive twice as much as they should [according to established productivity norms]; and there are even 'dead souls'[16] who regularly received wages...."[17] This situation is by no means confined to the construction industry. As a leading Soviet economist has recently pointed out, "some workers profit from the manpower shortage by demanding low productivity norms, excessive wages, and unwarranted bonuses, coming late for work or not

showing up at all and infringing in various ways on work dis-
cipline."[18] The picture is far from the ideals of the Protestant
work ethic or from the technocrat's ideal of a continuous in-
crease in labor productivity. It is also far from the image of
a Soviet working class deprived of all rights.

In the present context of social atomization and work aliena-
tion, these working conditions correspond to the life ideals of
certain strata of workers, such as the less-educated and the
semiskilled. No wonder they resisted technocratic reforms by
means of slowdowns, failures to achieve stipulated production
norms, and in some cases, open refusal to work or even indus-
trial sabotage.

Consequently, on the basis of common interests the inter-
mediate bureaucracy and less-skilled workers forged an in-
formal alliance that contributed to the interruption of economic
reforms by the early 1970s. This reinforced the legitimacy
and stability of Brezhnev's regime, since the leadership had
protected not only the interests of party bureaucrats but of
many workers as well. To some workers the regime actually
emerged as a defender against the arbitrariness of local man-
agers, the danger of new technology, and the threat of a reor-
ganization of the production process, which meant unemploy-
ment and tiresome retraining. Thus today Soviet workers, es-
pecially those who live in "closed" cities (where special per-
mission to reside is required), have remained able to wrest
certain concessions from management by quitting their jobs
at will or simply by threatening to do so. It is difficult to ex-
pect workers to resort to collective initiatives when individual
action proves at least partially effective, when the repressive
apparatus remains quite powerful, and when the "intertia of
fear" is still strong.

The Great Illusion

Support for the existing order among relatively unskilled work-
ers is also tied to another factor. Social atomization inevitably

leads to private consumption becoming the major source of individual satisfaction. Therefore, expanding the production of goods and services becomes a crucial factor for the system's political stability.

Though totally excluded from any decision-making and subject to extremely harsh deprivations because of forced industrialization and terror, the Soviet citizen, beginning with Stalin, could still expect a better tomorrow. This expectation has been one of the key elements in Soviet political culture.[19] It has been strengthened by ideological inertia and by documents like the latest CPSU program, which promised the advent of full equality and economic well-being — i.e., of communism — no later than 1980. Thus Soviet citizens have greeted anything that might worsen their material conditions with profound disappointment. Any reductions in current living standards have produced immediate upsurges in solidarity and the possibility of collective action. For example, Khrushchev's 1962 decision to increase the price of foodstuffs led to workers' agitation and, later, to the Novocherkassk revolt; far more eloquent was the case of Poland, where an analogous situation led to the fall of the Gomulka and Gierek governments and continuing labor unrest.

Therefore, short of using terror, Soviet rulers can maintain stability and preserve social atomization only by guaranteeing a constant improvement, however slow, in the quality of life. At first glance this seems easy to do. Some scholars, stressing what they see as the modest and manipulated needs of the Soviet population, believe that the control of needs is the key to the regime's stability.[20] In reality, things are less simple. After the economic reforms were suspended, the rates of economic growth declined sharply. Moreover, there is a form of hidden inflation in spontaneous wage increases not accompanied by corresponding increases in available consumer goods. And the leadership has been forced to maintain stable prices for basic necessities (which have not changed in twenty years) and confront a perennial housing crisis (by keeping rents at 1928 levels) despite the massive drain on the national budget from

military expenditures and repeated agricultural failures.
Where, then, is it to find funds for development?

Alcoholism as a Means of Government

At this point an ancient expedient has come to the regime's
rescue: the state's vodka monopoly. In his time Stalin had to
present the vodka monopoly as a temporary and unavoidable
measure for "procuring the necessary means to develop indus-
try through our own efforts and thus avoid the foreign yoke." [21]
This "temporary" measure has become one of the most stable
of all Soviet institutions. Vodka is the only commodity that
can be found any day, in any quantity, and anywhere in the coun-
try; according to some data, up to 70 percent of consumer goods
transported to the far northern cities are alcoholic products;
one risks not being served at a restaurant unless he orders
vodka or cognac. Unable to produce sufficient quantities of
goods, but with wages and demand high and prices low, the re-
gime has found a way out by developing an "illusory consumer
good" — vodka. Hence alcoholism has become an indispensable
element in the Soviet way of life. Today vodka is truly the
country's "number one commodity." [22]

In 1927 the consumption of vodka and samogon — home-
brew — annually averaged six liters per capita; in 1960 in the
Moscow region alone it had reached twenty-three liters. [23] A
study in another city from the same region found that the aver-
age resident spends 105 rubles per year for state-produced
vodka (compared to just over four rubles for books), which is
equivalent to an overall per capita consumption of thirty to
thirty-six liters of hard liquor per year. These data suggest
that individual consumption of vodka has increased at least
five to six times over a span of forty years. The USSR today
has probably the highest hard-liquor consumption in the world. [24]

As a result many relatively unskilled workers do not gain
much from wage increases. They practically work for vodka,
the production of which costs the state a few cents, even though

it sells steadily at high prices. One of the less timid Soviet
publications cites among the principal causes of drunkenness
"the psychological and material leveling of work, the monotony
of daily life, and the high wages of the relatively unskilled in-
dustrial labor force."[25]

Naturally, this policy results in a vicious circle: the sale
of vodka must compensate for the lack of other necessary goods;
but the ensuing violations in work discipline, absenteeism, low
quality of production, and delinquency cause, in turn, a subse-
quent decline in productivity and a scarcity of many consumer
goods. Periodically the CPSU Central Committee approves
resolutions on the need to fight alcoholism, while the press
keeps publishing the latest data (one of the studies, for exam-
ple, shows that up to 50 percent of Moscow's salespeople are
drunk on the job)[26] and invites the public to combat alcoholism.
With some sense of irony, Komsomolskaia Pravda finds an
"extraordinary social paradox" in a situation where, on the
one hand, the state struggles against drunkenness, and on the
other, "it produces unlimited quantities of alcohol and does
everything to deliver it."[27] Attempts to reduce the conse-
quences of drunkenness are not very effective because the
fight against its causes would require major modifications in
Soviet society together with considerable democratization and
the expansion of opportunities for creative expression.

Hence alcoholism is an important prop for the status quo.
Drunkenness guarantees a certain degree of satisfaction for
part of the population (especially unskilled workers and peas-
ants) as it lowers their needs. Indeed, the majority of the pop-
ulation does not realize that alcoholism is the result of specific
state policies and that, as a rule, the individual has no alterna-
tives. At the same time, by encouraging alcoholism, the sys-
tem continues to be able to concentrate its resources on heavy
industry, armaments, and space programs. In turn, this is
crucial in neutralizing discontent among highly skilled workers.

Discontent among Skilled Workers

Soviet literature of the 1960s presented better-skilled and

better-educated workers as more satisfied with their lot, more
favored by the present Soviet regime, and therefore more in-
clined to support it than did others.[28] Summarizing the find-
ings of Soviet sociologists in the 1960s, Mervyn Matthews
comes to the conclusion that "it would probably not be unfair
to think of the top layer of the working class as a latter-day
Soviet version of Lenin's 'pro-capitalist' workers, that is,
those who benefited most from the existing order, and were
most anxious to sustain it."[29]

In the 1970s, however, Soviet sociologists began to differen-
tiate more rigorously between the character of work with cor-
responding satisfaction with work, on the one hand, and socio-
economic conditions of work determined by political power, on
the other. For example, Ovshii Shkaratan and his collaborators
have developed a "socioeconomic evaluation of the worker"
based on the combination of two indices: worker's wages and
housing conditions.[30] The socioeconomic evaluation of the
worker contributes decisively to his general level of satisfac-
tion. This explains why skilled workers have valid reasons
for being dissatisfied with their lot and with the country's eco-
nomic development. Under the existing pay system the differ-
ences between wages of unskilled and skilled workers no longer
correspond to differences in their skills. This is not so much
the result of an imperfect wage system as of the more limited
use that skilled workers make of the right to voluntarily quit
their jobs as a weapon against management. Often these work-
ers are so highly specialized that changing enterprises entails
at least a temporary drop in salary and skills. These workers'
higher cultural level and more developed needs also make them
less inclined to look for satisfaction in alcohol. Skilled work-
ers are primarily dissatisfied with their housing conditions
and with their slow upward social mobility.

For example, with regard to the housing problem, one need
not confine oneself to a visitor's tour of Moscow's new neigh-
borhoods or to official data on the millions of apartments to
be built projected by the latest five-year plan. Big numbers
should not obscure concrete facts. Compared to the 1975 offi-

Table 6 [31]

Housing Conditions of Workers and Employees in Kostroma
(in %)

Living in	Workers	Employees
One-family apartment	15.5	25.2
3- or more room, one-family house	3.1	6.2
1- to 2-room, one-family house	19.1	15.8
2- or more room apartment shared with others	10.3	18.4
1-room apartment shared with others	30.4	22.5
One bed in a workers' dormitory	17.8	0.2
One-room or bed-sitting rental	3.8	3.5

cial "rational norm" of 19 square meters of habitable area per
capita, the urban population of Chita Region was given only 6.6
square meters and of Irkutsk Region, 7.7. Data on the housing
situation in Kostroma — a typical middle-sized city near Mos-
cow — show the housing conditions of workers (see Table 6).

Thus in communal apartments up to ten or fifteen families
share the same kitchen and service areas, while the term "one-
room house" is a euphemism for a hut. Moreover, as a well-
known Soviet sociologist observes, "much urban construction
lacks sewers and water, gas, central heating, etc." [32]

Conquering outer space cannot compensate for the workers'
dissatisfaction over sharing apartments with strangers and lack
of bathroom facilities, running water, gas, or heating in often
harsh climates. Several studies show that skilled workers do
not enjoy better living conditions. On the contrary, the spread-
ing practice of assigning apartments to workers adept at heavy
and menial labor without regard to waiting lists ultimately
worsens the status of skilled workers, who feel underpaid and
inadequately rewarded for their special efforts and qualifications.

Closed Enterprises and Skilled Workers'
Social Mobility

In approaching the social mobility problem, we should distin-

guish between a "structural" and an "exchange" type of mobil-
ity.[33] The former occurs when the number of administrative
and prestige positions in society increases, thus causing an in-
flux of "new" elements that belong to hitherto excluded social
strata; the latter occurs when the number of positions stays the
same but the social origin of persons occupying them changes.
Decreasing structural mobility results from the end of Soviet
industry's extensive development period, which derives in turn
from the exhaustion of Soviet labor reserves.[34] As for exchange
mobility, in the last fifteen to twenty years there has been an
intense process of consolidation in the Soviet class structure.
Extensive research shows that class membership has become
increasingly hereditary, and that specialist groups and the party
bureaucracy tend to reproduce themselves.[35] The situation is
especially pronounced in many Soviet republics where the cadres
of the national intelligentsia have perpetuated themselves
through self-recruitment and "only to a very insignificant ex-
tent are drawn from the working class."[36]

Today two basic mechanisms for upward mobility in the USSR
are higher education and territorial mobility. Many skilled
workers already reside in the larger cities. The territorial
mobility mechanism, therefore, cannot be widely used by them.
The use of the higher education system is also becoming in-
creasingly difficult for workers. Admission to universities
through competitive examinations offers substantial advantages
for applicants coming from families of specialists and the party
bureaucracy. In Soviet society, writes Fridrikh Filippov, "the
systems of vocational, specialized secondary, and high educa-
tion are nothing but 'extensions' of the existing social structure.
Each educational track is 'tied' to a corresponding class, so-
cial group, or social stratum."[37]

Suspending the reform drive in the late 1960s was also a hard
blow to skilled workers who, together with the specialists, had
a large stake in both continued technological progress and eco-
nomic liberalization. In effect, higher-echelon workers obtained
salary increases, foresaw the possibility for rapid improve-
ment in their living conditions, and were not really concerned

with unemployment. Continued stability in Soviet society will depend on whether the leadership can attract the support of this important social group and/or neutralize its discontent.

The role of the workers' stratum employed in the more advanced sectors of industry has been analyzed by Serge Mallet and other scholars, who showed how the massive concentration of skilled workers in the most advanced branches of industry and their organization strengthen their striving for self-management, for workers' control over production, employment, and organization of the work process, thereby determining the success of the entire workers' movement.[38] Under present conditions the ability of the Soviet working class to oppose atomization also depends primarily on the skilled workers, especially those employed in advanced industrial sectors equipped with modern technology and advanced methods of organizing the work process.

Consequently the regime has been elaborating atomization tactics that undoubtedly represent the latest step in the struggle of bureaucracy against the workers' movement. As shown in the previous chapter, the regime has been using closed enterprises as a new channel for upward social mobility and as an important means of neutralizing skilled workers' dissatisfaction. The closed enterprises are primarily connected with military industry and are bound by state rules of secrecy. Yet the concept of a state secret has undergone considerable dilution and today is applied not only to the armaments and space industries but also to industries that simply use more modern plants and advanced technology.[39] The distinction between open and closed (i.e., special status) enterprises or industrial sectors in the Soviet Union has evolved into a fundamental cleavage corresponding roughly to a subdivision between advanced industrial and traditional sectors.

The policy of dividing Soviet industry into open and closed parts has the following consequences. An artificial barrier is erected between the advanced and the traditional industrial sectors, with the consequent negative impact on the entire country's technological development. Progress in mechaniza-

tion and automation is much slower in traditional open enter-
prises that continue to employ a larger number of unskilled
manual workers. Characteristically, the amount of manual
labor required by Soviet industry increased in the decade from
1965 to 1975 by 3.5 percent.[40] Moreover, the policy of closed
enterprises entails the proliferation of statuses and an effective
subdivision of the working class into more and less privileged
categories. By joining privileged enterprises, skilled workers
enjoy a certain margin of social mobility while falling at the
same time under the elaborate control of the security apparatus.
These workers cannot contribute to any kind of concerted action
and are practically excluded as potential members of an orga-
nized workers' movement.

Incidentally, the Leninist concept of a "labor aristocracy"
does not seem applicable to workers in these special-status
enterprises. Lenin was referring to a category of workers who
received part of the surplus value created by the labor of less
fortunate comrades. Today workers in closed sectors are paid
more or less for what they actually contribute and cannot be
said to exploit the work of others. However, for the privilege
of being paid more equitably, these workers voluntarily re-
nounce collective action and consent to social atomization. The
mass media contribute to making such behavior "voluntary" by
presenting the USSR as a besieged country, while speculating
on the Chinese danger and touting defense work as the highest
of honors for Soviet citizens.

Finally, a dangerous consequence of this policy of industrial
compartmentalization is the reinforcement of chauvinistic ten-
dencies in Soviet society and the increasing importance of its
military-industrial complex. This development is also another
major factor in the previously discussed gradual rebirth of the
Stalin cult.

Squad Labor

The problem of highly qualified workers cannot be solved simply

by developing military industry because today all sectors
of the economy need this type of labor power. Hence the re-
gime insists on finding new forms of work organization that
will permit both management and less skilled workers to con-
trol more skilled ones. For instance, much current propaganda
advocates the use of the so-called "squad method with preestab-
lished objectives." Its principle is to unite workers of diverse
qualifications into a single squad (brigada) whose earnings do
not depend on individual performance but on the entire squad's
attaining its goal. The system is often aimed at controlling
skilled workers while allowing the administration to strengthen
its hold over the entire work force. Characteristically, the
term "Stakhanovite" has practically been forgotten, and yes-
terday's "Stakhanovites" may be called today "individualists."
In describing the new squads, the press uses the Leninist ex-
pression "work discipline among comrades" which should regu-
late the squad's operation and not permit individuals to distin-
guish themselves from others. The recent resolution of the
Central Committee "On Improvement in the Planning and Eco-
nomic Mechanism" calls for abandoning "growth for growth's
sake" as an approach and puts great stress on squad labor,
which "must become the dominant form of work organization
and stimulation during the Eleventh Five-Year Plan."[41]

There is no doubt, however, that closed enterprises and squad
labor policies can only temporarily alleviate but not solve the
problem of skilled workers' dissatisfaction. The problem of
young workers is likely to become increasingly thorny in the
near future. The working class's educational level is rapidly
growing. In 1959 workers with general or specialized second-
ary education made up only 8.4 percent of the work force. In
1970 this percentage went up to 19.9.[42] Now their number is
up to 30-35 percent of the working class.[43] The educational
level of young workers is especially impressive if compared
with that of older ones. A 1978 Taganrog study provides a pic-
ture of the relation between workers' age and education (see
Table 7).

Some Soviet scholars and industrial managers have proposed

Table 7[44]

Education Level of Taganrog Workers by Age
(%)

Educational level (years of formal schooling)	Age of respondents				
	24 and younger	25-29	30-39	40-49	50+
Less than 4	—	—	—	7	16
4-6	—	—	2	20	19
7-9	24	30	38	39	45
10 (secondary general)	50	47	38	22	10
10+ (specialized secondary, incomplete higher, higher)	26	23	22	12	10
Total	100	100	100	100	100

slowing down the spread of schooling and introducing a dual-track system of secondary education that would channel the majority of students onto the "vocational" path.[45] This proposal was rejected not so much because it would reinforce existing class inequalities in schooling, but rather because it would make them obvious. In the eighties the workers' ranks will be reinforced mainly by the young with general or specialized secondary education. As Fridrikh Filippov notes, given the level of young workers' education, "their dissatisfaction with available work is inevitable."[46]

Within the existing economic organization, the task of replacing manual with mechanized labor encounters many built-in obstacles. Rigid central planning deprives local administration of initiative and favors routine management instead of innovations and new technology. In addition, managers' remuneration depends directly on the number of workers rather than on their efficiency. Correspondingly, manual workers make up over 35 percent of the total labor force. Despite the tightening labor market and the government's emphasis on mechanization, the amount of unskilled manual labor may even increase in many sectors of the Soviet economy.[47] As a result there is a growing tension between occupational requirements and young

workers' aspirations for skilled and rewarding jobs.[48]

Skilled workers employed in the open sectors of industry also resent the decline in social mobility. Pravda itself quotes some young skilled workers as claiming that: "The more we think about the future, the more acutely we feel that we have reached the ceiling and there are no prospects for further growth."[49] During the past several years some publications have appeared in the Soviet press calling for the promotion of young and politically reliable workers into leading positions.[50] Some suggest a reduction in the importance of degrees for assuming directive functions; others propose favoring workers who take university entrance exams. An almost forgotten term, vydvizhenchestvo (i.e., extraordinary promotion of workers to managerial jobs), has reappeared. But these are appeals made only on paper. In view of the serious overproduction of specialists with university degrees and the unprecedented stability and continuity of cadres in positions of power,[51] any concrete step toward the implementation of such proposals meets with extreme opposition both from specialists and from the party bureaucracy. In the blunt words of a Soviet journalist, "the times of extraordinary promotions are over; there are too many engineers now."[52]

All these bureaucratic methods for achieving consent and neutralizing dissatisfaction among skilled workers have met with only partial success. The structural situation of skilled workers in the Soviet economy does not allow many of them to accept the present leadership's policy of maintaining the status quo. As the idea of the construction of communism loses its validity and persuasiveness as the unifying social myth, skilled workers — together with many technical specialists and some sectors of the humanistic intelligentsia — today constitute the biggest force favoring internal reforms and economic liberalization.

Prospects and Possibilities

Several conclusions can be drawn from the previous discussion.

a) The absence of a developed workers' movement in the Soviet Union today cannot be explained primarily in terms of massive terror. By the beginning of the 1930s Soviet workers had lost the class consciousness and solidarity they had achieved in the prerevolutionary period. "The nucleus of industrial workers surviving from the period before the revolution had been decimated and dispersed in the civil war, and never fully reconstituted.... Everywhere peasants and members of peasants' families formed an important element in the unskilled labor force in mines and factories and in the building industry."[53] During the Stalinist period terror greatly atomized Soviet society, and its colossal inertia is still felt today in all spheres of Soviet life. Soviet workers, especially unskilled and semiskilled ones, who lost the habit of political struggle or never cultivated it in the first place, today resign themselves voluntarily to atomization, which allows them to improve their living conditions through individual action.

b) Soviet rulers skillfully exploit and sometimes purposefully provoke internal divisions and contradictory interests so as to reduce the potential of skilled workers to organize and lead concerted action. The special-status enterprise system, also definable as a system of "morbid repression," now produces a variety of statuses and serves as a safety valve draining workers' social energies.

c) The majority of the Soviet working class supports the present regime, which during the 1970s was able to guarantee job security and to ensure a slow but steady rise in living standards. Particularly by rejecting the economic reforms of the 1960s and by avoiding massive layoffs and unemployment, the leadership has defended the workers' basic socioeconomic rights to full employment and voluntary mobility. If this process were to continue, however slowly, it would remain a crucial factor in preserving the regime's legitimacy.

d) The growth of private consumption has also helped in maintaining internal stability. It has, however, been stifled by traditional priorities for heavy industry and the growing military sector, by the fall in productivity due to the lack of incen-

tives, by violations in work discipline, and by labor turnovers.

What, then, are the prospects for a workers' movement in Soviet society? In the coming years the present equilibrium between workers' discontent and support may be seriously disrupted. By the 1980s the annual increase in the working population will decline further due to falling birthrates. Therefore Soviet economists predict a serious shortage of labor.[54] Relying on these facts, the CIA has predicted a plunge in Soviet production in the 1980s.[55] This prognosis, however, takes into account neither real growth in the Soviet economy nor working-class experiences during the past decade. In all probability the 1960s type of economic reform will be resumed, since by the mid-1980s it will have become absolutely necessary. Actually, the Brezhnev government has just taken the first steps in this direction. For example, a 1979 decree allowing many pensioners to continue working while keeping their pensions was meant to offset the decline in the labor force. The 1979 planning decree looked like a continuation of the 1965 economic reforms: it was very self-contradictory and inconsistent, a fact that can be explained by the present leadership's inability to develop meaningful reforms. Nonetheless, it indicates the direction in which a new political leadership might go.

The return of reforms will alter the social composition of the regime's support. Unlike in the 1960s and 1970s, during the 1980s the interests and needs of skilled workers will in all probability be heeded.[56] At the same time, dissatisfaction among lower-echelon workers will be tempered by continuing full employment. Hence the working class is likely to improve its position within the next decade. It remains to be seen, however, whether a better position will be "granted from above" by the ruling party apparatus, thereby reserving the option of taking it back at the first opportunity, or whether a more radical social turn results in decentralization and democratization. In other words, will the present social atomization continue? A realistic evaluation of today's Soviet economic and political situation can only lead to an affirmative answer.

It must be kept in mind, however, that one of the principal

effects of economic and political developments since the 1960s has been the emergence of certain prototypical forms of a civil society: a political opposition, weak but nevertheless real; the expanding sphere of a "second economy" independent of the state; market activity, etc. Toward the end of the 1970s, even before the Polish events and the formation of Solidarity, some Soviet workers sought to organize an independent trade union.[57] This attempt was immediately suppressed. After the Polish success in resurrecting civil society and separating it from the omnipotent state,[58] this initiative by Soviet workers no longer looks hopeless. Should the Polish workers' movement succeed in reforming and democratizing Polish society, the prospects for some analogous developments in the USSR will greatly improve.

4

SOCIOECONOMIC INEQUALITY AND CHANGES IN SOVIET IDEOLOGY

Today, surveying the history of Soviet society, one can, with
the benefit of historical hindsight, single out two phases of de-
velopment which might be called revolutionary and stationary.
When discussing the revolutionary phase in the history of a so-
ciety, it is useful to distinguish between the concepts of politi-
cal and social revolution. Political revolution can be defined,
following Alexis de Tocqueville, as an act of destruction directed
against the whole ruling class. By the time of Lenin's death,
the political revolution in Russia was completed. The social
revolution in the Soviet Union, however, lasted approximately
until the end of the 1950s. Social revolution can be defined as
a societal process in which a group of people with a strong
ideological commitment comes to political power, deliberately
mobilizes the population, and in a historically delimited period
of time radically restructures a society. As Theda Skocpol
points out, "what is unique to social revolution is that basic
changes in social structure and the political structure occur
together in mutually reinforcing fashion."[1] The social revolu-
tion in the Soviet Union was managed by the Stalinist regime —
a regime using systematic terror for the mobilization of all

societal resources to achieve industrialization and property
transfer by force. Under Brezhnev's leadership Soviet society
has reached a new level of developmental maturity that I call
a stationary phase, in which Soviet society faces new ideological
problems that differ significantly from those of the past.

The original Marxist aim — the elimination of inequality, the
eradication of all causes of man's alienation, the creation of
classless society — has not been achieved. On the contrary,
in the USSR there has emerged an entrenched system of eco-
nomic and social inequality. Recently, however, some Western
scholars have, after thorough calculation and manipulation of
certain Soviet official statistics, come to the opposite conclu-
sion. Thus Peter Wiles, in his Distribution of Income: East
and West, writes: "I doubt if any other country can show a more
rapid and sweeping progress towards equality."2 In the same
vein Jerry Hough criticizes the two very realistic books on So-
viet society written by Hedrick Smith and Robert Kaiser3 be-
cause "they have totally missed the real news of the last decade
in this realm: a continuation of the sharp reduction that began
after Stalin's death in the degree of inequality of incomes in the
Soviet Union."4 Assertions about "rapid and sweeping progress
towards equality" demand qualification. We should not accept
every official statement uncritically and without taking into ac-
count its hidden dimensions, nor should we also ignore certain
well-documented facts of everyday life in the Soviet Union. For
example, the decline in money-usage inequality that took place
in the USSR after Stalin's death and through the late 1960s needs
to be interpreted with care. Data on monetary inequality in
Soviet-type societies are deceptive, given the range of nonmone-
tary benefits, and are thus not a fully reliable indicator of the
degree of overall inequality.

A number of publications have recently appeared, however,
in which problems of inequality in the USSR are treated with a
greater profundity and, if one considers Soviet publications,
with a much greater candor than before.5 Nevertheless, cer-
tain theoretically important aspects of inequality in Soviet so-
ciety need further clarification. The most urgent problems

seem to be: the bases of inequality characteristic of Soviet society; hereditary and ascriptive traits of inequality in Soviet society closely connected with its class structure; and the question of whether the dominant tendency is to increase or decrease the inequality that exists in the USSR today. These problems can be solved only through the collective efforts of students of Soviet society. Here I wish to spell out some principal considerations concerning social and economic inequality in "actually existing socialism."[6]

Bases of Inequality

As Wlodzimierz Brus pointed out, "the traditionally accepted relationship between economy and policy as 'base' on the one hand and 'superstructure' on the other and hence as, 'in the last resort,' the determining factor and the determined factor, needs, with respect to socialism, fundamental modification."[7] The starting point for discussion of inequality in Soviet society must be its mono-organizational character[8] and the abolition of private property in the means of production; both conditions determine the specific character of inequality in the USSR.

In a seminal article Zygmunt Bauman rejects the widespread view that "there must be a single and all-pervasive standard of differentiation which underlies social inequality in socialist society."[9] He emphasizes instead that the social inequality of socialist society derives from two main sources. First, there is inequality generated by the actual power structure, which in turn "stems from the party, as the main repository of control, and permeates the whole of society by virtue of the fact that in socialist society the traditional distinctions between economic, political, social and cultural actions are blurred to an extent unthinkable in late capitalist society."[10] Second, there is inequality generated by the market relations that exist side by side with the administrative allocation of resources and rewards. A Soviet citizen in his everyday life relies more and more on money and market to satisfy his needs and to

choose between different commodities.

Bauman's position needs further elaboration. But his main idea of two power structures based respectively on political control over resources and rewards and on market relations can be applied fruitfully to the analysis of Soviet society. The degree of interdependence and relative autonomy of these structures, as well as the acuteness of conflict between them, changes in time and needs to be studied concretely for each particular period of Soviet history. From that point of view the degree of inequality of incomes can be realistically assessed only if one takes into account the differences between legal and semilegal/illegal incomes.[11] The use of these categories complicates the investigation but is a methodological imperative for studying income distribution in "closed" industrial societies where, as Gregory Grossman accurately observed, there exist a "two-tiered structure of prices and incomes" and "widespread black markets for goods and labor."[12]

Studying the inequality of legal incomes, an investigator faces the problem of significant wage differentials in the absence of a system of progressive income taxation, while the actual structure of income differences stems from decisions by the political-administrative elite. As Roy Medvedev testifies, the ratio between the highest and the lowest rates of pay may be 1 : 20 or even 1 : 30; but "if one takes into consideration the many services available to nomenklatura officials at public expense (food coupons, medical treatment, holidays, personal transport, dachas, etc.), the total value translated into monetary terms would make the ratio 1 : 50 or sometimes even 1 : 100."[13] In my experience I encountered a wage differential of 1 : 8 among drilling workers in the geological industry. Much of the difference is due to the arbitrary raising of certain enterprises to the rank of "strategically important" ones. These decisions create special groups of highly controlled and privileged workers within the working class.

In examining the wage differentials, the complex interplay of political power and market relations must be taken into account. For example, on the one hand, an unintended consequence

of the system of "closed" cities, which will be discussed be-
low, is that in them manual workers in certain occupations
have acquired significant bargaining power. As a result, their
earnings may be considerably higher than those of highly
skilled workers or even specialists. On the other hand,
the political decision to prohibit private medical practice
placed Soviet doctors in the lowest income bracket among
professionals.

The emergence of a restricted system of distribution of goods
and services is also responsible for a significant part of the
inequality of rewards. The introduction in the USSR of four
types of currency in addition to the ruble,14 with a correspond-
ingly differentiated network of special stores for a restricted
clientele, furnishes additional evidence of the role of the ad-
ministrative elite in the allocation of rewards in Soviet society.

Murray Yanowitch, Mervyn Matthews, and Alastair McAuley15
have examined in detail the scope of inequality that appears to
be related primarily to the political structure of society. These
scholars have, however, used different methods of gathering
data. Yanowitch and McAuley based their analyses on a thor-
ough investigation of the Soviet literature, while Matthews, in
the absence of sufficient published material, based his work to
a considerable extent on the testimonies of recent émigrés.
Correspondingly, the books supplement each other, giving us
a realistic picture of legal income differences in the USSR
today.

There also exists a growing body of data on economic inequal-
ity generated primarily by market relations in the Soviet Union.16
Illegal incomes stem from the "second economy" operating in
the country as well as from the corruption of officials and wide-
spread small-scale pilfering of state property. Certain occu-
pational groups and territorial communities in the USSR today
can be identified as the primary beneficiaries of this "second
economy." The problem clearly needs in-depth investigation.
The necessary data can also be obtained through a content-
analysis of those Soviet legal publications concerned with so-
called "economic crimes."

The Political-Administrative Ascription
to Social Class

An analysis of the relationship between inequality of rewards
and inequality of access to privileged positions is of primary
importance in understanding Soviet class structure. Such an
analysis should be based on a thorough examination of the in-
stitutional mechanisms through which regulation of access to
inequally rewarded positions is implemented, such as the
internal passport system. It is of primary importance in
this investigation because it is a major "class-forming"
factor.

The passport system in the USSR is now celebrating its fifti-
eth anniversary. What implications for class formation and in-
equality stem from its operation? This question has rarely
been asked. Here I shall limit myself to several obvious ex-
amples of how the passport system gives an ascribed character
to some of the most odious and most desired social statuses
in Soviet society.[17]

As is well known, each citizen of the Soviet Union, the collec-
tive farmers being the only exception, is required to obtain an
internal passport at age sixteen. The document entitles the
citizen to reside permanently in an urban area. Each passport-
bearer has to be registered in the militia at his permanent
place of residence (so-called propiska). Registration, in
turn, gives him the right to permanent employment in the
urban area.

This system, therefore, divides the Soviet population into two
categories: passport-bearers and collective farmers. The
latter are deprived of the rights to geographical mobility and
free choice of labor (the repeated violation of the "passport
regime" is punished by imprisonment). Collective farmers as
a social group combine both the characteristics of a class and
an estate, using "estate" in Max Weber's sense. In principle,
a person born in the countryside has to stay there for life and
continue to work on the collective farm.[18] Here we see how the
simple mechanism worked which forced peasants to work on

collective farms during the Stalin period, when they often were
not paid at all, and which still forces them to work there today
when, according to Brezhnev, the prices on some agricultural
products, fixed by the state, are so low that they fail to cover
farm expenses.[19]

In 1981 the exchange of old passports for new ones was com-
pleted. But the assertion that Soviet peasants "were granted
an unconditional right to a passport in late 1974"[20] is the result
of a misinterpretation. In reality the 1974 Statute on the Pass-
port System points out that "citizens residing in rural localities
to whom passports have previously not been issued, shall be is-
sued passports when they depart for other places for a long
term."[21] The issuance of passports to the Soviet peasantry is
thus acknowledged only as a theoretical possibility. Local of-
ficials continue to control totally the issuing of passports to
peasants, whose rights to leave the collective farm, to move
freely through the country, and to freely choose their work are
still denied.[22]

Soviet statistics divide the agricultural population into two
large groups: collective farmers (kolkhozniks) and agricultural
workers, the former representing 13 percent, the latter approx-
imately 7 percent of the total labor force.[23] In practice two
neighbors can live in the same village and be doing the same
agricultural work, but one may be classified as a "collective
farmer" while the other may be classified as a "worker." This
is not an idiosyncrasy of Soviet statistics; on the contrary, it
shows very precisely that these persons, by virtue of different
political-administrative ascriptions, belong to distinct classes
of Soviet society. In contrast to the collective farmers, the ag-
ricultural worker, as a worker, has a passport and can leave
his job at will and migrate to urban areas. Soviet statistical
data show that the direct average wages of the agricultural
worker (without taking into account other material and psycho-
logical benefits) are 35-40 percent higher than those of the col-
lective farmer. This figure allows us to make the first step
in measuring "income" based on passport possession or ex-
ploitation based on passport deprivation.

The existing system of internal passports is responsible for still another social division within the Soviet population: between people with the right to reside in the so-called "closed" cities and those who do not have this privilege.[24] Under the system of closed cities, special permission is required to settle in any of the major urban centers of the Soviet Union. Normally such permission is acquired by right of birth and passed down to offspring, but it may also be granted by the authorities. Passport-bearers without such permission have to live in small cities and towns where serious shortages of food and difficulties in obtaining employment have persisted for a long time.

One should understand the hierarchical structure of the passport system. An inhabitant of a closed city can easily move to an open city or to the countryside; an inhabitant of an open town can move to another open town or village, but for him to move permanently to a closed city is very difficult; and collective farmers, as we have already seen, have no passports and must overcome special barriers to leave the rural area. Soviet industry, for historical reasons and because of the underdevelopment of transportation systems, is mainly concentrated in the larger cities. This fact entails a significant difference in the situation between the groups of highly skilled and semiskilled workers. First, the majority of highly skilled workers is concentrated in closed cities, while in smaller cities and towns unskilled or semiskilled workers make up a higher proportion of all workers. Second, as I have mentioned, in the small cities and towns serious employment difficulties have been evident for a long time. The passport system, therefore, limits the basic right of a Soviet worker — the right to quit his job at will, which compensates to a significant extent for the absence of the right to strike and protest collectively.

The political and economic consequences of the operation of the passport system for the working class must not be overlooked. For example, an unintended outcome of the system of closed cities is that in them groups of manual workers in certain occupations have acquired significant bargaining power. As a result, their earnings may be considerably higher than

those of highly skilled workers or even specialists. On the other hand, workers in the same category who reside in smaller cities are much more docile because they cannot effectively use their right to leave a job at will to exert pressure on the administration. The Soviet passport system divides the working class through the imposition of rigid boundaries between its various groups. More importantly, the most advanced and organized segment of Soviet workers, concentrated in the closed cities, can satisfy their economic demands by strictly individual actions. The passport system also permits the preservation of cultural backwardness and a low level of organization among semiskilled workers in open towns, preventing them from migrating to large industrial cities where they could raise their skills, cultural level, and standard of living in general.

In the stationary phase of Soviet society, the status structure has rigidified, and the process of status inheritance is clearly evident in all spheres. That the class of specialists (intelligentsia) attempts to perpetuate itself is a well-known truism from the middle 1960s, and one can find even in the Soviet press the observation that "for the most part, the stratum of the intelligentsia reproduces itself."[25] In recent years such statements have become even more frequent because "the principal context of most serious Soviet discussions of social inequality has been the problem of access to higher education."[26] Many Soviet sociologists believe that the only possibility for social mobility of peasants' and workers' children lies in expanding the number of specialist positions. Then, even if all children from specialist families were to inherit the class status of their parents, there would still be enough specialist positions for young people from other classes.[27]

Today only one out of every five or six high school graduates gains admission to higher education. Under these conditions the system of selection based on competitive entrance examinations has become an instrument for the transmission of specialist positions from one generation of specialists to the next. What accounts for the spectacular success in competitive examinations of graduates from specialist families if one is not

inclined to believe that the class of specialists is intellectually superior? It must be emphasized that under the influence of the dominant ideology of the "leading role of the working class," some inconsistent attempts at preferential treatment of graduates from working-class families were made from time to time. What, then, is the actual mechanism of reproduction of unequal access to higher education?

Soviet authors single out several social determinants of differential access to universities. First, higher incomes allow specialists to support their children during university attendance.[28] The better housing conditions of specialists provide a superior physical environment for learning, while the extra free time of the adult members of a specialist family permits them to spend more time with their children and offer them greater assistance with schoolwork.[29] Second, parental plans and expectations concerning their children's future strongly affect their children's orientation toward higher education.[30] Third, the significant difference in school quality between rural and urban areas and between urban neighborhoods, especially taking into account the emergence of specialized schools for "gifted" children, is another determinant of inequality in university access.[31] Finally, specialists are better able to pay for tutors to prepare their children for examinations.[32]

All of these reasons are plausible, undoubtedly partially correct, and probably most are familiar to the reader. But, as is often the case, there is a hidden dimension in the data published in the Soviet Union. Unfortunately, Soviet sociologists, constrained by censorship, cannot even touch on the more profound reason for the intergenerational perpetuation of specialist status. Here again our attention should be directed to the operation of the passport system.

In contrast to other classes, the majority of specialists have the right to reside in closed cities where, coincidentally, all major universities are also located. Thus the specialists are geographically, professionally, and structurally connected with the system of higher education. This factor underlies, and to a significant extent determines, the operation of such related

factors as access to better schooling and housing and especially to personal ties and contacts with relevant networks. Marc Granovetter has convincingly shown the crucial role of informal interaction networks for getting jobs at professional and managerial levels.[33] What Granovetter wrote about Western industrial society applies with equal force to Soviet society, where the situation is probably aggravated by the absence of some basic human rights and the influence of many noneconomic factors.

The interaction between class stratification and geographical stratification seems to be of primary importance for understanding the internal development of Soviet society.[34] In it we can observe the purest example of a rigid territorial stratification constructed by political power and used as a means of organizing and maintaining inequality. Territorial stratification deeply affects the everyday life and class consciousness of all classes of Soviet society, especially its working class. It, or more precisely the internal passport system that includes among its main functions the organization of territorial stratification, plays an important role in maintaining the stability of the Soviet regime as a whole. How it does so is discussed at some length in Chapter 6, "Closed Cities and the Organized Consensus."

Inequality in the Brezhnev Period: Growth or Decline?

We have a great deal of information about social and economic inequality in Soviet and East European societies. The important question, however, concerns the trend of this inequality: is it increasing or decreasing?

Socioeconomic inequality, to be sure, was not unknown in the Stalinist period. In fact, huge wage differentials emerged precisely during the intensive industrialization of the 1930s. The policy of the first postrevolutionary years, when no party member was permitted to earn more than a skilled worker, was

abolished. Stalin defined egalitarianism as a "peasant attitude" having nothing in common with Marxism, declaring along with his aides that Bolshevik policy demanded a "resolute struggle against egalitarians as accomplices of the class enemy, as elements hostile to socialism." But the resultant inequality could be effectively counterbalanced in the revolutionary phase of Soviet development. First of all, the rapid cultural improvement of the population — in education, knowledge, skills, ideological commitment — could at least temporarily make up for such results of forced rapid industrialization as decreases in living standards and increases in inequality. Second, both the policy of exterminating the kulaks (well-to-do peasants) and the terror of the 1930s, directed against political, economic, and military elites, led to peculiar, one-time-only opportunities for mobility and equality. The possessions and perquisites of the kulaks and the other better-off victims of the purges — their garden plots, houses, jobs, personal belongings — were redistributed among more fortunate members of Soviet society, and the jobs of the elite became available to their subordinates. The situation changed, however, after Soviet society entered its stationary phase in the 1960s. Jonathan Kelley and Herbert Klein assert that the abolition of private property is not itself sufficient to prevent the long-term growth of inequality, since much inequality "arises from differences in education, skills, language and other forms of human capital which are almost immune to redistribution."[35] The experience of Soviet society supports their view.

What justifies the claim that the inequality entrenched in Soviet society is not only all-pervasive but has actually been growing during the Brezhnev period? Proponents of the idea of a "rapid and sweeping progress towards equality" in the USSR could easily refer to certain undeniable facts that seem to contradict this assertion. For example, average wages in Soviet industry have almost doubled compared to the Khrushchev period. The poorest strata of Soviet society are slowly improving. At the beginning of the 1970s, the concept of a "poverty line" was de facto introduced in the USSR, and

children in families with monthly income below 50 rubles per capita are now granted state assistance. The minimum wage today is 80 rubles per month. And collective farmers have at last been granted the right to old-age pensions, although their minimum rate is still below the established "poverty line."

Nevertheless, even Soviet official data indicate that "the inequality of earnings of both industrial workers and workers and employees reached a low point in 1968 (associated with the increase in the minimum wage to sixty rubles per month) and has since increased."[36] Moreover, the data on monetary earnings do not show the full scale of inequality: money, as a Soviet sociologist put it, carries "unequal weight in different hands";[37] in addition, some of the most desirable goods and services cannot be bought but are rather directly distributed by political authorities. The analysis of formal incomes, therefore, may be misleading, as may vague Soviet statistics on reductions in basic wage and salary differentials.

Moreover, the general improvement in standards of living in the USSR does not offset some social processes that generate privileges and increase de facto inequality. Several of them should be mentioned here, although the list is far from exhaustive:

1) The increase in societal affluence under which groups already privileged are able to reinforce uneven distribution of rewards and inequality of access to the most desirable positions.

2) The strengthening of the passport system. In 1981 an invigorated passport system, which serves as an elaborate mechanism for the administrative assignment of the character of labor, place of residence, and ethnic origin, and which maintains the hierarchy of locations, class, and ethnic boundaries, was fully implemented.

3) The institutionalization of the restricted system of administrative distribution of goods and services.

4) The significant expansion of the sphere of the black and "colored" markets, based to a considerable extent on a "second economy" that combats the state's monopoly.[38]

5) More favorable conditions for status and property inheri-

tance stemming from the "peaceful" development of society.
6) The rapid expansion of commercial, scientific, technical,
 and cultural contacts with the West.[39]
These processes are leading to a situation quite different
from "progress towards equality." It can reasonably be argued
that the relative size of highly privileged groups and strata has
increased significantly, while at the same time, the gap between
highly privileged and nonprivileged groups has become more
pronounced. Of course, the respective dimensions of these
two processes remain to be determined empirically. Unfortu-
nately, present conditions in the Soviet Union are not very con-
ducive to such empirical study.

Changes in Soviet Ideology

In this section I want to approach the problem of changes in
Soviet ideology to show how the "fit" between the actual political
regime and the dominant ideology is accomplished. What has
been the fate of the dominant Marxist-Leninist ideology in the
new developmental stage of Soviet society? More particularly,
how is this ideology affected by entrenched and even growing
inequality?

As Max Weber formulated it, "socialistic and communistic
standards, though by no means unambiguous in themselves, al-
ways involve elements of social justice and equality."[40] The
course of development Soviet society has taken in the Brezhnev
period seems to have separated the political regime from its
dominant ideology. Under these conditions it might be predicted
that the political regime will destroy its own ideological founda-
tions.[41] On the other hand, one could also argue that the dom-
inant Marxist ideology, with its emphasis on egalitarianism and
democratism, might put a serious obstacle in the way of stabil-
izing and legitimizing the regime. Some scholars even assert
that the Soviet ruling group is in a very precarious position and
that the Soviet Union is an inherently unstable society.[42] But
Soviet society in its present stage has preserved its flexibility

without suffering any major internal crises. Changes in the
character of Soviet Marxist ideology and its social functions,
resulting in the adjustment of the ideology to the new conditions,
are among the most important recent developments conducive
to the increase in social stability. Western students of Soviet
ideology are well aware of these changes, although explanations
given in terms of the "end of ideology"[43] or the "deradicaliza-
tion of Marxist movements"[44] seem to be one-sided and
unsatisfactory.

The Diachronic and Synchronic Approaches

Soviet ideology has an important historical dimension; there-
fore the unity of the diachronic and synchronic approaches is
an important methodological premise for the study of Soviet
Marxism. In the diachronic approach the distinction between
historical Marxism as a doctrine and Soviet Marxism in some
concrete period of its existence is analogous to the distinction
between underlying structure and overt behavior, which in post-
Saussurian linguistics is expressed in the categories "language"
and "speech." Historical Marxism is a body of knowledge or
set of ideas whose internally consistent meaning is drawn from
the writings of Marx and Engels. Or, taking Soviet Marxism
as a starting point, it can be described as a set of ideas based
on historical Marxism but developed and transformed largely
by the works of Lenin and Stalin. As Leszek Kolakowski,
among others, has pointed out: "Soviet Marxism became a con-
cept of institutional, rather than intellectual, content."[45] The
process of revision and repudiation of some of its tenets, con-
ducted from time to time by officialdom, connects Soviet Marx-
ism, defined in any given period as a more or less stable core
doctrine, to its actualization and interpretation in a given period.
That is why sociologists should be especially interested in in-
vestigating the activities of the "office" that is entitled, or
which usurped the right, to change and interpret the doctrine
during a particular period.

In the synchronic approach an ideology can be conceived as a two-tiered system. These tiers are described by various scholars in slightly different terms: as official ideology versus operating ideology,[46] or as doctrine versus action program,[47] or as fundamental principles versus operative ideology.[48] If we look at the actual versions of Marxist doctrine in various periods of Soviet history, the most striking characteristic is the limited and gradual character of the change it has undergone. It has proved to be an ideology with high levels of stability and flexibility. There are various reasons for this. One must mention, first, the exceptional explanatory strength and absorptive capacity of Marxism, and second, its role as the sole official ideology in a single-party system, where Marxism is used to legitimate the distribution of power and the performance of roles. (The danger of splits and factional feuds within a ruling party becomes much more serious after the seizure of power.) Third, Marxism, as the dominant ideology of the international communist movement, plays a unifying role that also prevents it from undergoing major rapid changes.

The major modification can be found rather at the level of the actual use of doctrine, i.e., in the sphere of "operating ideology," which, being in direct contact with a world in flux, undergoes regular changes. That is why the general principle followed in comparing the historical variants of Soviet Marxism should be an investigation of the relationship between doctrine and operating ideology in a given period. Sociological analysis of this problem demands the investigation of the structure and functions of those social organizations and institutions responsible for the production of ideology. This allows us to answer the question: what functions does an ideology perform in its relationship to society as a whole and to specific social groups in society?

Ficticization and Consolidation in Soviet Ideology

In studying Soviet ideology, we can single out two historically

different phases in its development. They correspond to the revolutionary and stationary phases of Soviet history, called by Peter Ludz the phases of revolutionary and consolidating ideology. Ludz asserts that in the first phase, the discrepancy between doctrine and operating ideology decreases, whereas it increases in the consolidating phase.49 The real relationship between doctrine and operating ideology in the stationary stage is, I think, more complicated.

Two processes that, paradoxically, contradict and at the same time supplement each other can be observed in Soviet ideology today. The first is the widening of the gap between doctrine and operating ideology, which we can call the ficticization of ideology.50

Together with the process of ficticization, another, to some extent opposite, process is going on — the consolidation of the doctrine with the operating ideology. These processes differ in their content, in the social organizations and institutions responsible for their implementation, and in the social groups which are their intended targets. They also differ dramatically in the way language is used, that is, in the choice of oral versus written language and the choice of the linguistic code by which ideological information is transmitted.

The process of ficticization: its organization and language

Ficticization of ideology is not a new process for Soviet society; it began under Stalin, who, as Sergei Utechin penetratingly observed, "resorted to a large scale application of fictions." This practice led to "the divorce between private conviction and public utterance" and was an important instrument in controlling the population's behavior.51 At that time, however, the party leadership had at its disposal more powerful means for eliminating even potential opposition. In the mid-1960s the process of ficticization came into the foreground, with the following organizations being of primary importance for guiding and carrying it out: the ideology, agitation, and

propaganda section of party committees at various levels; the counterpropaganda subsections, with their system of "closed" lectures; the network of circles for political and party enlightenment; and the permanent institutions for organizing electoral campaigns (agitkollektivy). The counterpropaganda organizations that emerged as specialized institutions in the mid-1960s are particularly significant and deserve special examination.

Since the practice of jamming Western broadcasts in Russian was suspended in the early 1960s, these broadcasts have become one of the main sources of information in the Soviet Union. This, in turn, has led to the Soviet mass media significantly changing their ways of working[52] and the appearance of sections of mass counterpropaganda. Next to the Soviet mass media and Western broadcasts, such sections have become the most influential source of information and means of indoctrination of the Soviet population. Strikingly, between 1968 and 1973, when authorities again began to jam foreign broadcasts, these organizations were not eliminated but were invigorated and institutionalized, taking on the function of fictionalizing ideology. Counterpropaganda sections still exist today, attached to party committees at various levels, which have regularly appointed personnel whose sole responsibility is lecturing to different social groups, especially workers. A special ritual of so-called "closed" lectures has been worked out, including checking documents at the entrance, granting permission to put anonymous questions in written form, and other measures that stress the significance of the information given and the degree of trust invested in those present.

The most notable difference between the closed lectures and other official arrangements is that in these lectures, the use of "private" language is permitted and encouraged. The horizontal differentiation of Russian language into public and private spheres is one of the most peculiar consequences of the ideological dictatorship and absolute centralized control by the party apparatus over all means of mass communication. As Claus Mueller has formulated it, "public language is an expression of official symbols and predefinitions, private language

is the expression of individualized needs and privatized mean-
ings."[53] The effect of dropping the political jargon of interna-
tional Stalinism in closed lectures is comparable, in the view
of some Soviet sociologists, to the shift from Latin to local
languages in church services.

In a recent resolution of the Central Committee, "On the
State of Lecture Propaganda and Measures for Its Improve-
ment,"[54] one finds the following statement: "Lecture propa-
ganda must be vivid in form, uncompromising and militant in
the struggle against bourgeois, Maoist, and revisionist ideology.
It must give exhaustive answers to important and pressing is-
sues. It must serve as an effective means for the formation
and investigation of public opinion." One who deciphers these
clichés and ossified stereotypes of official language will see
here clearly the nature of the activities of the counterpropa-
ganda sections. The emphasis on the allegedly precarious po-
sition of the USSR between American military power and the
Chinese threat allows the regime to explain in popular form
the spectacular growth of military and space programs.

Within this theoretical framework, entrenched inequality may
be "frankly" discussed and even made acceptable. In the open
press a Soviet author, in approaching a problem such as social
mobility, has often to manipulate statistics or indulge in dema-
gogy. "It is necessary to bear in mind that the traditionally
hereditary nature of some workers' occupations, which pass
'from father to son,' does not by virtue of the high general so-
cial status of the worker in the USSR signify either a rise or
a decline in social status. This also applies to the children of
professionals."[55] In a closed lecture Ovshii Shkaratan, the
author of these remarks and one of the most astute observers
of the Soviet social structure, would not need to be so evasive.
Lecturers in their closed seminars never shun the problem of
inequality; instead they explain and justify it by appealing to
patriotism and the need for sacrifices in the face of numerous
external and internal enemies. The perpetuation of socioeco-
nomic inequality inside the Soviet Union is rationalized as a
temporary necessity in a period when the very survival of the

Soviet state is once again at stake.

Peasants and manual workers are much more receptive to Russian (or Soviet) nationalism as the ideology of political totality than to the idea of the international brotherhood of workers, which has no comparable roots in their personal or collective experience. An increasingly important role is played by official anti-Semitism, which is historically closely connected with Russian nationalism. The work of mass counterpropaganda organizations, in tandem with some special measures against would-be emigrants, has facilitated the emergence in the conscience collective of a standard syndrome of concepts — "dissident-Jew-alien element" — and has contributed considerably to the isolation of the dissident movement from the broader population.

Through the activities of mass counterpropaganda and other institutions concerned with the ficticization of ideology, Soviet workers and peasants are given two sets of ideas: the Marxist doctrine, with its internationalist, democratic, and egalitarian tendencies; and the operating ideology, with its nationalism and antidemocratism. The Marxist doctrine, transmitted through official public language, seems to be far from the "real state of life" and to be meant "for them" — for opponents and enemies or for those who are uninitiated and unworthy of knowing the truth. The operating ideology, expounded through private language and by word of mouth, tends to describe experience correctly and predict realistically what is happening to a person.

The oral character of the ficticization of ideology deserves special mention. Recently, James Scott and Alvin Gouldner have drawn our attention to Robert Redfield's distinction between the written "great tradition" of the urban elites and the "little tradition" borne orally by folk cultures. This distinction helps to explain the problem of transformations and adaptive changes in an ideology, particularly Marxism, in the process of its mass diffusion and popularization.[56] The process by which ideology is fictionalized and that by which Soviet Marxism is transformed in order to be understood and accepted by the population may have some common features. The differ-

ences, however, are more important. Its oral character was imposed on the process of ficticization by the sheer need to preserve the unifying role of Marxism in other domains of social life. Also, the main distinction between the two processes lies in the fact that ficticization is an intended distortion of Marxism as an ideology of social change. The process is used today in the Soviet Union as an important instrument for neutralizing and blocking the potential role of Marxism as a doctrine capable of generating some type of workers' movement. Thus the class awareness of Soviet workers may be expressed through resentment against their low rate of social mobility or through their increasing sense of social injustice, but it is prevented by this process from being raised to the level of class consciousness, thereby preventing the emergence of a workers' movement. As Robert Lane has correctly noted, a total incongruence between ideology and experience "extinguishes a social movement." [57]

The process of consolidation and the "Soviet way of life"

In Soviet society today the opposite process — closing the gap between doctrine and operating ideology — is also underway. The ideological authorities try to consolidate these two aspects of Soviet Marxism in order to win over to their side the important groups of highly skilled workers, professionals, and students, i.e., those groups which because of their functions and structural location in an advanced industrial society need an intellectually coherent and rationally defensible ideology. The process of consolidation is accompanied by some major changes in the central doctrine, the most significant of which is the attempt to replace the ultimate ideological goal — the creation of a communist society — with the concept of the "Soviet way of life." The idea of communism has become generally discredited in the eyes of the population. The program of the Communist Party of the Soviet Union, adopted under Khrushchev and still in effect today, promised the advent of

communism by 1980. Khrushchev's period of "revolutionary
romanticism," with its shifts, turns, and permanent chaos,
dealt a strong blow to the idea of communism as a practical
goal.

In 1973 the party leadership launched a propaganda campaign
for the "Soviet way of life." For the last several years thou-
sands of articles and books have been published on the subject.
The Soviet way of life is a very loose conglomerate concept.
Its components, which include such notions as the leading role
of the party and of the planned economy, full employment and
the welfare state, the need to maintain ideological discipline
and the absence of individual freedoms, are freely lumped to-
gether. Socioeconomic inequality in Soviet society is readily
accepted and justified by the concept of the Soviet way of life,
which introduced a new variant of the principle of meritocracy.

The meritocratic approach to social inequality is one with
which Soviet citizens have been well familiar since the late
1920s, when Stalin started his attack against egalitarianism
(uravnilovka). There have been, however, significant differ-
ences in its use in Soviet ideology at various stages of Soviet
history. During the Stalin period economic privileges and dis-
criminations were explained as results of an individual's con-
tribution to economic and cultural growth. They were presented
as if they had nothing in common with class division and de-
pended strictly on a person's objectively calculated "merit."[58]
Soviet doctrine at that time explained these inequalities as
a strictly temporary measure aimed at the most rapid
achievement of specific production targets, and one which
would be abolished in the near future. The process of the
permanent purge, whose most spectacular victims often
belonged to the most privileged strata of the population,
supported the idea of the temporary character of privi-
leges.

Today Soviet ideology has nearly eliminated any emphasis
on the transient character of inequality. In spite of the pro-
claimed achievement of the stage of "mature socialism," there
is still a long way to go to the next stage, where inequality in

productive contribution would presumably not be accompanied
by inequality in rewards. Still more important is that the
meritocratic principle in contemporary Soviet ideology has lost
its direct connection with differences in individual merit. The
concepts of the social division of labor and the historically con-
ditioned structure of production are used to account for social
inequalities, since different occupations and statuses required
by the existing structure of production provide very unequal
opportunities for a person to develop his talents and abilities.
Yanowitch, in his discussion of Soviet attitudes toward and in-
terpretation of inequality today, has justifiably noted: "What
the 'social division of labor' approach ignores, however, is the
obvious fact that inequalities of rewards (at least of economic
rewards) are determined in the process of political decision-
making."[59]

The meritocratic principle is, therefore, used to justify both
labor ascription and the highly institutionalized system of priv-
ileges and discriminations. This line of reasoning is widely
used in publications intended for specialists. An article by the
noted Soviet sociologist Vladimir Shubkin, published in the high-
brow monthly Novy mir, where he also deals with inequality of
access to higher education, can be taken as an example. He
refers first to the difficulties in establishing the social origin
of a university applicant because of the increasing homogeneity
of Soviet society, whereas, on the other hand, the problems of
social structure are not sufficiently elaborated. Then he points
out that the main task of the system of higher education is "the
most efficient use of the country's intellectual potential" and
asserts that the competitive entrance examination is "the best
way for the education of the most worthy, prepared, and capable
people" who will contribute to society's cultural and economic
growth. A certain differentiation in the social composition of
the student body between various types of educational institu-
tions (Shubkin means simply the difference in social origin be-
tween students of universities and vocational schools) is "an
inevitability as long as the differences between urban and rural
areas, manual and mental labor, as well as income, educational,

and cultural differentials between families exist." [60]

The argument in favor of competitive entrance examinations is blatantly unconvincing, almost absurd to anybody who is familiar with the actual procedure. [61] Nevertheless, this kind of argument is still warmly welcomed by the Novy mir reader- ship, since the advantages of the present system of university admission are widely shared by its readers. As Barrington Moore has stated: "The power of ideas does not depend upon their logical coherence alone, but also upon the social functions that they perform." [62]

The partial success of the "Soviet way of life" campaign among Soviet specialists is a result, in my opinion, of the fact that advanced industrial society exists today in two quite dif- ferent variants — the Western type and the Soviet type — which lend themselves to direct comparison to the "quality of life" provided by each. The idea of the Soviet way of life implies a division of human rights into spheres of socioeconomic and personal freedom which are seen as potentially opposed and of quite unequal weight: noneconomic aspirations are represented as inferior to economic achievements and job security. The partial success of this ideological campaign is also the result of a definite oversupply of educated personnel in the Soviet Union today. To a Soviet professional the threat of unemploy- ment among "overeducated Americans" is a familiar problem, and he readily appreciates the efforts of the Soviet regime to avert it.

The concept of the Soviet way of life can successfully serve as a sort of a middle-level theory mediating between the doc- trine and the operating ideology of Soviet Marxism. It aids in consolidating both tiers of Soviet Marxism into a consistent and cogent entity, a Soviet world-view acceptable to and con- vincing for a considerable part of the Soviet new middle class. At the same time, this shift from a goal to be achieved in some indefinite and remote future to a goal of polishing and improv- ing on a "mature socialist society" indicates that the transition of Soviet Marxism-Leninism from the revolutionary ideology phase to the consolidating ideology phase has, by and large, been completed.

But while both processes — ficticization and consolidation of ideology — aim to achieve societal integration by preserving the status quo, their targets are essentially different. Ideological ficticization is directed toward weakening and destroying working-class radicalism by increasing the incongruence between ideology and life experience. The massive propaganda campaign on the "Soviet way of life," on the other hand, is directed primarily against the radicalism of the new middle class.

Analysis of these ongoing changes in Soviet ideology allows us to formulate a hypothesis that concerns not only the role of ideology in advanced socialist societies but also the role of ideology in advanced industrial societies in general: the various components of an ideology are connected in particular ways with different social classes and affect them differently. When the main function of an ideology becomes that of defending the status quo instead of changing and reforming it, two processes — both an increase and a reduction in discrepancies between core doctrine and operating ideology — may coexist simultaneously and be used for this purpose.

THE ETHNIC QUESTION
IN THE USSR

What makes the ongoing debate concerning ethnic[1] relations
in the USSR so predictable is that the authors' conclusions can
almost be deduced by knowing in which country they happen to
live: Soviet literature tends overwhelmingly to stress the in-
ternationalizing effects of ethnic integration, while Western
literature emphasizes just as forcefully the disintegrating ef-
fects of ethnic nationalism.[2] The Soviet emphasis can, of
course, be partly explained by the fact that Soviet sociologists
cannot publish anything which fails to substantiate the official
claim that "the integration of nationalities in the USSR proceeds
at an increasingly rapid rate." Moreover, Soviet researchers
have not carried out comparative studies of ethnic relations
and nationalist phenomena in Western and Soviet-type soci-
eties — studies which would lead them to a more complex un-
derstanding of the issue. Meanwhile, Western students of the
USSR, who undoubtedly have their own ideological axes to
grind,[3] tend to oversimplify ethnic politics by concentrating
mainly on the alienating impact of the Soviet system or by ex-
amining only the manner in which the Soviet system generates
antagonisms and provokes ethnocentric responses. Compara-

tive analysis of Western neonationalist movements might help temper such judgments; so would examination of the ways to contain ethnic separatism that have been developing in the USSR. This chapter analyzes precisely those mechanisms elaborated and continuously perfected to contain potentially disruptive ethnic sentiments in the USSR.

Three aspects of the structure and functioning of the neo-Stalinist state must be considered in examining ethnic relations in the USSR:

1) The system of internal passports used by the regime in order to maintain almost impassable boundaries between nationalities.

2) Soviet federalism as a principle of organization inherited from the October Revolution, which was essentially non-nationalistic.

3) The domination of society by a single party, hierarchically organized and committed to the ideology of ethnic unification and assimilation.

Nationality and the Passport System

The study of ethnic processes in the USSR must begin with an inquiry into the bureaucratic procedures by which ethnicity is determined. Introduced in 1932, the system of internal passports imposes a nationality on every citizen: this is the famous "fifth point" of Soviet questionnaires and internal passports. According to the original rules in force during the thirties, citizens could freely choose their own nationality when the passport was issued. The analysis of official documents and the testimony of persons[4] who received their first passports in 1933-35 reveal that nationality was recorded on passports on the basis of oral declarations. Changing one's family name — an operation often necessary for a person seeking to hide his ethnic origin — was also quite simple. However, only a very limited number of people chose to change their nationality at that time. There were three reasons for this. First, the Soviet

regime opposed any kind of nationalism during the first years of its existence. The revolution's struggle against ethnic dis-crimination and privileges ascribed to minorities produced favorable conditions for the free manifestation of ethnic con-sciousness and for the self-determination of nationality. Sec-ond, nobody could have predicted the role later played by the passport system in general, and by the entry "nationality" in particular. Finally, the recording of nationality did not have any historical precedent, since during the tsarist period in-ternal passports registered religion rather than nationality.

Later, changing one's nationality as recorded in the passport was prohibited, and the nationality of a child from then on was determined by the recorded nationality of its parents. This important political act passed totally unnoticed, and even now scholars pay very little attention to it.[5]

But it is precisely the passport system which establishes rigid boundaries between ethnic groups. Soviet experts are evidently aware that national membership is "not a biological but a social category, determined not by birth but in the pro-cess of socialization of the individual and in the process of con-scious ethnic self-identification."[6] It is equally evident that ethnic membership or national orientation can change in the course of the life of one individual and, even more so, in the course of the life of several generations. Nonetheless, the ethnic identification chosen by Soviet citizens in the thirties still determines once and for all the legal national membership of their offspring in the eighties. In this way the present re-gime has inherited a unique instrument to guide ethnic processes.

In the context of Soviet society, therefore, concepts like "eth-nic identity" or "change of ethnic identity" may still be useful, but their meanings differ from their counterparts in Western industrial societies. For example, the situation of an Armenian family that has always lived in Moscow, has adopted the Russian language and culture, and has lost all language and other links with its own ethnic group could be described as a case of changed ethnic identity. Yet on their internal passports these citizens remain Armenians, and their children will be able to

register and be treated only as Armenians in all important aspects of life — admission to university, employment, draft, housing, travel abroad, etc. — in conformity with the "quota" allotted to Armenians at any given time. This fact is never forgotten by the concerned parties and by those in their immediate environment.

Census data concerning the numerical composition of Soviet nationality groups, increases in them, etc., do not correspond with the data derived from passports because the former are compiled on the basis of oral declarations. Soviet authors freely admit the discrepancy. As Victor Kozlov, the noted Soviet ethnographer, has pointed out: "These census data should not be considered 100 percent accurate, and the data concerning the numerical composition of each nationality, even though calculated to the last person, should not mislead anyone."[7] Census data can reflect what certain groups of the population regard as desirable, but they can be very different from passport reality. Substantial groups of people living in Western Belorussia, for example, declared themselves Polish in the 1959 census and Belorussian in the 1970 census. This was not the result of some dramatic change in ethnic identity occurring within a few years: on their passports these people had to maintain their Polish nationality, but being unable or unwilling to move to Poland, and belonging to an ethnic category with few privileges, the members of this group expressed through the census questionnaires their desire to join a more privileged group.[8]

Mixed Marriages

In the Soviet Union mixed marriages among people from different nationalities are rather frequent. Between the late 1950s and 1970, the number of mixed families increased by 50 percent, and in 1970 they represented 13.5 percent of all Soviet families. In the cities mixed marriages were as high as 17.5 percent.[9] Mixed marriage is the only case in which the current passport system permits a choice of nationality. In the last years of Stalinism (1947 to 1954), even this choice was not

possible; a special regulation established that the nationality
of those born to mixed marriages had to be the maternal one.
According to current regulations the child can choose between
the nationality of one or the other parent. This is done at the
age of sixteen, when the first internal passport is issued. The
law is formulated in a way that reduces to a minimum the al-
ready limited freedom of choice by stating that "no subsequent
change in nationality entry is permissible."[10]

In an advanced industrial society with a great deal of vertical
and horizontal mobility, the recording of nationality on the pass-
port leads to absurd situations. For example, it is very hard
for the children of a Tatar and a Ukrainian parent living in a
rapidly developing center which attracts people from all over
the USSR to choose their own nationality, especially if the lan-
guage and culture assimilated from childhood are Russian.
Yet they will appear on their passports as "Tatar" or as
"Ukrainian," even though they do not consider themselves
either. As Kozlov indicates, the nationality entry on the pass-
port "obfuscates the effective ethnic orientation of many citi-
zens of the USSR and in some cases even upsets it, with the re-
sult of obscuring the real evolution of the ethnic situation, and
particularly that of the processes of assimilation and integra-
tion among nationalities."[11] Galina Starovoitova, studying the
attitudes of the urban population in relation to a person's na-
tionality, observes that most young people oppose the existing
passport system as the main determinant of nationality.
Younger respondents place higher value on "the desires of
young persons themselves." Starovoitova sees this variant as
"the most democratic, in that it does not impose dogmatic pat-
terns of behavior in the sphere of ethnic self-identification,"[12]
suggesting implicitly a return to an earlier system of free
choice of nationality entry. During the preparatory phase of
the passport reform in 1973-74, some letters appeared in the
Soviet press that went so far as to suggest the removal of the
"nationality" entry from the passport; it was to be replaced by
the general category "citizenship" (obviously Soviet).[13]

These criticisms and suggestions are probably seen by the

leadership as manifestations of naive moralism. As they try
to maintain the current power structure, the leadership has no
interest in bringing about some "natural" assimilation or a
democratic choice of nationality, and they are even less inter-
ested in emancipating citizens from dogmatic models of behav-
ior. The multinational ruling group is not in the least willing
to give up so efficient a means of control and regulation of re-
lations among nationalities. As Mikhail Kulichenko, the official
theoretician on ethnic relations, puts it, the danger is not in the
awakening of ethnic consciousness and feeling as such. Rather,
"the greater danger lies in allowing such processes to develop
spontaneously, without any guidance, and in letting hostile na-
tionalist elements influence the growth of ethnic self-conscious-
ness."14

While the number of published empirical studies on ethnic
relations is modest, and while censorship is particularly harsh,
direct or indirect surveys on mixed marriages in the USSR as-
sume great importance. They illustrate the real behavior of
Soviet citizens who are in a position to exercise limited choice.
One of the main reasons for the choice made is in fact the po-
litically determined social standing of an ethnic group. The
analysis of such trends in the area of mixed marriages provides
an invaluable insight into the role of federal policies in shaping
Soviet ethnic processes.

Soviet Federalism and Ethnic Stratification

According to the constitution, the USSR is a federal state made
up of fifteen national republics. The national republic is the
highest form of state organization accessible to Soviet national-
ity. In addition there are other territorial units, such as au-
tonomous republics, autonomous provinces, and national dis-
tricts. Finally, there are national groups without their own
territory, such as Germans, Jews,15 Poles, and Crimean
Tatars.

Many political scientists view Soviet federalism with skepti-

cism, asserting that the Soviet Union is "not a federal but a
unitary state."[16] National republics, however, enjoy a relative,
although limited, sovereignty over their respective territories.
That in the contemporary USSR federalism is a palpable reality can
be seen by examining many social processes, such as the sub-
division of the state budget according to republics, or the ori-
gins and functioning of national political elites, or ethnic
stratification.

Ethnic stratification translates into social inequality when
ethnic origin is used as a criterion for the distribution of so-
cially important rewards. Not only is research on ethnic strat-
ification neglected in the USSR, but the very existence of such
inequality is denied. Soviet scholars use euphemisms such as
"ethnic prevalence" or "differential ethnic attractiveness,"[17]
thus camouflaging the fact that they are discussing a case of
domination over and discrimination against one ethnic group by
another. Nevertheless, the fact that up to 93 percent of the
children born from Russian-Jewish mixed marriages choose
Russian nationality demonstrates not so much "the strong ten-
dency of Jews to integrate with people surrounding them,"[18]
but rather the existence of discrimination against them. The
choice in favor of Russian nationality in Russian-Jewish mixed
marriages is only an extreme example of a general trend
throughout the Soviet Union: everything else being equal, most
children from Russian–non-Russian mixed marriages choose
Russian nationality. The only exception to such a trend is the
case of a mixed Russian–non-Russian family residing on the
national territory (republic) of that ethnic group to which the
non-Russian party belongs. Thus data from the Baltic repub-
lics show that more than half of those born in families where
one parent is Russian and the other Lithuanian, Estonian, or
Latvian choose the nationality of their republic.[19] Yet in al-
most all those families the children speak not the native lan-
guage of their republic but Russian, and in everyday life they
tend to define themselves as Russians. The national affiliation
they have adopted in accordance with the passport regulation
does not, therefore, correspond to the ethnic self-identification

of many adolescents from mixed marriages.[20] The persistence
of the federal principle offers one explanation for such choices:
general Russian domination is counterbalanced by certain priv-
ileges granted to indigenous nationalities. On the republics'
territories the representatives of indigenous populations are
favored vis-à-vis access to higher education, professions, and
positions offering greater social rewards.[21]

Official USSR theoretical literature does not see any future
for ethnic groups and, consequently, for federalism. In the fu-
ture nationalities are expected to merge. This is described as
a "general process of withering away of ethnic differences, the
ultimate result of which will be that the nations will have ceased
to exist and will all join a unified humanity."[22] The rapproche-
ment of nations and their ultimate fusion are seen as "an ob-
jective law of the development of socialist society." According
to some authors, the process of assimilation has already gone
so far that the elimination of the federal principle is the next
logical or even necessary step. During the debate on the draft
of the new constitution there were attempts to introduce the
concept of a "single Soviet nation," to limit the union republics'
privileges, and to eliminate their proclaimed right to secession.
Behind the usual rhetoric on the fusion of nationalities one can
easily detect an ill-disguised dissatisfaction with the economic
and social privileges granted to the native populations. Realis-
tically evaluating the existing situation, the Soviet leadership,
however, has judged these proposals untimely and relegated
their introduction to an indeterminate future. The impact of
the Soviet federal structure, therefore, continues to be strongly
felt in ethnic relations. At the same time, the Soviet leader-
ship spares no effort to further the process of assimilation of
nationalities, thus actively fostering Russification and Soviet-
ization.

Voluntary and Forced Russification

In a multiethnic society assimilation may go in one direction

when there is only one assimilating group or in different direc-
tions when various assimilating groups are present. The as-
similation the Soviet regime currently promotes is unidirec-
tional and is intended to result, in some not-so-distant future,
in the formation of a Soviet nation based primarily on the Rus-
sian people, language, and culture.[23] Characteristically, the
word "Russification" is not found in Soviet literature, except
in the specific genre of political literature called "critique of
bourgeois ideology." Unidirectional assimilation in the multi-
ethnic society is always partly voluntary and partly forced,
while the official doctrine, following Lenin, assigns a progres-
sive character only to voluntary or "natural" assimilation.[24]

The dominant position of Russians, primus inter pares in
Soviet society, scarcely needs to be demonstrated. Russian
hegemony within the tsarist empire was seriously compromised
by the revolution. According to Lenin, it was the task of social-
ism to promote the internationalization of economic, political,
and cultural life.[25] He recognized the need to struggle against
Great Russian chauvinism and against the legacy of tsarist na-
tionalism and militarism. His appeals did not remain rhetori-
cal. But in the late thirties, and even more so during World
War II, state policy on the national question underwent a sudden
shift toward Russification. The reasons for the shift are evi-
dent. The Russians, who constitute the biggest ethnic group in
the country, populate compactly the largest part of the USSR
and also form a considerable part of the population in almost
all national republics. It was the Russians who made the ma-
jor contribution to industrialization and to the country's mili-
tary efforts. Russians constitute the nucleus of the ruling party
and hold almost all top posts within the leadership (nearly all
positions in the Politburo, the Secretariat of the Central Com-
mittee, the key positions in the party apparatus and military
administration, etc.). The strengthening of Russian centrality
in the leadership's composition is considered a means of pre-
serving the present distribution of political power in the coun-
try and of furthering the regime's centralized character. As
T. Rigby has pointed out, the Soviet leaders "seek to integrate

national pride and loyalty with their goal-legitimated authority
by crediting the historical Russian nation with the exceptional
qualities which enable it to pioneer the 'socialist' revolution
and transmit it to the other nations of the old Empire and later
beyond her borders. The leadership, in defending and advanc-
ing the cause of socialism, also — and in part thereby — em-
bodies the will, integrity and interests of the historical Russian
state and nation."26

How can the development of Russification in the USSR be
dealt with? Iurii Bromlei, the Director of the Moscow Institute
of Ethnography, discussing unifying ethnic processes, particu-
larly assimilation, suggests that the following be distinguished:
cultural changes (from cultural adaptation to cultural assimila-
tion); linguistic changes (from bilingualism to linguistic assim-
ilation); change of ethnic identity (from dual ethnic self-con-
sciousness to total change of self-consciousness).27 There
are still no published Soviet empirical studies on ethnic assim-
ilation which have fully taken these processes into considera-
tion. Nevertheless, since the Russian language and the pass-
port system are the primary and most effective instruments
of Russification, and simultaneously the most important deter-
minants of nationality, data on language and on nationality as
registered in passports can be assumed to be an objective and
reliable indicator of the dynamics of ethnic processes.

Mechanisms of Linguistic Russification

The Russian language is the main instrument of ongoing Rus-
sification. Soviet scholars justifiably point out that national
language and national self-identification are closely linked.
"Change in native language, although it does not necessarily
mean the full restructuring of national consciousness, attests,
however, to the fact that deep ethnic changes have occurred
and that processes of assimilation are now taking place. The lack
of coincidence between ethnic membership and language use in-
evitably leads to a change in one's national self-awareness."28

Voluntary acceptance of the Russian language must not be confused with its forced imposition, which depends on political decisions. In the most balanced and thorough research published on Soviet linguistic policy, E. Glyn Lewis observes that the Russian language "has a greater degree of usefulness over a wider range of purposes and situations than the other indigenous languages of the Union."[29] Nonetheless, for political reasons the superiority of the Russian language in the Soviet Union is strongly exaggerated by the central authorities.

The very structure of Soviet society, with its high degree of centralization, encourages the substitution of Russian for other languages in many areas of social life. Crucial social institutions like the military have a unified rather than a federal base. Within the military, which touches the entire male population, the Russian language is used exclusively. University education is highly Russified. In the Ukraine and Belorussia, nations which are linguistically close to Russia, Russian prevails even in elementary school and kindergarten. Already under Stalin, even the alphabets of some ethnic languages had been Russified.[30] At that time some authors proposed a theory of "world languages" related to various socioeconomic formations. Latin was seen as related to slave societies, French to feudal societies, English to capitalist societies, and Russian, correspondingly, to socialist formations. Now, Russian is still presented as the only language that Soviet people can use for international communication.[31] The Soviet organization of information also aids Russification. Today the ethnic press publishes international information very late because it must first translate it from Russian. In this way ethnic populations are encouraged to use the Russian mass media and are artificially forced to consider ethnic languages as second-class.[32]

The central government, furthermore, attempts to achieve the intermeshing of various ethnic groups through carefully planned migration policy. For example, large construction projects are planned in the Baltic area, where there is a shortage of local manpower, and thus Russian and Ukranian workers and technicians are imported. At the same time, the leadership

tries to promote migration from the densely populated republics to the Russian republic. The linguistic consequences of these migrations for the members of Russian and non-Russian ethnic groups are quite different. The dominant position of the Russian language does not stimulate Russians to study ethnic languages, and consequently bilingualism is a rare phenomenon,[33] while the high percentage of Russians in the republics greatly affects the diffusion of the Russian language. On the other hand, ethnic migrants to the Russian republic all learn Russian and rapidly become linguistically Russified.

Finally, from the middle seventies on, a new centralist shift in language policy occurred, with the tendency to reinforce the supremacy of the Russian language and to stimulate the replacement of other ethnic languages with Russian. The 1978 decree of the USSR Council of Ministers "On Measures to Further Improve the Study and Teaching of the Russian Language in the Union Republics" introduces far-reaching reforms into the Soviet educational system, particularly into language instruction. The decree, presented as a response to "the numerous requests from citizens of various nationalities," has still not been published.[34] It and the following all-Union conference, "The Russian Language, Language of Friendship and Collaboration among the Peoples of the USSR" (Tashkent, 1979), adopted new measures concerning the expansion of Russian-language study in the non-Russian republics (including the organization of teaching in Russian in preschool institutions, the reduction of hours reserved for teaching ethnic languages in schools while increasing those reserved for Russian, the reorganization of the system of language instruction in universities, and so on). The stated goal of this campaign is to achieve complete bilingualism among the younger generations of non-Russian nationalities in the eighties.

While data on language affiliation by nationality are available, and while Soviet language policy as a means of Russification has been extensively studied, the analogous role of the Soviet passport system has remained largely unnoticed.

The Passport System and Cultural Russification

It has already been pointed out that mixed marriages are today
a very widespread phenomenon and that in the majority of cases
children born of a mixed marriage with a Russian parent adopt
Russian nationality on their passports because of the advan-
tages this provides. This practice constitutes what can be
called the overt dimension of the Russificatory impact of the
passport system.

Even more important is the fact that the system which "de-
termines" nationality in the citizens' identification documents
leads to the hidden cultural Russification of those ethnic groups
which, residing on the territory of the Russian republic, have
their own territorial formations, such as autonomous repub-
lics, autonomous provinces, or national districts. Passport
registrations and the quota system guaranteeing autonomous
nationalities' access to professional and managerial positions
on their territories effectively protect the interests of the new
ethnic middle classes. The most educated part of the popula-
tion thus readily accepts the Russian language and culture.
Cultural assimilation is rapid among them, insofar as the na-
tional intelligentsia lacks the incentive to further develop its
ethnic language and culture, which in any case could not easily
compete with their Russian counterparts. Acquisition of Rus-
sian as a second language is "a direct response to demands and
opportunities to learn Russian created by both social circum-
stances and social policy."[35] The present passport system,
which often establishes arbitrary but strict boundaries between
ethnic groups, protects the ethnic group's middle class against
competition and prevents many ethnic minorities from develop-
ing their own national culture, thus contributing to their cul-
tural Russification. Within one or two generations the only dif-
ference between Russians and many ethnic groups residing in
the Russian republic may be only the "nationality" recorded on
passports. When this entry is removed — and this can be done
at the discretion of the central authorities, as can be seen by the

recent elimination of the entry "social origin" — these ethnic groups will have lost all ethnic linguistic and cultural characteristics.

The passport system, however, effectively prevents full Russianization. Although cultural assimilation and linguistic changes, from bilingualism to the replacement of local languages by Russian, advance quite rapidly in the Russian republic, changes in ethnic identity may hardly happen when there is no legal procedure to change nationality as recorded on the passport.[36] Thus Russification is only the major aspect of the more general process of Sovietization, understood as the homogenizing of all nationality groups in terms of their social and political structure, culture, and commitment to perpetuate the existing social order and distribution of power. The regime promotes Soviet culture, "national in form and socialist in content," as Stalin put it. This culture, as Soviet authors state, carries out the "general mission of strengthening the Soviet social system, of maximizing the consolidation of Soviet society — nationalities, classes, strata, and groups — around the principles and ideals of the Communist Party."[37] And Russification happens to be one of the most convenient ways of implementing the assimilationist and homogenizing policy of the Soviet regime. Thus the passport system, the federal structure, and the ruling party's assimilationist policy determine the dynamics of ethnic processes and the extent of ethnic nationalism in Soviet society.

Types of Nationalism in Soviet Society

Students of ethnic relations have always had difficulty defining nationalism. Discussing various historical forms of nationalist ideology, Hans Kohn points out that "what remains constant in nationalism through all its changes is the demand of the people for a government of the same ethnic complexion as the majority."[38] Isaiah Berlin argues that any nationalist doctrine preserves the following four characteristics: "The belief in the

overriding need to belong to a nation; in the organic relation-
ships of all the elements that constitute a nation; in the value
of our own simply because it is ours; and, finally, faced by ri-
val contenders for authority or loyalty, in supremacy of its
claims."[39]

A further distinction between different varieties of national-
isms can be made by taking into account the types of ethnic
groups that are their principal supporters. In the Soviet multi-
national state nationalism takes two main forms: the ideology
of ethnocentrism, separatism, and disintegration when it con-
cerns an ethnic minority, and the ideology of Russian suprem-
acy and forced assimilation (Russification) when it concerns
the dominating Russian group. In this sense the distinction
formulated by Lenin between the oppressive nationalism of the
nation and the defensive nationalism of the oppressed nation is
still valid.[40] It is significant that while after the revolution the
focus was on the struggle against Great Russian chauvinism,
such nationalism has been completely neglected by Soviet the-
ory and propaganda in the postwar period. If we had to rely on
contemporary Soviet publications, it would appear as if nation-
alism occurs only among ethnic minorities, while the Russian
majority is completely immune from such "errors."

Dealing with the nationalism of Soviet minorities, Teresa
Rakowska-Harmstone recommends subdividing it into "ortho-
dox" and "nonorthodox" varieties. Orthodox nationalism aims
at the recognition and extension of national autonomy within the
limits permitted by the Soviet political system. It is orthodox
insofar as it does not threaten the official doctrine of Marxism-
Leninism, but it is nevertheless a certain challenge to the he-
gemony of the Russian ethnic group. Rakowska-Harmstone be-
lieves that since the midfifties, this type of nationalism has
been tolerated by the leadership. As for "nonorthodox nation-
alism," it "combines national self-assertion with rejection of
the actual political system and is frequently coupled with the
civil rights movement and separatism."[41] This type of nation-
alism is harshly repressed. To concretize this useful distinc-
tion, a structural analysis of ethnic groups should be introduced

in order to pinpoint which classes and social groups within an
ethnic group are the main bases of "orthodox" and "nonortho-
dox" nationalism.

The work of Soviet sociologists (above all Iurii Arutiunian,
Ovshii Shkaratan, and their collaborators) published during the
past decade demonstrates that Soviet modernization and social
mobilization affect in quite different ways the national psychol-
ogy and the rate of assimilation of different groups and social
classes within an ethnic group. As Arutiunian has observed,[42]
traditional "folk"-type nationalism is present in that part of the
population which, because of its low level of education and rate
of mobility, has a traditional and strict system of values and
avoids contacts with people whose way of life contrasts with
their conservative mentality. An increase in the range of cul-
tural orientations and contacts with other ethnic groups and
their cultures will certainly contribute to the overcoming of
such "backward nationalism." The social mobilization of these
strata of the population will accelerate the process of rap-
prochement of ethnic groups and will weaken their ethnocentrism.

The situation of the educated part of the population is com-
pletely different. The strengthening or weakening of the na-
tionalism of Soviet specialists depends not so much on their
cultural orientation or the degree of internationalization of
their ethnic group, but on the complex combination of their so-
cial and occupational interests. Data provided by Soviet so-
ciologists confirm the thesis according to which the new mid-
dle class subscribes, in the modern, industrial, multinational
Soviet society, to a "nationalism of convenience" used as an
instrument of struggle against other ethnic groups for economic
and political privileges.

In this sense the processes of industrialization and social
mobilization can either accelerate or slow down assimilation,
producing within certain limits opposite effects on different
social groups. These processes promote the homogenization
of urban and rural workers from different nationalities, but
they also foster the ethnocentrism and nationalism of the new
middle class. These conclusions explain both the increase in

nationalistic tendencies among certain segments of various
Soviet ethnic groups and the unquestionable success of the re-
gime's strategy in controlling and containing ethnonationalism.

Before analyzing the actual treatment of nationalities as well
as their responses, it is necessary to briefly outline some of
the effects of modernization on the Soviet republics. This can
help us grasp the social locations of supporters of nationalism
and the nature of their grievances.

The Unifying Impact of Modernization and
Economic Inequality among the Republics

From the very beginning, the Soviet regime has consistently
pursued a policy of equalization among the republics, and its
attempts to develop the economy and the culture of the most
backward ethnic groups have not been in vain. As a result of
rapid industrialization, which has affected nearly all of the
USSR, differences in the class structure of the national repub-
lics have gradually become attenuated. Thus, as Mikhail
Dzhunusov calculates,[43] if in 1939 the index of the proportion
of workers in the gainfully employed Russian population is as-
sumed to equal 1.0, the following figures applied in the same
year to the other nationalities: Ukrainians 0.8; Armenians 0.6;
Belorussians 0.5; Georgians, Azeris 0.4; Uzbeks, Turkmen 0.3;
Kirghiz, Tadzhiks 0.2. However, by 1970 these figures had
changed significantly. They were: Armenians, Azeris, Belo-
russians, Estonians, Latvians, Lithuanians 0.9; Ukrainians 0.8;
Georgians, Kirghiz, Tadzhiks, Uzbeks 0.6; Moldavians, Turk-
men 0.5. Differences between the nationalities have also con-
siderably diminished with regard to specialists (intelligentsia).
If the index of the proportion of the intelligentsia among the
Russian population in 1970 is assumed to equal 1.0, the corres-
ponding figures for the other nationalities are: 1.1 for Lat-
vians; 1.0 for Estonians and Ukrainians; 0.9 for Armenians,
Azeris, Belorussians, and Lithuanians; 0.7 for Kazakhs; 0.6
for Moldavians, Tadzhiks, Turkmen, Uzbeks. The data clearly

demonstrate a considerable degree of uniformity in the class structure of the Soviet republics.

Furthermore, the unified system of education and political indoctrination, combined with stringent state control of the mass media, has created a considerable homogeneity of attitudes and life styles among analogous social classes of the different nationalities. As Arutiunian observes: "Identical elementary, secondary, and higher educational curricula, rigorously coordinated courses in the social sciences, primarily history and literature in the secondary schools, the uniformity in ideological emphasis of the material disseminated through newspapers, magazines, TV, movies, and the theater facilitate the shaping of a unitary world-view among people of diverse nationalities."[44]

There are, however, certain socioeconomic data which seem to indicate the persistence of traditional ethnoregional fragmentation. Thus Alastair McAuley provides the following data on per capita income derived from employment:

Table 8[45]

Per Capita Personal Income in the Soviet Republics
(%)

	1960	1965	1970
RSFSR	107.8	106.7	108.0
Ukraine	94.5	99.6	97.1
Belorussia	81.2	88.9	93.8
Uzbekistan	77.4	73.0	74.2
Kazakhstan	95.1	89.8	87.5
Georgia	94.2	87.8	89.4
Azerbaidzhan	73.0	68.1	66.0
Lithuania	107.8	110.3	117.7
Moldavia	69.9	85.7	86.0
Latvia	124.9	122.7	125.1
Kirghizia	71.8	77.6	72.5
Tadzhikistan	66.2	72.7	63.0
Armenia	85.0	83.0	87.1
Turkmenistan	74.0	77.4	78.8
Estonia	129.0	130.0	133.2
USSR	100.0	100.0	100.0
(R per year)	446.0	584.0	799.0

To provide another example, after an analysis of Soviet bud-
getary policy, Peter Zwick comes to the conclusion that "Soviet
national development in the post-war era was characterized by
intensified ethnoregional socio-economic fragmentation."[46]
He even goes so far as to assert that "the persistence of so-
cio-economically based regionalism serves as a constant re-
minder of the regime's inability to create at least the image
of a nation whose residual inequalities can be explained by ref-
erences to economic underdevelopment rather than discrimin-
atory policies in public benefit allocation."[47] The problem,
however, is that Soviet statistics on the distribution of incomes
derived from state employment or from the sociocultural bud-
gets of the republics should not lead to such conclusions about
differences in the nationalities' standard of living.[48]

First of all, the cost of living in different areas of the coun-
try varies considerably due to differences in physical or cli-
matic conditions. Moreover, social inequality in Soviet-type
societies, as we have already seen, derives from two main
sources: inequality generated by the actual power structure
and inequality generated by the market relations which exist
and expand alongside the administrative allocation of resources
and rewards.[49] The "second economy" is a growing phenom-
enon in the USSR. Official statistics by republic on income
distribution or on budgetary sociocultural spending, therefore,
cannot serve as adequate indicators of the relative living stan-
dards in different parts of the country. Private economic ac-
tivity, in its legal as well as illegal forms, must also be taken
into consideration. Both inequality generated by budgetary al-
locations and inequality generated by market relations bear
heavily on the exacerbation of ethnic tensions, although the sig-
nificance of these factors is quite different for members of
different social classes. Thus it is necessary to briefly ex-
amine the main social classes and groups which constitute So-
viet society — local political elite, specialists, workers, and
peasants (kolkhozniks) — for their structurally determined
receptiveness to nationalistic ideas.

The Control of Local Elites

From the very beginning the Soviet regime has systematically
pursued a policy of "indigenization" of local republic adminis-
trations. It has implemented this policy by reserving a con-
siderable number of seats for members of local nationalities
and, later, by skillfully exploiting the passport system in or-
der to achieve their representation. As a consequence, repre-
sentatives of the titular nationalities today hold most leader-
ship positions and higher-status jobs in almost all of the
republics.[50]

During the Brezhnev period this policy of securing "the due
representation in their party and state organs"[51] for all ter-
ritorially based nationalities has been consistently implemented.
Sociological data confirm the considerable increase in the rep-
resentatives of local nationalities among the highest industrial
managers and heads of state and party organizations during
the 1970s.[52]

Yet the local political elite does not represent the particular
interests of its own ethnic constituency. Since local elites are
primarily established through appointment and cooptation by
the central party apparatus, the various national political lead-
erships are responsible first and foremost to the central au-
thorities rather than to the local population. A local party
leader, whose appointment and dismissal depend fully on Mos-
cow, can encourage nationalistic sentiments only at a tremen-
dous personal risk. The dependence of the local elite on cen-
tral power is further strengthened by a peculiar system of re-
wards for the membership.[53] The leadership receives mone-
tary remuneration that is already significantly higher than that
of an average specialist, in addition to remuneration in kind
(cars, apartments, country houses, use of special shops), to-
gether with various types of privileges (access to information,
journeys abroad, etc.); the latter are generally regarded as
much more valuable than monetary compensation, but they
cannot be "banked." Such a system, consequently, prevents the
elite from accumulating wealth that would permit it a greater

degree of independence, and losing a job would thus mean a catastrophic loss of income.

Yet there are some psychological and social mechanisms of ethnocentrism and nationalism that potentially can bind the local elite to its ethnic group. That is why the central power pays great attention to manifestations of nationalistic sentiments within the local leadership and takes care to place in positions of major responsibility the most Russified elements which, due to the system of internal passports, still belong to the local nationality. The activities of the local party apparatus are also effectively controlled by the central elite.[54] Thus the local political elite has little opportunity to carry out a nationalistic policy even if it wanted to: Moscow can adopt quick and harsh countermeasures at any time.[55]

The system of central planning often generates economic tension and conflict over the proportion of the republics' income derived from local resources that will be siphoned off by the state budget. Efforts by the local leadership in defense of the republics' economic interests should not, however, be overestimated. The bickering between the central powers and the republics for the distribution of resources or the allocation of new plants is a normal phenomenon in the Soviet economy. Members of the local leadership avoid going beyond the limits of purely economic bargaining and do not even dare show much obstinacy for fear of bringing on political accusations that would mean the end of their careers. As the official theoreticians state, "the redistribution of resources is closely connected with the patriotic and internationalist maturity of the national consciousness of the workers," while "particularism is akin to nationalism."[56]

Having analyzed speeches at party congresses by leaders of the nationalities, Glyn Lewis singled out "their subservience to Russia and its language" as their most striking common feature.[57] This observation can easily be extended beyond the sphere of linguistic behavior to practical actions. The national political elites should not be seen in any case as carriers of nationalistic tendencies. On the contrary, they slavishly follow

the central authorities, and they often appear to be more zealous supporters of Russification than the Russians themselves.

The Control of the New Middle Class

If the national political elite follows the central line, the specialists, or the new middle class in Soviet society, are more prone to be influenced by "nationalism of convenience." The structural position of this class in society, especially its humanistic stratum, induces it to use the national language and culture as weapons in the struggle for the most prestigious and remunerative jobs. The humanistic intelligentsia within the new middle class is in a more vulnerable position than the technical specialists, and Zbigniew Brzezinski suggests with some justification that "the intellectuals, the humanists, the pseudointellectuals (school teachers, run-of-the-mill journalists, and the like) tend to be more nationalistic elements in the different republics, across the ethnic spectrum."[58] The well-being of this stratum depends in particular on the republics' continued financial support of the social-cultural sector. But, as Zwick has shown, while all republics enjoyed noticeable rates of growth in per capita sociocultural expenditures between 1960 and 1970, the differences between republics did not decline.[59] The regime's continuing preoccupation with unlimited industrial growth, combined with a policy of centralization and Russification, makes a sudden shift in budgetary policy, which would diminish such regional differences, quite unlikely. Nevertheless, the Soviet leadership is well aware of the nationalistic tendencies of the specialists and expends a great deal of effort on controlling and neutralizing them.

As in the case of the national political elites, the registration of nationality on the passport and the politics of Soviet federalism play an important role in controlling the new middle class. Competition among specialists of various ethnic origins is regulated on the institutional level by a quota system (numerus clausus) which gives considerable preference to ethnic groups

residing in their own republics. Thus the situation of the potentially most explosive ethnic discontent — when educated members of the minority find their social mobility blocked by members of the majority group — is essentially avoided. Furthermore, the occupational interests of the middle classes are protected by a set of socioeconomic measures. The Soviet leadership seeks first of all to create jobs for representatives of the local intelligentsia, rapidly strengthening the scientific sectors and so-called "creative unions" (of writers, painters, etc.) in all republics. In a recent essay Zhores Medvedev describes the academies of sciences in the republics as follows:

> All these academies organized their structure according to certain standards, with presidiums, divisions, and research institutes in all the main fields (physics, biology, chemistry, etc.) and with some specialized local research units. All academies started to publish their Proceedings and other journals. The Soviet Union as a state does not need all these provincial academies; there are too many of them, and duplication or low-quality research is inevitable given such structures. Each academy has its own bureaucratic apparatus, with planning and coordinating commissions and much more. In many union republics there were not enough scientists with high qualifications to be elected as academicians, and in many cases provincial "national" academicians are very mediocre research workers, not well-known within their professional fields. The establishment of so many academies was a matter of prestige rather than necessity, a symbol of the equality of national minorities.[60]

Prestige alone, however, is not enough to explain the existence of these academies: the colossal surplus of researchers is the price the political leadership is willing to pay in exchange for internal stability. It would be naive to think that the specialists in national republics do not appreciate the efforts of the regime in creating jobs, avoiding intellectual unemployment, and assuring them privileged positions. In a recent ethnosocial study in the Moldavian republic, Soviet scholars compared job satisfaction among Moldavian specialists and specialists of Russian origin who live and work in Moldavia. Characteristically, the findings reported in Table 2 show that in all specialists' groups, the humanistic group being the only exception, Moldavian specialists are more satisfied with their jobs and promotion opportunities than their Russian colleagues.

Table 9[61]

Job Attitudes of the Intelligentsia in Moldavia
(% %)

Job and interethnic attitudes	Intelligentsia groups							
	scientific-technical		scientific-humanistic		adminis-trative		art	
	Mold.	Rus.	Mold.	Rus.	Mold.	Rus.	Mold.	Rus.
Fully satisfied with job	70	64	63	78	73	63	74	68
Satisfied with opportunities for growth and promotion	59	53	50	50	60	49	58	52
Consider ethnic composition of the personnel unimportant	79	73	70	78	88	86	74	57

The success of the struggle against middle-class nationalism is also due to the Soviet political structure, which practically prohibits the emergence of any type of ethnic organization that recruits its members exclusively from the members of a single nationality. All organizations in the various republics are tightly integrated into the all-Union bureaucratic system.

Furthermore, the solidarity of a national group depends on the intensity of communication and interaction among its members. The social and territorial barriers erected among classes, in part aided by the passport system, seriously limit the ability of the new middle class to increase national self-consciousness within their ethnic groups, to intensify interaction, and to achieve ethnic solidarity.

All of this notwithstanding, the growing new middle class of the national republics, especially but not exclusively its humanistic segment, remains the main reservoir of ethnic nationalism. The policy of intensified Russification on the part of the central authority triggers ethnic response on the part of non-Russian specialists.

Workers and Peasants in
the National Republics

The "traditional" nationalism among certain strata of peasants and workers is, as a rule, aimed not so much toward the dominant Russian group as toward the population of the neighboring republics. In Georgia the prevailing feeling is anti-Armenian, in Armenia anti-Azerbaidzhani, in Azerbaidzhan anti-Armenian and anti-Georgian, and so on. These local nationalisms, based on centuries of prejudice, do not constitute a unifying ideology able to compete with the official doctrine of centralism and gradual elimination of national differences.

In general, the social position of peasants and workers makes them more indifferent to nationalist ideas. The members of the collective farm usually live in an ethnically homogeneous environment, and their contacts with the external world are infrequent and irregular. But even if traditional ethnocentrism and nationalism were widespread among them, this in itself would not constitute a threat to the regime, since the collective farm population is not a coherent political force. Moreover, the operation of the "second economy," which has been gaining momentum since the late sixties, has changed the economic situation of many collective farmers in the non-Russian republics. The perennial shortage of agricultural products permits some people in warmer regions to obtain substantial additional income. However, those market incomes are not uniformly distributed among the inhabitants of the national republics. On the contrary, the income is concentrated in the hands of certain social and territorial groups, foremost peasants and various middlemen, resulting in a considerable increase in economic inequality both within the republics and in the Soviet Union as a whole. Unless the central government develops some drastic antipeasant policies, under existing conditions the participation of non-Russian peasants, even as silent supporters, in ethnic movements remains unlikely.

As to workers in non-Russian republics, the nationalist idea

also does not have the same appeal to them as to the members of the new middle class. First of all, the nationalist ideology developed by some strata of the national intelligentsia does not represent a real alternative to a regime with a credible program of economic and social reforms for the republics. Unlike specialists, workers and peasants do not need to use their own language or any other cultural marker in the competition for more lucrative jobs: given their low social status and the chronic shortage of labor power in large and medium-sized towns, the problem of competition does not exist. The life chances of ethnic workers are not at all affected by their membership in a non-Russian ethnic group. Programs of cultural revival, including the publication of books in the national languages, the development of the language itself, and its use in education on various levels, above all in the universities, are not a priority for peasants and workers in the republics. Furthermore, skilled workers are generally more removed than the intelligentsia from a romantic vision of the advantages resulting from the creation of autonomous national states.[62] There is evidence indicating that the populations of most republics (excluding, perhaps, Belorussia) believe that they return to the Soviet treasury more than they receive.[63] In practice, however, workers are so removed from any form of participation in decisions on investments, management, etc., that these problems do not seem pressing enough to provoke an active response.

Class barriers and contradictions also weaken ethnic solidarity in Soviet society. The general decline in the rate of social mobility that characterized the Brezhnev period hit workers hardest. "The rapid growth of the cadres of the national intelligentsia," admits Mikhail Kulichenko with rather unusual candor, "occurs mainly through its self-perpetuation and through recruitment from the collective farm peasantry. Only to a very insignificant extent are these cadres drawn from the working class."[64] Differential access to so important a resource as the system of higher education, which in Soviet society is the main channel for upward social mobility, increases

the social distance between workers and the new middle class, thereby enhancing the class awareness of the working class as a whole. As Michael Hechter puts it, "if an individual perceives his class origin to be more important for the determination of his life chances than his ethnicity, he is more likely to be class than ethnically conscious."[65]

An analysis of the class location of the supporters of ethno-nationalism and the previous discussion of the dynamics of ethnic processes in the USSR are useful in evaluating the state of national relations and conflicts in the country in the 1970s. In order to understand the capacity of the Soviet political system to control ethnic relations and to neutralize ethnic movements, it is worth examining the cases of some typical republics, such as those in the Baltic and in Central Asia, as well as considering the case of one national movement, that of the Crimean Tatars.

Ethnic Relations and Conflicts in the 1970s

The Baltic republics. The Baltic republics have always been considered the stronghold of ethnic nationalism in the Soviet Union; they have old and strong cultural traditions and a recent, although brief, experience of national independence. Their relatively large population occupies a vast territory at the border of the Soviet state, where they can enjoy some exchange of information with Sweden, Finland, and Poland. Their advanced economies and the high percentage of specialists in them create the major preconditions for a nationalist movement. In fact, however, the Baltic example demonstrates how the Soviet regime manages to neutralize the nationalist threat by means of the centrally planned economy, federalism, and the passport system.

The degree of Russification of the Baltic republics, which results not so much from the process of modernization as from political factors, is increasing steadily.[66] The local party apparatus is fully controlled by the central organization and

consists only of reliable, often highly Russified elements. [67] The central authorities deliberately require the construction of huge plants in the Baltic republics, where available labor power is inadequate. Substantial economic incentives are granted to workers and specialists immigrating from other republics, above all Russia, the Ukraine, and Belorussia. The passport system permits the importation and concentration of aliens in all the main strategic areas of the Baltic republics: these areas are generally declared "closed cities," where residence rights and housing distribution are strictly controlled by the party apparatus and the militia. As a result, Latvians today constitute barely more than half of the population of their republic and are essentially concentrated in the agricultural areas. In the early 1970s they constituted 47 percent of the urban population, and in the capital, Riga, they made up only 40 percent. Analogously, the growth of the Estonian urban population is predominantly the result of in-migration from the Russian, the Belorussian, and the Ukrainian republics.[68]

The local languages are still spoken by all native Balts, but Russian is widespread everywhere as the second language. Schools and universities give the formal right to choose any foreign language. But if someone in fact were to choose, say, English over Russian, he would be declared a "bourgeois nationalist" and would suffer serious consequences. On the other hand, local science, literature, and arts are actively supported. The various unions of writers, artists, composers, etc., are supported by the state. An independent Estonia, for example, could not afford such a large number of writers, painters, and scholars, and the local intelligentsia is fully aware of this.

The effectiveness of this state of affairs for the purpose of neutralizing any separatist aspirations is evident. As Edward Allworth has aptly noted:

For a time after 1944, Baltic ethnic reliance rested considerably upon memories from the immediate past. By the 1960s, the nationalities had shown an inclination for change in this respect. Responding to more than external threats, a real or sensed need to transfer reliance from past supports soon developed among several Baltic nationalities. That new realism conceivably

represents a movement away from nostalgia toward maturity in the local read-
ing of current domestic affairs in the USSR.[69]

The Central Asian republics. The situation of the Central
Asian republics is followed with particular interest in the
Western world because of the disproportionally rapid popula-
tion growth in that part of the USSR. Many authors locate in
this phenomenon a major threat to the Soviet regime. In the
1970s the population of the Slavic republics (Russia, the Ukraine,
Belorussia) grew by only 6 percent, while in Uzbekistan the
growth rate was 30 percent, and in Tadzhikistan it was 31 per-
cent. Many observers seem to attribute a special significance
to the fact that the Russians will soon be a minority of the So-
viet population; they forget that within the tsarist empire they
constituted less than 44 percent of the population but still played
the dominant role. Also, according to various scholars, Soviet
Moslems,[70] who amounted in 1970 to about 50 million people,
will soon be 85 and then 100 million strong by the year 2000.
This growth, they believe, will cause an "Islamization" of their
way of life, the dissolution of the five republics artificially cre-
ated in Central Asia, and their unification on the basis of Islam
and of the intensification of the struggle for national independ-
ence. Following this reasoning, some authors refer to the
"Islamic revolution" in Iran.[71]
 The major defect with this type of argument consists in ar-
bitrarily drawing a political conclusion from a demographic
premise. Demographic growth is identified with growth of po-
litical activity, and the social power of a group is assessed
solely on the basis of its size, without taking into account the
level of organization and the degree of control exercised by
the group over resources. Sociological analysis does not war-
rant such a conclusion. Thus in recent research concerning
the degree of nonwork activity (participation in cultural, politi-
cal, and educational activities) of the various social and demo-
graphic groups in the Moldavian republic, Iurii Arutiunian ar-
rives at some interesting conclusions (see Table 10). These
data, rare for Soviet society, demonstrate that the rural popu-

Table 10[72]

Diversely Active Population in Different Social and Demographic Groups
(as % of total number in each group)

Population groups	Urban			Rural		
	I	including		I	including	
		II	III		II	III
Men	40.4	24.6	6.5	8.2	5.2	1.7
Women	33.6	16.3	3.7	9.3	3.6	1.3
18-29	56.5	12.1	0.6	17.0	4.3	0.4
30-49	35.1	30.8	8.6	7.6	6.1	2.9
50 and over	14.9	12.3	4.4	0.9	0.7	0.3
Engaged in physical labor	18.3	10.2	2.2	4.5	1.5	0.4
Engaged in mental labor	62.1	34.1	9.2	50.9	31.8	13.2

Note: I — percentage of persons having five or four of the characteristics
for diversity of activity;
II — same, but with children;
III — percentage having all five characteristics and having two or
more children.

lation is less active socially by a factor of almost five than the
urban population; that individuals with two or more children
are five to ten times less active than those without children;
and that blue-collar workers are considerably less active than
white-collar workers. The validity of these data obviously de-
pends on the perhaps questionable survey methods used by
Arutiunian, but the tendency to which he points is beyond a
doubt real. In this sense, if the population of the Central Asian
republics should remain prevailingly agricultural, maintain
high birthrates, and show little inclination to migrate, its growth
from 50 to 100 million will not in the least affect its social be-
havior and will not seriously threaten the regime.

It is quite obvious, however, that the Soviet leadership, driven
by the deterioration of demographic conditions, will attempt to
encourage a massive migration of the Central Asian population.
In this attempt the regime is likely to deploy in Central Asia
the same mechanisms and tactics it successfully used against
Baltic, Ukrainian, Georgian, and other nationalisms. And the
results of such a policy will in all likelihood be the same: the

emergence of a "new realism" seeking to increase material and cultural standards of living within the Soviet system and replacing the nostalgia for independence.

The claim that the "Islamization" of the Soviet Central Asian republics is an inevitable scenario for the future is unwarranted. To expect that the Moslem religion will suddenly exert a strong solidarizing effect on these republics, i.e., to state that religion will become a determining force in Soviet industrial society, means to apply once again different criteria to Soviet and Western society. There may be some augmentation of the influence (through example, propaganda, etc.) of the increasingly powerful oil-producing Moslem countries and the religious/political movements taking place there. We still do not have, however, any example of sociocultural influences by the developing countries on the advanced industrial countries of such magnitude that these influences have led to major internal changes in the latter. What evidence is there that the Central Asian republics will become just such a first case?

The Crimean Tatars. The advantages enjoyed by those ethnic groups which have their own state within the Soviet federation become evident if we consider the position of those ethnic groups that lack a semisovereign territory. The latter include: the "deported groups" (Germans and Crimean Tatars) deprived of their national territory during Stalin's time; those who have legally been assigned a territory where they never actually lived (Jews);[73] and those who for various reasons never had a national territory within the USSR (Poles).[74] All these groups, except the Poles, are engaged in a bitter struggle for the recognition of their national rights, including the right to emigrate (Jews and Germans) or to return to their ancestral territory (Crimean Tatars).

The case of the Crimean Tatars is most interesting. Along with some other groups, they were accused of high treason by the Stalinist leadership. On May 17 and 18, 1944, almost 200,000 Tatars were deported from the Crimea to remote regions of Central Asia and Kazakhstan. Many of them died during the journey.[75] After Stalin's death the Crimean Tatars were "rehabilitated" from the charge of treason, but they were

not allowed to return to the Crimea where they had lived for many centuries (the Crimea having been annexed by the Ukraine). Lacking a territory, they have very limited access to higher education (the previously mentioned system of "quotas" for the indigenous population does not apply to them) and are practically deprived of a national intelligentsia. This socially homogeneous ethnic group clearly aspires to the recognition of its own historic territory and to its share of self-government. The resulting conflict gave rise to one of the strongest national movements — alive now for a quarter of a century — in the USSR. The Crimean Tatars sent individual and collective letters of protest to all possible Soviet and international authorities; for some petitions they gathered more than 120,000 signatures. Activists attempting to organize demonstrations in Moscow are prevented from coming to the capital through various devices, including a prohibition against the sale of train and plane tickets to Tatars. If they somehow manage to enter in spite of these obstacles, they are arrested and fined or imprisoned. A certain number of Tatars have nevertheless managed to return to the Crimea, where they legally bought houses (sometimes the very ones they owned in the past). But a disposition by local authorities prohibits the employment of Tatars and the schooling of their children. Troops, aided by the immigrant population, often destroy the houses bought by Tatars and send their owners back to Central Asia. The reasons for the obstinate refusal on the part of the central leadership to recognize the rights of Crimean Tatars are economic and political in nature.[76] Particularly, weighing the protest of the Tatars and the potential dissatisfaction of the Ukrainians if the Tatars were to return, the leadership pragmatically decided in favor of the stronger group. Furthermore, since the Soviet democratic movement was weakened in the 1970s by repression and emigration, the voice of the Crimean Tatars lost influence worldwide. After twenty-five years of struggle, the movement of Crimean Tatars still has not scored any major success.

The 1970s saw a seemingly unlimited capacity of Soviet institutions to contain and harness ethnic nationalism and national movements. However, in the early 1980s some new phenomena

are discernible. The deterioration of the internal situation in the USSR began to have repercussions on the relations between the Soviet nations, mainly for two interdependent reasons: economic difficulties and the intensification of Russian nationalism.

Economic Difficulties and Ethnic Relations

A slow but steady increase in the standard of living continued until about the middle of the 1970s and was the main reason for the legitimacy which the Brezhnev leadership enjoyed in the eyes of large sectors of the population.[77] But in the past four or five years, a new situation has developed, both in the economic arena and in the population's mood. During the Twenty-fourth Congress of the CPSU, Brezhnev declared that for the first time in Soviet history, group "B" (the production of consumer goods and services) would be given priority over group "A" (the production of means of production). Yet even before the Twenty-fifth Congress, this policy was reversed under pressure from the heavy industry and military sectors. The ensuing slowdown in investments and productivity, above all in light industry, foodstuffs, and services, has meant a deteriorating standard of living. The inertia of Brezhnev's policy, centered on stabilization and maintenance of the status quo, and the gerontocratic character of the leadership lead the population to believe that the regime will be able neither to carry out the promised economic reforms nor to give the people new economic incentives to increase productivity. Even official Soviet literature today timidly admits that "in the phase of mature socialism," the rhythm of economic growth might "drop slightly."[78]

Another important reason for the deterioration in the standard of living is inflation. Table 11 indicates the relations between the supply of consumer goods and the money deposited in savings accounts, and it records the increased rate of inflation. Savings increased by approximately 15 billion rubles per year over the past several years. Such savings are defined as "deferred demand" by Soviet experts. In fact there is a ravenous appetite for goods, but products manufactured by light in-

Table 11 [79]

The Ratio of Commodity Stocks to the Population's Deposits in Savings Banks
(in billions of rubles)

Years	Commodity stocks	Total deposits	Ratio of total commodity stocks to deposits (in %)
1950	9.8	1.85	530
1960	24.5	10.9	224
1970	45.7	46.6	98
1973	52.2	68.7	76
1975	58.2	91.0	64
1977	61.0	116.6	52

dustry are often of such poor quality that the people do not buy them but put their money instead into savings, even though banks pay very low interest rates (from 2 to 3 percent per year). As Igor Birman has calculated, "the money accumulation of the population is now about 200 billion rubles, at a minimum." [80] This places a permanent strain on the entire system of consumer goods distribution, to the point that some form of rationing is necessary. During the 1970s crowds, alarmed by rumors of an imminent price increase or the devaluation of the ruble, frequently invaded stores in total panic, buying all the available goods, provoking the immediate exhaustion of stocks, the formation of interminable lines, and so on. In this situation the importance of various markets — legal, semilegal, and illegal — grows enormously, leading to a rapid increase in the price of food products and consumer goods.

The general deterioration in the economic situation has a direct effect on ethnic relations in the Soviet Union. Thus during the 1960s and 1970s, the central administration was constrained by the rapid growth of the Central Asian population to invest heavily in those republics to create new jobs, social services, and schools in order to avoid another increase in the already existing inequalities of per capita income between different regions of the country. Though politically justified, such investments are obviously of small productive value; under existing economic conditions it is unlikely that they can continue.

It is more likely that the leadership will direct investments toward those regions that guarantee maximum returns. It should not be forgotten that productivity per capita in Estonia, Latvia, and the RSFSR is more than three times higher than in the Central Asian republics.[81] At the same time, the government must adopt serious measures to increase migration from Central Asia and from Moldavia, where there is a surplus work force, toward the RSFSR to counterbalance extremely low birthrates. Several years ago no one criticized the arguments of some economists from the national republics who emphasized developing the periphery, limiting emigration by skilled workers, and gearing universities in the national republics toward local exigencies.[82] Today the same arguments are attacked insofar as they "artificially limit relations among peoples and hinder the policy of bringing together nationalities."[83]

Inflation and the increased importance of markets also influence relations between nationalities. As already mentioned, certain groups among the population of the national republics are the primary producers of meat, wool, vegetables, and even textiles (if we consider the development of these industries on the periphery and the relative weakness of state control over their activity). The Russian population views itself as ever more dependent on a market whose prices continually increase, and which is dominated by representatives of the southern republics. Russian workers who compare their incomes with those of Southern "trading people" — the marketplace being the principal place of contact — feel envy and irritation. What follows from this is a considerable embitterment in relations, at the interpersonal level, between Russians and other ethnic groups.[84]

The Growth of Russian Nationalism and the Politics of Brezhnev's Leadership

It is not surprising, therefore, that Russian chauvinism and nationalism have been substantially reinforced during the 1970s. As Teresa Rakowska-Harmstone has justifiably noted, "the

study of Russian nationalism has been largely neglected in the analysis of the Soviet ethnic scene, research being concentrated mainly on manifestations of nationalism among minorities."[85] The revival of Russian nationalism, documented by numerous observers,[86] makes such a position untenable. The discontent generated by diminished social mobility in the large cities, by the economic situation, by the scarcity of consumer goods — discontent which develops in a context of atomization of the working class and limited communication between workers and specialists — easily changes its object, turning toward an external object. Also contributing to it is the reaction to Soviet propaganda, which for years has exploited the theme of emphasizing the development of national republics and the necessity of sacrifices to render "fraternal help" to Czechoslovakia, Cuba, Vietnam, Egypt, Afghanistan, etc.

The reinforcement of Russian nationalism is also favored by the growth in the number of low-skilled workers who, after the abandonment of the 1960s reforms, have lost any incentive whatsoever to raise their level of education and qualification. Within this stratum the ideas and tempers of traditional nationalism, typical of other groups of the population, are readily transformed into the ideas of chauvinism, of the Russian nation's superiority, of the cult of Stalin and military victories — a cult which is maintained by propaganda from the military-industrial complex. As already indicated, Stalinist tendencies have also spread among highly skilled workers, in particular among those who work in "closed" enterprises favored by special statutes.

As for specialists, the growth of nationalism may be related to diminished social mobility and to an overproduction of specialists. Among the Russian specialists who are frustrated by this blocked mobility there might well be a need to displace frustration onto ethnic minorities, while using to their own advantage the passport registration of ethnic origin.[87] Moreover, one part of the Russian humanistic intelligentsia is sincerely preoccupied by the scarce attention paid in the country to the development of Russian national culture, and to obtain

more widespread support, they have formed something similar
to a nationalist lobby. The crisis of Soviet Marxism as a dom-
inant system of values also has led a sector of the Russian in-
telligentsia to seek a new system of values where Orthodox re-
ligion and so-called roots play a notable part.

As Isaiah Berlin has observed, nationalism — as distinct from
merely national consciousness — is often born as "the result
of wounded pride and a sense of humiliation in most socially
conscious members, which in due course produce anger and
self-assertion."[88] This social-psychological atmosphere is
today readily apparent in the Russian intelligentsia. Alexander
Yanov, in his analysis of the major theorists of present-day
Russian nationalism, aptly emphasizes their characteristic
sense of profound national mortification derived from the feel-
ing that in the USSR, "the Russians are disdained by all."[89]
Right-wing samizdat continually emphasizes that Russian na-
tionalism is a reaction to preferential treatment afforded to
ethnic minorities in Soviet society or to anti-Russian separatist
movements in the republics.[90] Besides being a mass psycho-
logical tendency of certain sectors of the working class and of
the new middle class, Russian nationalism also manifests it-
self and finds support in that neo-Stalinist wing of the leader-
ship which is closely tied to the military establishment and the
coercive apparatus. With this support one can understand how
the most nationalist wing of the Union of Writers took over
some important, mass-circulation periodicals, such as Ogonek,
Molodaia gvardiia, Nash sovremennik, etc., as well as such
popular publishing houses as Sovetskaia Rossiia, Moskovskii
rabochii, etc. The recollection of past military victories, from
those of Imperial Russia to those of Stalin during World War II,
is a major theme in this important branch of contemporary
Soviet art and literature.[91]

All this notwithstanding, Brezhnev's leadership follows a
politics of equilibrium between the various factions of the ap-
paratus. On the one hand, it does not permit the Russian na-
tionalist wing to get too far out of line: "right" dissidents are
persecuted with the same diligence as liberal-democratic

dissidents. [92] On the other hand, Brezhnev's leadership does not tolerate even the slightest open criticism in the press of Russian nationalism — it is as if the phenomenon did not exist. [93] More important, however, is the fact that the Brezhnev leadership opts for a non-nationalistic demographic policy. Proposals to introduce a differentiated demographic policy favoring a rising birthrate for Slavic and Baltic nationalities are now frequently seen in Soviet literature. [94] These proposals have obvious discriminatory or even racist overtones. The leadership still avoids implementing such measures. A 1981 decree [95] concerning state assistance to families with children remains basically nondiscriminatory, even if it goes into effect in the Kazakh, Caucasian, and Central Asian republics one or two years later than in the Russian republic.

Nevertheless, the revival and reinforcement of Russian nationalism are beginning to have a noticeable impact on national relations in the Soviet Union. Many measures enacted by the central administration to consolidate the existing system, and not to encourage Russian nationalism, have nevertheless begun to appear as concessions to this nationalism and have provoked considerable reactions not only on the part of the middle class in the national republics, but also on the part of some political elites preoccupied with their positions. In particular, this growing Russian nationalism enables the humanistic ethnic intelligentsia to mobilize so powerful a force as the fear for ethnic survival within groups that have always been in a minority in the country. [96] For the moment, Russian nationalism has not yet aroused true ethnic conflict, but the foundations for it are clearly being laid.

In light of what has been said, one might conclude that the Soviet regime has succeeded in controlling the difficult problems of ethnic relations in the USSR. There have been efforts to develop and modernize peripheral republics, satisfy the interests of the political elites and of the new middle classes of the ethnic minorities, engineer a migration of the Russian population to the national republics, and promote a gradual "voluntary-coercive" substitution — through bilingualism — of

Russian for local languages. These politicies have undoubtedly been successful. Having analyzed Soviet ethnic relations in the 1970s, Seweryn Bialer aptly concludes:

It is the process of the formation of such native elites, of the political and so-cial mobility that it represents, of the opportunity and satisfaction of indigenous cadres that it reflects, which forms the basis of the probably still strong com-mitment of these cadres to the existing system and a key element of the ex-planation for the stability of nationality relations in the past decade.[97]

There has been a growth of national consciousness among many ethnic groups. Even Soviet researchers do not deny this, explaining that authentic integration is dialectically associated with differentiation. But this growth in national consciousness is placed within the context of dominant institutions and ideology without the unity of the Soviet state itself being discussed. Ethnic groups, particularly those having their own governing institutions, strive to attain the most advantageous distribution of resources, something completely normal in a centrally planned system in which territorial entities are planning units. True nationalism and separatism are supported by some groups of the new middle class, but a considerable segment of the non-Russian specialists accepts the Soviet system and supports it. Nationalist ideology has little support among workers, for whom the vision of national independence is far less romantic than for the intelligentsia.

Until now ethnic conflicts have played an insignificant role in the evolution of Soviet society. Under certain circumstances, however, the situation could change. This will depend far less on the development of national relations themselves than on the policies of Brezhnev's successors. The problem of prospects for the future of the neo-Stalinist state will be discussed in the concluding chapter.

6

CLOSED CITIES AND
THE ORGANIZED CONSENSUS

Simple biological laws guarantee that in the near future we will
witness the departure of Brezhnev and his particular leader-
ship — this "generation of 1906," as it has been called by a
Soviet demographer.[1] In the history of Soviet society, essen-
tial policy changes have always occurred after, and were a di-
rect consequence of, leadership successions.[2] Thus the course
of the Soviet Union's future development will largely depend on
the politics of Brezhnev's successors. However, the options
open to the new Soviet leadership will be, to a great extent,
contingent on the present state of society, as well as on its
open and latent conflicts. Thus it is crucial to address the
problems and contradictions which have evolved in Soviet so-
cial structure[3] as a result of the Soviet leadership's policy of
organized consensus.

The most important and lasting effect of the Khrushchev pe-
riod was de-Stalinization, which mainly implied the abandon-
ment of the policy of physical terror as a governing principle.
On the other hand, the Khrushchev government's attempt to
reform the economic system proved unsuccessful. Several
years of experimentation with territorial economic manage-

ment (regional economic councils) demonstrated the unfeasibility of major economic reform without a concomitant change in the structure of political power. Albeit in an inconsistent and chaotic manner, Khrushchev attempted to reform the regime's political structure — in particular, to divide the monolithic party apparatus into two bodies, supervising industry or agriculture, and to introduce the principle of periodic rotation of the ruling cadres. The party apparatus's reaction resulted in Khrushchev's swift ouster.[4]

The Brezhnev-Kosygin tandem that replaced Khrushchev immediately revoked all of his half-baked economic and political reforms in favor of a new reorganization of the country's economy. As previously shown, considerable political reform was necessary to bring about these seemingly purely economic measures countrywide. Brezhnev's leadership opted for the preservation of the status quo. An external crisis — Czechoslovakia — undoubtedly contributed to the decision to abandon economic reform in favor of reinforcing the party's monopoly on political power. Even without the additional impetus provided by the Czech crisis, it seems likely that the Soviet leadership would have come to similar solutions, since social groups do not tend to relinquish power and privileges without being compelled to do so.

Thus for the past two decades Soviet society has remained essentially the political-economic system first created under Stalin, with the one important modification that the use of terror has diminished and changed in character. The Brezhnev period can be seen as an endeavor to rationalize Stalin's political-economic system while preserving its essential nature. Correspondingly, Brezhnev's leadership has pursued two major strategic goals. Its first objective was to achieve military parity with, or better, superiority over, the United States. The present structure of political power in Soviet society was created to bring about forced industrialization — its overwhelming priority being the development of heavy industry. Today heavy industry, and especially those sectors directly connected with the war and space industries, which strive to maintain their

privileged position in the Soviet economy, form the very founda-
tion of the Soviet political system. In addition, the constant
threat of foreign intervention, which characterized the Soviet
regime from its inception to the end of World War II, helped to
justify the absolute centralization of political power in the eyes
of the population. Now the Brezhnev leadership continues to
enjoy "the legitimacy the Soviet regime actually earned for it-
self by organizing the country to repel the Nazis."[5] To a
great extent the preservation of the current structure of politi-
cal power depends on the continuing credibility of the idea of
an impending foreign invasion — American or, even better,
Chinese with American support.[6] Under such conditions the
priority assigned to heavy industry justifies and is justified by
the centrality of the military industry in the Soviet economy.[7]
Attempting to tilt the world balance of military power in its
favor is a logical extension, as well as a reinforcement, of the
symbiosis of the party-state administrative apparatus and the
military-industrial complex. At the same time, militarization
permits the full exploitation of all the reserves of legitimacy
that stem from the war experience.

The slow but steady rise in the population's standard of liv-
ing, especially of the key groups essential to internal stability,
became the second strategic goal of Brezhnev's regime. Forced
labor had already proved its inefficiency, while the reserves of
revolutionary enthusiasm connected with the building of a new
society had also been exhausted. Having abolished mass terror,
the regime had to achieve a new social compromise with the
populace and to provide new stimuli for labor. That compro-
mise would permit the transformation of the "futuristic" nature
of Soviet legitimation, when the rulers "justify their rule and
demand obedience in the name of an ideal society they are set
on building,"[8] into a legitimation based on popular consensus
and acceptance of, or at least indifference to, the rulers' chosen
course.

Until a few years ago Brezhnev's regime had proved success-
ful in achieving these goals. The Soviet political-economic sys-
tem had demonstrated its definite developmental potential. The

regime's legitimation was successfully displaced from building
an ideal society to achieving the "Soviet way of life" as a real-
ized ideal. According to Seweryn Bialer, the centralization of
the Soviet administration apparatus presently "is, if anything,
greater than at the beginning of the Brezhnev era." Bialer also
points out that "the overwhelming feature of the Brezhnev era
is the sociopolitical stability of the country."[9]

The Soviet population, and the working class in particular,
effectively barred from participating in decisions regarding
production management and investment, accepts the existing
distribution of power on certain important conditions: (1) that
the low prices for basic foodstuffs (bread, meat, vegetables,
milk and milk products, sugar, and so on) and the nominal pay-
ments for rent, utilities, and major services remain stable;
(2) that the availability of work remains guaranteed; and (3) that
people are free to seek individual ways to improve their living
standards.

These three main conditions of the "historic compromise"
between Brezhnev's political regime and the populace were,
of course, never set out in writing and countersigned by the
parties concerned, as was the agreement between the Polish
government and the "Solidarity" federation. They are, rather,
a direct consequence of the way in which Soviet society functions
as a new socioeconomic formation. In a Soviet-type system
the stability of prices of essential goods and services becomes
one of the main pillars of its legitimacy and, in addition, pro-
vides a convincing argument in favor of the new system when
compared to capitalist society. Conversely, the regime's in-
ability to abide by this condition leads to serious social prob-
lems, such as the workers' unrest following the rise in prices
under Khrushchev in 1962 or the unending Polish crisis, where
the population reacts to each price increase by compelling the
regime to choose between rescinding the price increases or
dismantling the present power structure.

The way in which Soviet postcapitalist society functions also
guarantees a stable demand for labor. As is well known, the
Soviet economy is not profit-oriented, and production is largely

unaffected by the free play of market forces. Whatever ideas regarding the utilization of social surplus Soviet central planners may have, the principal method of disposing of the social surplus remains its reinvestment in various sectors of the state economy, with the corresponding creation of new enterprises and jobs. Moreover, Soviet economic relations produce chronic overinvestments, which may result in production becoming increasingly an end in itself. What these new enterprises produce may have little or nothing to do with the population's well-being: they may produce machines that produce other machines to produce still other machines. What matters is the fact that the present Soviet economy is oriented toward creating new jobs. Indeed, the number of jobs increases faster than the employable population. Calculations by central planners indicate that in order to fulfill the plans presented by the very same planners, the Soviet economy requires more than a million new workers annually.[10]

This situation constitutes the basis of the third condition of the compromise: the population accepts its estrangement from the decision-making process and relinquishes full control over economic development to the political apparatus if, in exchange, the authorities refrain from suppressing the semifree market for labor.

The strength of the Soviet working class is not based on conscious collective action in defense of its interests; in the USSR strikes are very rare and can be crushed with extreme brutality, as happened at Novocherkassk in 1962.[11] The coercive apparatus is powerful enough to suppress any seditious attempt at organizing a mass strike. In this respect the Soviet working class is completely atomized. In explaining the use of brute force against strikers, the authorities habitually employ the following sophism: political power is wielded by the working class, consequently neither a random group of workers nor their trade union may do battle against authority, for that would be equivalent to struggling against oneself. Pravda's response to the 1980 Polish events is typical: "In a socialist society strikes basically indicate either the inability of the workers to

fully exercise their rights or a certain lack of patience on the part of some segments of the working class, the desire of some to sue for special privileges while interfering with the gradual improvement of the standard of living for all."[12] Soviet authorities can thus prevent the populace from employing collective action. But they have proved unable to enforce Stalin's decree of 1940, which prohibited changing one's job at will, thus freezing workers at the positions they occupied when the decree was issued. The abundance of jobs, coupled with manpower scarcity and the reintroduction of the worker's right to quit by his own volition, immediately resulted in the emergence of a semifree labor market. Its existence for the past twenty-five years has significantly affected the country's internal situation. Powerless to prevent this development, the authorities have instead striven to maintain control over the labor market. Their unrelenting efforts to contract and segment the labor market have resulted in different contractual powers of different territorial groups, in the appearance of new strata within the working class, and so forth. This does not invalidate the fact that in the past two decades, Soviet citizens have had at their disposal various means of improving their social status and economic conditions.

When various groups of people pursue a similar course of action, spontaneous social movements are often formed. Political power at first attempts to suppress these outcomes but eventually ends up tolerating them. Even in the Stalin era, consent was only partially wrung from the population by the coercive apparatus: to a considerable extent it was voluntarily granted by members of some key social groups in exchange for actual or future benefits. This holds even truer for the Brezhnev period as well and is, indeed, its distinctive feature. Soviet society is far from being a lump of clay that yields to any pressure from above; its internal policy does not merely depend on the whims of the party leadership. Brezhnev's period is especially characterized by a continuous dialectical interplay of state and society, which is not limited solely to governmental initiatives and the population's mechanical reaction but also

incorporates mass popular actions that occasionally compel the state to yield. The organized consensus represents a certain equilibrium between the population and the administrative apparatus, such that the latter succeeds in preserving the present political-economical structure by maintaining a delicate balance of give-and-take. It does this in various ways, first of all by creating new opportunities for upward social mobility.

Soviet Upward Social Mobility

Soviet-type industrial societies create patterns of stratification in many respects different from those in the West.[13] Social activities enabling Soviet citizens to raise their status in the social structure, to improve their material standard of living, to satisfy their rising aspirations, to realize their creativity, and to give vent to their social energies differ in various ways. They can be enumerated as follows:[14]

1) a career within an organization;
2) voluntary labor turnover;
3) migratory activity;
4) graduation from an institution of higher education;
5) membership in the party;
6) participation in the "second economy" and various markets;
7) officially sanctioned political participation and "public activity";
8) marriage leading to upward mobility;
9) collaboration with the secret police.

This list, of course, is by no means exhaustive. Obviously, the use of one of these channels does not preclude the use of others. A person may be simultaneously involved in several types of activity or may sequentially employ alternative channels at various stages of his life. Various activities can be combined to reinforce the resulting mobility. For example, membership in the party may facilitate promotion within an organization. A convenient marriage may serve the same end in one case or

may furnish a means for geographical mobility in another.[15]

The authorities manipulate the accessibility of various types of activity by limiting or suppressing some actions while encouraging others. The long-term consequences of this complex interplay of official control and regulation with the quasi-social movements composed of those seeking economic or political advancement may even clash with the goals consciously pursued by the party-state apparatus. In particular, stability and governability obtained as a result of some planned governmental actions may be temporary and even lead to destabilization.

An analysis of the organized consensus, therefore, presupposes an investigation both of the effectiveness of the regime's massive efforts to maintain stability while avoiding serious transformations and of those destabilizing tendencies that have begun to appear in the Soviet system as a result of its leadership's deliberate inactivity and inertia.

Some routes of upward mobility have been studied extensively, while the role of others remains unclear. The following discussion will focus on new developments in internal migration and on the system of higher education during the Brezhnev period, since internal migration and the organization of higher education perform a major role within the system of organized consensus.

Soviet Internal Migration

Internal migration was relatively easy immediately after the revolution, when it was mainly a function of economic and political factors. The system of internal passports, introduced in 1932, however, began to regulate internal migration. Two main periods of regulated migration are discernible. The first lasted approximately until the end of the fifties and corresponds roughly to Stalin's reign. This period was characterized by rapid urbanization and mass migration from the countryside to the city. Numerous migratory groups, mostly rural dwellers, headed toward the large cities and the developing industrial

centers. The major result of this migration was an explosion in upward social mobility, which affected a significant portion of the population. Thus rapid urbanization and migration to cities played a major role in legitimizing the Soviet regime. This led to considerable popular support for it. Altogether, between the years 1926 and 1970 the urban population increased by 133 million, with 60 percent of the increase the result of migration from the countryside; however, the past decade has witnessed a decline in rural migration and a decrease in its importance as a source of urban population.

That rapid urbanization was of paramount importance to the legitimization of the regime is well documented. For example, Walter Connor has justly noted that "insofar as socialism appealed to and raised expectations, it was fortunate in being able to meet many of them through the mobility processes it fostered."[16] Stanislav Ossowski, on the other hand, has suggested that there is no simple causal relationship between social revolution and this increase in social mobility: "It is the 'social-economic expansion' and not the revolutionary introduction of a socialist order which can be considered a necessary condition of this increase."[17] Notwithstanding its possible validity, this viewpoint is irrelevant when one considers the Soviet people's actual political culture. In the people's eyes mass upward social mobility is inextricably tied to the Soviet regime which, through its economic policies, brought it about.[18]

The second period of regulated internal migration covers the 1960s and 1970s and is characterized by a marked increase in complexity. This migration can no longer be understood as simple urbanization. Internal migration during the Brezhnev period differs significantly from the previous period in two main respects. First, despite the continuation of rural-to-urban migration, intracity migration came to predominate by the end of the sixties.[19] Second, the very mechanism of regulating and controlling internal migration underwent noticeable change, as did the character of the migrants. Vladimir Tomin has remarked that "the migrating segment of the population between 1920 and 1940 was, on the average, less educated than

the population as a whole and was markedly different from that
of the sixties and seventies in its social, professional, and es-
pecially in its educational aspects."[20]

Territorial stratification in the Soviet Union

As John Logan has pointed out, "the notion of stratification
of places can usefully supplement the more traditional dimen-
sions of class and status."[21] The stratification of places "im-
plies sets of advantages and disadvantages for persons who are
tied to each place and thus affects the chances for individual up-
ward or downward mobility."[22] Soviet society is the most ob-
vious example of such territorial stratification established by
political authority through administrative means. The admin-
istratively organized hierarchy of locations includes three types
of territorial communities: the village, the open city, and the
closed city.

1) It is well known that village life, especially as a collec-
tive farm member, is the lowest form of social life in the USSR.
Sociological studies indicate that slightly over 5 percent of
peasants surveyed want their children to pursue careers in oc-
cupations connected with the collective farm and to remain in
the countryside.[23] A significant number of young people man-
age, through various channels, to escape from the collective
farm to the city: "Dissatisfaction with country life is one of
the main reasons that the flow of migrants from the country to
the city greatly outpaces the economically justified outflow of
the agricultural work force."[24]

2) Defining cities as "command posts in the territorial or-
ganization of society"[25] is especially valid in the USSR, where
the political and economic role of the center with respect to the
periphery is further enhanced by the supercentralized system
of political power. Thus in the Soviet Union "there evolved a
distinct hierarchy of cities as centers of control," such that
the hierarchical level of a city is mainly determined by "its
role in supervising surrounding territories."[26] Small and
medium-sized towns, usually administrative centers of agri-

cultural regions, occupy the lowest rung in the hierarchy. For a young peasant successful migration to such a town implies an upward mobility that changes his life. On the other hand, permanent dwellers in such towns have different standards of comparison and justifiably feel that their living standard is depressed. Such towns often provide limited employment opportunities. Correspondingly, possibilities for social mobility and for achieving a desired way of life are greatly diminished. In such towns, according to Vasil'eva's data, up to two-thirds of the workers do not improve their social and occupational status (i.e., remain unskilled or semiskilled workers) from the beginning of their working lives until the age of thirty.[27]

3) The so-called "closed cities" occupy the uppermost position in the system of stratification of locations. In Soviet parlance a closed city is one where the authorities use the passport system and the issuance of <u>propiska</u> (a permit for permanent residence in the city) to pursue a consistent policy of selecting immigrants and limiting population growth.[28] As previously mentioned, the closed cities include all capitals of Soviet national republics, almost all cities with a population in excess of 500,000, and several smaller towns and regions which, for various reasons, are especially attractive for migration. A sufficiently accurate approximation of the number of people residing in closed cities can be obtained by assuming that all of the largest cities are closed. Thus, according to the 1979 census, the population of closed cities numbers 51.8 million people — 31.7 percent of the country's urban population and 19.7 percent of the population as a whole.[29] Soviet research indicates that the "closed city" policy, applied in the sixties and seventies, reduced the intensity of the influx of migrants into these specially designated areas and limited it to 32-33 percent of the country's total migration.[30]

Closed cities "experience a considerable migrational pressure,"[31] the reasons for which are obvious. A Soviet closed city is a social-territorial unity that provides optimal opportunities for individuals to undertake various activities in order to satisfy their needs. Permanent residents of such cities bene-

fit from greater freedom of behavior and a wider choice of pos-
sible activities. In other words, a closed city signifies greater
opportunity for education, raising one's qualifications, exchange
of workplace, and most importantly, consumption. Soviet so-
ciologists openly admit the tremendous gap in living standards
between residents of large and small towns in the Soviet Union.[32]
Soviet closed cities are in a privileged position with respect to
supply of provisions and other goods, investment in and rates
of dwelling construction, and development of social services.
Consequently, closed cities "are at an advantage when compared
to other places according to a whole array of indicators re-
flecting the standard of living and the way of life of their
inhabitants."[33]

The demographic situation of closed cities is determined by
several factors. First, closed cities are characterized by a
low birthrate and widely practiced birth control. Available data
for Moscow and Leningrad reflect the general situation, even
if in an exaggerated form. For example, in 1978 population
growth in Moscow was lower than the country's average by a
factor of 6; the corresponding figure for Leningrad was 3.2.[34]
Second, the population of closed cities is aging — the number
of persons of advanced age is rapidly increasing. Third, closed
cities experience a constant scarcity of manpower, which must
be imported from other regions. For example, in 1973, 81 per-
cent of Moscow's population growth and 67 percent of Lenin-
grad's were the result of in-migration.[35]

Migration under Brezhnev

Until the advent of the sixties, Soviet industrialization and
urbanization took place under conditions that made any consis-
tent policy of selecting migrants heading for large cities im-
practicable. At best, the number of migrants could be regu-
lated, while the composition of the migrant flow, especially
with respect to its social-territorial origin, was largely a re-
sult of the migrants' individual preferences. From the author-
ities' viewpoint internal migration was largely spontaneous.

The housing conditions in large cities were then so miserable that mainly collective farmers from villages affected by famine were willing to move there. The Soviet regime was forced to endure this type of migration, which soon revealed its negative aspects.

As is generally the case, the migration of peasants to the city led to a radical alteration in the methods of social control. For the local urban authorities the most obvious consequence of in-migration was a considerable increase in social problems in districts populated by migrants. These districts typically exhibited a higher incidence of alcoholism, criminal activity, and psychiatric afflictions.[36] On the other hand, the assumption that the in-migration of rural dwellers would result in a higher birthrate proved fallacious. Difficulties of adaptation and inadequate dwellings quickly compelled rural migrants to change their initially positive attitudes toward a large family. As a result, the recent migrants' fertility was comparable to that of urban dwellers.[37] Also, the in-migration of rural dwellers not only caused an increase in the rate of deviance in closed cities but also hindered the social mobility of people from small and medium-sized towns. The resources of small towns were inadequate to guarantee upward social mobility to their inhabitants, while "vacancies" in large cities were being taken over by peasant migrants.

In the Brezhnev period a significant "optimization" of internal migration has taken place.

Territorial stratification is directly related to the following three migratory flows moving: (1) from the open town to the closed city, (2) from the countryside to the open town, and (3) from the countryside to the closed city. "Certain measures regulating access to cities"[38] have a great effect on closed cities, insofar as these measures permit strict control over the quantitative and qualitative composition of the migrant flow. The administrations of closed cities employ the following means to regulate the inflow of migrants: (1) control over the arrival of migrants entering various educational institutions; (2) placement of vocational school, tekhnikum, and university graduates;

(3) relegation of incoming migrants to certain jobs and certain industries; (4) secret and continuously revised instructions fixing the ratio of permanent residence permits (propiska) to those issued on a temporary basis; and (5) secret regulations specifically prohibiting (or permitting) issuance of propiska or acceptance to a university in a particular closed city of migrants from certain regions of the country. As a result, notes Evelina Vasil'eva, "there exists, in fact, a practice of 'reserving' jobs and university vacancies for migrants, which leads to a manifest process of selection of migrants endowed with certain personal characteristics."[39] These characteristics include the educational and occupational level of the migrant, his initiative, and his social, ethnic, and territorial origins.

Using all these means and mechanisms, the Brezhnev administration has succeeded in sharply reducing migration from the countryside to the closed cities and in redirecting it to open towns. Eduard Klopov, a Soviet sociologist, summarizes the effect of migration control in the Brezhnev period thus: "One of the most important aspects of the current working cadres' migration is its 'gradational' (two-step) character, where a significant segment of rural migrants move to small and medium-sized towns, while young people from these towns move to the large and largest cities."[40] Governmental manipulation of migration has far-reaching political and economic consequences.

Commuting to closed cities

As a result of the policy of territorial stratification, each closed city becomes an enormous agglomeration, where the difficulty of obtaining a permanent residence permit increases as one approaches the center. "Since moving into the city proper (i.e., gaining propiska) is always very difficult, great masses of workers gravitate to the suburbs," writes the well-known demographer Viktor Perevedentsev.[41] This invariably leads to massive commuting. Some of the commuters succeed in renting a room or in obtaining a berth in a hostel, and they start living in the closed city on a semilegal basis. The 1970

census thus revealed the existence in Moscow of several hundred thousand "extra" inhabitants, not registered by the appropriate administrative bodies: "they are people legally residing on the outskirts of the Moscow region [oblast'] who nonetheless live in Moscow."[42] In turn, the Moscow region was found to contain more people than officially registered, i.e., people registered in neighboring regions but who work in the Moscow region.

This discrepancy between census data and the official number of propiskas illuminates one of the widespread types of migration from a small town to a closed city. People begin commuting, having found a job in the closed city, usually at an enterprise in dire need of manpower.[43] Eventually the name of the commuter will find its way onto the list of valuable workers to be rewarded with an apartment. Thus he will receive a propiska and realize his dream — to settle permanently in a closed city. The waiting period may be quite long — up to fifteen years. Once the process is complete, though, the living space previously occupied by the commuter will become vacant and will in all probability be passed on to a worker living even further away from the center but working in the area. This new inhabitant of an advantaged region may either continue working at the same enterprise or begin commuting to the closed city. But the chance that this migrant will end up in the closed city proper is very slim. That will be the hope of his offspring. Thus a peculiar migratory chain is initiated.

Migration from open cities has become the leading contributor to population increase in closed cities during the Brezhnev period. Yet, although it has been relegated to a secondary role, countryside-closed city migration remains worth discussing.

Migration to closed cities: limitchiks

The regulation of Soviet internal migration also has given birth to a new and distinct social group in closed cities — the limitchiks. Any analysis of Soviet society and the Soviet work-

ing class which ignored the limitchiks would be as incomplete
as an analysis of the German working class which failed to con-
sider the role of the Gastarbeiter. Territorial stratification
and the functioning of the passport system are instrumental in
creating a situation in which some sectors of the economy func-
tion like "social sluices," as Klopov put it, accepting peasant
youth into the working class.[44] These sectors are, first and
foremost, the construction industry, then the chemical indus-
try, metallurgy, the textile, and several other industries, es-
pecially for certain occupations in which work is particularly
hard and tedious.[45] That group of rural migrants who continue
to enter large cities owes its existence not only to the general
scarcity of manpower but also to the presence of certain low-
status jobs which the urban population refuses to perform.

Limitchiks originate from the following practice. Under con-
ditions of constant manpower scarcity,[46] the manager of an
enterprise approaches the party organs responsible for the
registration of inhabitants in a closed city and asks permission
to import a certain number of workers. Often the request is
accompanied by threats that production plans may be disrupted
unless permission is granted. Once the request is granted, the
enterprise is empowered to import a certain number of work-
ers, up to a given limit. Such workers are consequently called
limitchiks[47] — a word with derogatory connotation in colloquial
Russian.

Most limitchiks are rural migrants from the collective farm
who will accept work on the conditions offered. The imported
workers are usually young and single. They are issued a tem-
porary propiska, which may be renewed if the administration
of the enterprise so desires. As they are completely at the
mercy of the plant's administration, limitchiks work conscien-
tiously and diligently, surpassing quotas and production plans.[48]
Their relations with cadre workers are rather strained. The
latter tend to regard limitchiks as scabs or rate-busters be-
cause limitchiks are often used by the plant management to
raise production norms. For their part, limitchiks see cadre
workers as exploiters or privileged people who care only about

themselves and use to full advantage the privileges of their permanent residence in a closed city.

Perevedentsev has described limitchiks as follows:

Limitchiks live in enterprise residences; they have no right to exchange jobs, to sign up for a new apartment (because they lack a permanent propiska), to buy on credit, and so on. Of course, these people find their administrative status untenable. They search for a way out, the most obvious being marriage. The permanent dwellers of the city know well, however, that for some limitchiks marriage is but a means to achieve the status of a permanent resident, and thus they are reluctant to marry them. Only marriage within the group remains. He lives in one hostel; she in another. Family? Hardly a normal one.[49]

Perevedentsev also refers to an unpublished study of Moscow limitchiks. According to that study only 22 percent of those who have been living in Moscow for over five years were married, the figure for a comparable group of permanent Moscow residents being about 80 percent.

Determining the number of limitchiks in closed cities is difficult. Several types of Soviet statistics can be used, namely, figures for migration to the largest cities, number of workers in certain occupations, data from some sociological research,[50] and some other, circumstantial data. It may be significant, for example, that an annually reviewed decree of the Soviet Council of Ministers reserves 10 percent of newly built apartments in some closed cities for construction workers, overwhelmingly limitchiks.[51] Nevertheless, the most dependable method is, in all probability, an expert estimate.[52]

Criticism of the closed cities system

Soviet experts have consistently criticized the closed cities system from both an economic and a demographic viewpoint.[53] They cite incontrovertible data proving "the current organization of commuting counterproductive,"[54] for it markedly reduces labor efficiency, depresses the workers' social activity, and results in an increased incidence of work-related injuries. The closed cities system ultimately aggravates the tendency

of such cities to have an increasingly older population: senior citizens refuse to leave large cities for fear of losing their propiska. Analogously, Soviet specialists always gravitate to large cities, with the ensuing waste of education and immense losses for society. The system is also a colossal strain on migrants. Many side effects manifest themselves in migrant families: a falling birthrate, an increasing divorce rate, and even diminished performance of migrants' children in school when compared to other children. In such closed cities as Moscow, a "somewhat increased mortality of men in the employable age bracket"[55] can be observed. Some specialists hypothesize that this fact is connected with the operation of the passport system, which creates harsh physical and psychological conditions for commuters, limitchiks, and the like.

The present system of regulating in-migration to large cities is "not simply counterproductive but also wrong," writes Perevedentsev. He recounts his argument with a high official of Gosplan (the state planning agency). The demographer suggests the abolition of the closed city system or, at least, an experiment: "Select a typical closed city, reclassify it, and see what happens."[56] The administrator, for his part, fails to appreciate the demographer's arguments and flatly rejects the experiment. The opponents obviously have contrasting aims: one seeks to alter the status quo, while the other seeks to maintain it. Perevedentsev convincingly depicts society's losses resulting from the closed city system, but he ignores its advantages for the existing political power structure. The functioning of the higher education system, which is directly related to the system of closed cities, illuminates the logic behind the Soviet policy of territorial stratification.

The Overproduction of Specialists

Unarrested growth of specialists is one of the most characteristic features of the Brezhnev period. This is especially true with respect to engineers, who form "not only the largest group

of those engaged in intellectual labor but also the broadest
socio-occupational category, insofar as they are employed in
almost all areas of the economy."[57] The Soviet Union lagged
behind the United States in graduating diploma specialists until
the midfifties but began to pull ahead in the sixties. By 1974
the number of engineers graduating in the USSR was six times
greater than that in the United States.[58]

The overproduction of specialists in the USSR became appar-
ent in the early seventies, and since then proposals to curtail
admission to institutions of higher education and to expand
training programs for skilled workers have continuously ap-
peared in the Soviet press. Between 1976 and 1979 vocational
schools, which train skilled workers, had a combined enroll-
ment of 9.8 million, exactly equal to the total enrollment of
universities and tekhnikums, which produce specialists.[59] As
a leading industrial manager emphasizes: "Such a ratio of
specialists to working cadres corresponds neither to the actual
present requirements of the economy nor to those in the fore-
seeable future."[60] Nonetheless, the Soviet leadership and cen-
tral planning agencies refrain for various reasons from rem-
edying the situation.

First, there is a considerable inertia in the higher education
system which, striving for self-perpetuation and growth, has
a vested interest in the expansion of the student population.
Another factor at work is the tendency of Soviet enterprises
to consistently inflate their resource requirements, including
manpower. These enterprises accordingly exaggerate their
requests for new specialists and will not admit responsibility
if universities turn out superfluous specialists several years
hence. Furthermore, under the existing wage system techni-
cians' pay is very low; and in order to prevent loss of man-
power, enterprises are compelled to employ engineers in lieu
of technicians, which leads to the proliferation of statuses and
to a devaluation of the status of engineers. As a result, in the
contemporary Soviet economy the ratio of diploma specialists
to technicians is 1 : 1.3, while optimally such a ratio should be
1 : 4.0.[61]

These reasons alone would not prevent the Soviet leadership
from devising appropriate measures to correct the existing
overproduction of specialists. However, two other, fundamental
factors intervene. First of all, one must consider the effect of
closed cities on the territorial distribution of specialists. Here,
as a Soviet economist has observed, a "paradoxical situation"
develops: on the one hand, the number of graduating special-
ists, and especially of engineers, grows continuously; on the
other hand, such leading sectors of the economy as metallurgy,
mining, construction, transportation, and agriculture experience
a sizable shortfall of specialists.[62] What all these industries
have in common is the fact that their enterprises are frequently
located outside the closed cities, while the situation existing in
the country prompts specialists to "gravitate" to the closed
cities.

The current system of placement of specialists operates in
this context. Upon graduation a specialist is required to work
at a location selected by the government for a period of three
years. Thereafter he is granted the right to change work, and
the overwhelming majority of specialists return to the closed
cities once the opportunity arises.[63] The closed city system
must be dismantled before the overproduction of specialists
can be significantly reduced. But this would create an immense
migration that could be avoided only through a radical change
in investment priorities. Such a change would, in turn, threaten
the status quo, which is exactly what the Brezhnev leadership
is trying to avoid.

The same concerns with internal stability account for the
second essential reason for Soviet university policy. "The
need for higher education is very strong among today's youth,"
writes Mikhail Sonin, "and society is obligated to satisfy that
need."[64] Similarly, Nariman Aitov postulates that the cur-
rently high level of education of the Soviet population "is due
to social rather than economic reasons."[65] In actual fact, an
overwhelming majority of high school graduates in closed cities
seek higher education. Sarukhanov's data indicate that in 1978,
85 percent of Moscow's high school graduates wanted to enter

a university, and the situation in other closed cities is simi-
lar.[66] Maintaining or even increasing the availability of uni-
versity education contributes to preventing the downward so-
cial mobility of the Soviet specialist class and also guarantees
access to higher education to capable youth of other social
strata.[67]

The economic consequences of the continuing expansion of
the specialist class, as promoted by the Soviet authorities, can
only be described as disastrous. On the one hand, overproduc-
tion of specialists leads to a colossal expansion of bureaucratic
personnel and of unproductive strata, especially in closed cities.
On the other hand, it significantly decreases the productivity
of specialists. According to calculations by Soviet researchers,
in 1966 the productivity of engineering labor in the United States
exceeded that in the Soviet Union by a factor of 3.6.[68] Since
then the gap has increased. The data in Table 12 demonstrate
both the impending economic stagnation and the general rigidity
of the Soviet economic system during the Brezhnev period.

Their contradictory nature notwithstanding, the political con-
sequences of the higher education policy are generally favor-
able with respect to the main aim of Brezhnev's leadership,
that of maintaining internal stability while totally restricting
political power to the party apparatus. Overproduction of spe-
cialists sharply increases the competition for vacancies, pri-
marily in closed cities. This situation may be conducive to de-
stabilizing tendencies. As already noted, increasing competi-
tion for specialist vacancies contributes to tensions in ethnic

Table 12[69]

Declining Productivity of Scientists and Engineers

	1965	1978
Number of innovations per scientist	6.1	3.9
— per engineer	2.5	1.1
Number of items of new technology per		
10,000 scientists	7.0	2.8
— per 10,000 engineers	2.8	0.8

relations and, in particular, provokes the growth of Russian
nationalist feeling. In fact, the increasingly anti-Semitic new
middle class became one of the major reasons for the current
Jewish emigration from the USSR.[70] However, in spite of spe-
cialist overproduction, the Soviet regime has thus far success-
fully avoided intellectual unemployment. In this manner the
precarious position of specialists given their objective over-
production leads to an increase in administrative control over
the middle class and in turn enhances the loyalty of the middle
class to the regime. In addition, the overproduction of special-
ists supports tendencies which favor an administrative redistri-
bution of the social surplus. It also promotes the growth of
those social groups in which members have a vested interest
in centralized planning and, to use Konrad and Szelenyi's term,
in an economy of "rational redistribution" that maximizes the
size of the surplus product available for redistributive deci-
sions.[71] As long as the Soviet system manages to guarantee
suitable work for specialists and simultaneously ensures better
living conditions in closed cities, it will continue to enjoy the
support of the specialist class.

This situation may radically alter should the Soviet economy
fail to provide a sufficient number of positions and if the living
standard of the specialist class should begin to fall. Under
such circumstances a significant portion of the specialist class
would find itself among those demanding economic and political
reforms of the democratic or, more likely, the technocratic
variety. This would be especially true since the position of the
new middle class in the social structure and the nature of its
work predispose it to be concerned with the technical effective-
ness of its means and to support a relaxation of political con-
trol over its activity.[72]

The Organization of Consensus under Brezhnev

The predicament of limitchiks and closed enterprises workers,
the system of territorial stratification, and higher education

policies exemplify the predominant political strategy during the
Brezhnev period. The Soviet leadership no longer seeks social
transformation but strives to preserve the status quo. Having
ruled out the possibility of forming independent organizations
for collective economic-political actions or for group interest
representation, the regime has had to permit individual citi-
zens' initiatives for economic betterment and other forms of
social mobility. The range of possibilities along these lines
has considerably expanded during the Brezhnev period, although
chaotic individual efforts have been streamlined and directed.
The regime has succeeded in achieving a popular consensus
by improving the living standards of those social groups re-
garded as strategic in maintaining internal stability and by
skillfully stimulating, controlling, and manipulating social
mobility.

Walter Connor shows how the role of upward mobility is of
paramount importance in Soviet-type systems: "The prospects
for socio-occupational mobility in the future are still important,
all the more so since the historical experience of an earlier
expansion of mobility opportunities, and socialist rhetoric, have
generated a greater and broader orientation toward mobility
than has ever before existed in socialist states."[73] Undoubtedly,
some types of social mobility, such as the vydvizhenchestvo of
the 1930s, when millions of workers and peasants were pro-
moted to nonmanual positions, are, by their very nature, tem-
porary. Today the expansion of the more desirable nonmanual
sector can afford only quite limited opportunities for upward
mobility among the working class. Nonetheless, social mobility
remains a major factor in Soviet society. The regime seg-
ments society by erecting a veritable network of administrative
barriers between social, ethnic, and territorial groups. Today
the coercive apparatus operates unopposed: at least three So-
viet generations have been brought up thinking that organized
resistance to the authorities is completely out of the question.
Accordingly, the tasks of the coercive apparatus are limited
to fueling the "inertia of fear" and extending the deliberate
segmentation of society.[74]

To a large extent, inequality of opportunities in Soviet society is regulated by political authority. John Goldthorpe has astutely pointed out that "to a significant degree stratification is <u>organized</u> in order to suit the political needs of the regime."[75] Both privileged regions and clusters of privileged positions are maintained within the country: closed enterprises, closed cities, ethnic groups within certain territorial limits, etc. Moreover, by controlling both the rigidity and the penetrability of administrative barriers between groups, the party-state apparatus creates and enforces rules governing the transfer from one social or territorial category to another, up to and including the average amount of time required for a change in social status. By combining bureaucratic permits and restrictions and by calculatingly shifting rewards from one group to another, the regime generates new opportunities and channels for upward social mobility.

Hierarchical differentiation has become crucial in maintaining internal stability. Thus, as already discussed, two-step migration and territorial stratification during the Brezhnev period offer considerable opportunities for a significant portion of the population. Migrants who manage to move to a higher level of the territorial hierarchy acquire a new, economically and culturally superior life-style. Thus, although those migrating to closed cities end up much worse off than the indigenous city dwellers, both in terms of the intensity of social mobility and achievable socio-occupational status, their initiative is rewarded by successful resettlement and previously unavailable privileges. In addition, new migrants displace the original inhabitants in unskilled and unwanted occupations, thus pushing them up the social ladder.

The policy of territorial stratification — especially the closed cities system — provides the regime with considerable operating freedom as well as new means of controlling the labor market through noneconomic means. To check pressures by closed city workers who have acquired considerable bargaining power, the authorities have created a large, docile, and obedient working force with a temporary <u>propiska</u>: members of these occu-

pational strata readily accept the most unpleasant and tedious jobs while relinquishing the right to leave their job at will. Thus the working class is fragmented and prevented from struggling collectively for economic goals even at the level of one enterprise, not to mention concerted action at several enterprises. As Bialer has correctly emphasized, political power "does not confront generalized demands of 'society' as a whole, but rather specific demands of separate segments of society, which can be turned by the party against one another or neutralized in order to keep strong the party's position."[76]

During the Brezhnev period territorial stratification has considerably affected the demographic structure of the Soviet population. According to Soviet researchers these changes "for the most part contribute to the broadening of social differences."[77] On the other hand, administrative barriers between groups are sufficiently flexible and penetrable to allow the most energetic and enterprising members of the disadvantaged groups a certain margin of upward social mobility. This aspect of the current regulation of migration has been unanimously stressed by Soviet researchers: "Migration robs the countryside of its most active and educated inhabitants," writes a Siberian sociologist.[78] Migration from small towns to closed cities has the same effect: "Not all youth contingents are equally represented in migratory flows. Those who are more active and prepared to work and study change their place of residence more frequently."[79] A process of mass selection is at work. The people selected and promoted, of course, are those who, because of their psychological qualities, could have organized collective popular action. The regime avoids frustrating their aspirations and, instead, provides them with opportunities for individual improvement.

This strategy should not be viewed as evidence of the wisdom of the Soviet leadership in anticipating the long-term consequences of their current policies. On the contrary, having decided to avoid any major political-economic changes, the Brezhnev leadership has often simply responded to immediate exigencies. The system of organized consensus is thus a log-

ical extension of Stalin's socioeconomic system. The organized consensus is the result of the system's self-regulation at a time when mass terror has generally been abolished. Thus Roy Medvedev is certainly right in emphasizing the dialectical interrelation of the Stalinist social system and territorial stratification: "Over a long period of its development, the Soviet economy has depended on freedom of movement being seriously restricted and so it is hardly surprising that this has become a condition of its normal functioning. In other words, specific economic factors do now exist that serve to consolidate and perpetuate restrictions on freedom of movement."[80]

The Organized Consensus and Soviet Economic Performance

The strategy of organized consensus whereby the regime creates privileged sectors in society and regulates social mobility has its shortcomings. First, economic efficiency is sacrificed for the sake of internal political stability. Privileged structures have run into unforeseen problems: the rapid aging of the population of closed cities, the counterproductive concentration of specialists, and other economically unfavorable disproportions in the work force.[81] The country's already serious demographic situation has been further aggravated.[82] Even if long-term considerations do not weigh heavily with the present aged leadership, it is clear that the closed cities system eventually results in lowered productivity and a strained economy. Furthermore, to cope with the lack of manpower and to stimulate social mobility, the system of territorial stratification needs constant expansion, which correspondingly requires growing massive investment. The system of organized consensus works as long as the Soviet economy can ensure at least a gradual improvement in the living standard of the population as a whole, a sizable gap between the privileged sectors and the rest of the society, and reasonable opportunities for social mobility.

The 1970s witnessed massive Soviet rearmament —

unprecedented in peacetime. Consequently, the Brezhnev regime
has achieved strategic parity with, if not superiority over, the
United States. Yet, at the same time, the deteriorating per-
formance of Soviet industry (especially agriculture), the pop-
ulation's dissatisfaction with the availability of basic goods and
services, and the unusually harsh and open criticism of the
economy in the Soviet press indicate that the economic base of
the organized consensus is shrinking.

If improvement in living standards was noticeable during the
first decade of Brezhnev's rule, the deterioration of Soviet eco-
nomic performance has become obvious since the midseventies.
Academician Aganbegian provides some data on the USSR's
economic performance.

Table 13

Soviet Economic Performance, 1961-80 (%)

Growth	1961-65	1966-70	1971-75	1976-80	
				plan	actual
Productivity	25	32	34	31	18
Work force	22	14	8	4	8
Volume of production	47	46	42	35	26

"While the increase in the industrial work force, significantly
exceeding planned growth, in no way compensates for the de-
crease in the rate of productivity," comments Aganbegian, "it
did result in an insolvent wage fund, aggravated the already
difficult situation in satisfying popular demand for goods, and
prompted an increase in the work force deficit.... This, in
turn, adversely affected labor turnover and work discipline
and caused other undesirable social consequences."[83] Dis-
satisfaction with the regime's performance in such important
areas as the availability of foodstuffs, consumer goods, and
services is growing even in closed cities.[84]

In the 1970s, after the abandonment of the economic reform
of 1965, the contradictions of the Soviet economy became very
pronounced at all levels. Central planners "are not constrained

by the need to present alternatives to the population and to seek its consent, and thus they push accumulation to its limits."[85] Indeed, accumulation rates are extremely high in the Soviet Union. Between 1965 and 1978 the population increased by 13.5 percent, while the accumulation fund grew 115 percent.[86] At the same time, this seemingly complete control over accumulation and the use of surplus value on the part of central planners has certain important limitations.

First, keeping intact Stalin's political-economic structure requires maintaining a basic disproportion between investments in heavy industry and in consumer goods. Since the sixties the share of group A production (heavy industry) has remained stable at 74 percent of GNP, "with unfavorable consequences for the growth of personal consumption."[87] Having imposed its own set of priorities on society, the regime has become a prisoner of its own decisions. Thus the actual experience of the Soviet economic system differs radically from the socialist principles proclaimed by official theory. Lenin defined central planning as consciously maintained, proportionate, and balanced development.[88] Contemporary Soviet literature also proclaims planned, proportionate, and balanced economic development as one of the central laws of socialism.[89] In fact there is a planned, consciously maintained disproportion in the economy. Hesitant attempts during 1971-72 by central planners to alter the existing allocation of resources were quickly abandoned in view of both the determined resistance of the military-industrial complex and fears that reduction of authority over the economy entails curtailment of political power.[90] The population's real needs are sacrificed for the sake of internal political stability and the leaders' political ambitions.

A second limitation on central planners is due to the emergence of certain spontaneous, unplanned processes in the economy, specifically the fact that the increasing role of markets restricts the state's economic power. The existence of a semifree labor market is strongly felt in the Soviet economy. Not only are workers able to exert pressure on local administrations, but the free labor market also allows managers to

effectively resist the obligatory target-planning from above and thus creates real constraints on the operation of the command system. Both managers and workers are interested in obtaining a minimal plan target and a maximum realization price, wage fund, supply of raw materials, and so on. The enterprise managers' interests are often at variance with those of central planners; consequently, the local administration struggles constantly (and often successfully) against planners.[91] A compromise is reached by the widely used "planning from the achieved level" practice.[92]

The drawbacks of this practice are well known. Planning from the achieved level results in further overinvestment and overaccumulation, and in a sharp increase in waste of resources and human energies. It penalizes success by determining "the upper limit of labor productivity" — surpassing this limit is frowned on at the level both of single workers as well as of enterprises.[93] This system encourages routine management and discourages innovation. It enforces the implementation of the plan or any other success indicator regardless of quality and cost, with serious consequences for the living standards of the populace. Planning from the achieved level produces apathy and aggravates stagnation trends. Stagnation of consumption standards has already resulted in a colossal rise in savings bank deposits, "repressed inflation," mounting shortages of many necessities, endless queuing, expansion of markets, and considerable price increases for basic market goods.[94]

Experts differ in their evaluation of the Soviet political-economic system's ability to meet the needs and expectations of the populace. Curiously enough, many Western experts are far more optimistic in their assessment than their Soviet colleagues. Paul Hollander judges the people's expectations in the USSR to be very low and manageable and asserts that "the key to the stability of the Soviet system lies in its management of expectations rather than in the powers of the KGB."[95] Bialer concurs by observing that the management of expectations is the major pillar of the Soviet regime's stability: "Since popular demands remain relatively modest and are by and large

being met, the strong identification of the government with the state of the economy has enhanced the long-run stability of the system."[96] Soviet society, however, is far from being a less developed and therefore less affluent analogue of its Western counterpart. It is, rather, a new socioeconomic formation in its own right. Accordingly, the values and aspirations of Soviet citizens should not be measured by the standards of the affluent West. Judged from the viewpoint of those within the system, Soviet popular expectations are not modest at all. They are not modest by any standards when one considers what is taken for granted by every Soviet citizen: the stability of state-supported prices of food, basic consumer goods, and services. Thus the price of housing has remained at the level of 1928, which makes housing, heating, gas, telephone, and other utilities practically free. The burden of price subsidies is becoming heavier for the state budget every year. Moreover, a member of the Soviet system derives by far the largest part of life's satisfactions from his work.[97] The Soviet economy, with its planning from the achieved level, inherent conservatism, and inflexibility, resists technological innovation and preserves enormous sectors of unskilled and unproductive manual jobs. The high level of education prevents young people from identifying with such labor, and job dissatisfaction is thus widespread among them.

Soviet specialists frequently claim that the current economic system is no longer capable of keeping up with popular demands. According to Aleksandr Levin, in order to increase personal consumption it is necessary to alter the existing proportions of investment in heavy industry and the consumer goods sector, to modify the current ratio between the accumulation and consumption funds, to sharply increase the share of consumption in national income, and in particular, to get the rate of growth of the consumer goods sector to exceed the rate of growth of the population's monetary income.[98] Thus, to increase the availability of goods a Soviet citizen finds desirable and gratifying demands a kind of revolution that would radically disrupt the existing political-economic system. Today, notes Mihaly Vajda, the system's predominant contradiction lies in the fact that it can maintain its totalitarian power structure only by

privatizing all human initiatives: "The power apparatus must encourage consumerism, in spite of an official ideology which condemns consumerism, and in spite of an economic system which does not favor the production of consumer goods."[99]

The Soviet economy can still sustain an annual growth rate of 2-3 percent. Comparing this performance with Western economies during recessions, Alec Nove claims that a comparison favors the Soviet side: "Even 3% is better than zero."[100] A direct comparison, however, is not fully justified. An economy based on the abundance of consumer goods functions differently from an economy of permanent scarcity. Similarly, the respective people's behavior and expectations are quite different. In the Soviet economy growth is often achieved by producing goods that do not satisfy any real need — not to mention statistical exaggeration. The permanent conflict between the use value and the exchange value of commodities "may often manifest itself in a very sharp form."[101] The deliberate policy of underinvestment in the consumer good sector, coupled with the defects inherent in centralized planning, results in "the alarming and growing gap between the cash and savings in the hands of the population and the supply of goods, especially foodstuffs."[102] Growth of production and wages in heavy industry is not accompanied by a corresponding increase in consumer goods and services. Soviet economists now openly admit that workers are losing their incentives to work.[103] In turn, falling productivity, the high rate of labor turnover, and the increased incidence of alcoholism produce further scarcity of consumer goods. Workers themselves are the first to experience food and dwelling scarcity, the first to be victimized by queues and black markets.

The Brezhnev compromise is revealing its temporary character by beginning to crumble because of the economy's deteriorating performance and the absence of work incentives. The lack of work discipline clearly indicates a conflict between the party-state machine and large segments of the working class. It is important not to ignore or underestimate this conflict just because it is not accompanied by open and organized struggle.

Two Perspectives for the Future

It is exactly this problem — work discipline and incentives —
that has during the past few years led to heated debate in both
the Soviet mass media and specialized journals. The discussion
has not only revealed the state of mind of the Soviet establish-
ment, and of managers and engineers, but has also shed light
on the possible options for Soviet society after Brezhnev. Nu-
merous publications on the state of labor discipline have shown
the existence of two clearly discernible lines of thought, epito-
mized by the Literaturnaia gazeta caption: "To force or to en-
courage?"[104]

The first line of thought can be defined as neo-Stalinist and
can be easily found in the press. "I think there is no other
problem today as urgent and intense as the strengthening of
labor discipline," writes an official of the ministry for heavy
machinery.[105] He then proposes stringent measures in order
to remedy the situation, in particular: broader militia juris-
diction; greater powers to courts and administrations regard-
ing forced rehabilitation of alcoholics; imposition of additional
penalties and administrative sanctions against discipline vio-
lators; shortening of the period after which a voluntarily unem-
ployed person may be declared a "social parasite" and be sub-
ject to persecution, etc.[106]

The second line of thought is technocratic in character. It
favors a return to the economic reform of the sixties, embodied
in the Shchekino experiment. For example, in an article on the
social aspects of the Shchekino experience, an economist de-
picts its essential characteristics as follows: "The collective
rids itself of weak, slack workers; a rational and wholly sci-
entific redistribution of personnel, from workers to engineers,
takes place."[107] In other words, a reserve labor force comes
into being, practically annulling the worker's right to quit his
job at will and permitting a considerable improvement in labor
productivity. But what will happen to workers who lose their
jobs? Suggestions to pay such workers the official minimum
wage, i.e., to introduce unemployment benefits, have already

appeared in the press.[108]

The proponents of technocratic reform are far from suggesting any kind of democratization that would greatly increase the number of persons participating in the country's internal decision-making. Instead, what they seek is economic liberalization, i.e., a reduction in the state's economic hold over individuals and society. The system of organized consensus has already given birth to spontaneous tendencies toward economic liberalization, e.g., the growth of a second economy and of various markets. In some cases the authorities themselves have been forced to relax their control over certain private activities, such as the cultivation of individual plots. The proponents of technocratic reforms suggest that the government should take the lead in transforming the economy. Their proposals do not aim at eradicating the party apparatus's monopoly on political power but rather at prolonging the existence of the organized consensus without the dangers of political pluralism.[109] However, even this moderate program will, in the long run, require a serious modification of the economic and, hence, the political structure of Soviet society. Hungary's social development as well as recent Polish events demonstrate that such developments are quite feasible and perhaps even probable in the Soviet Union.

Advocacy of the opposing tendency involves a return to the old Stalinist model. The regime is sufficiently powerful to increase the role of terror in managing society, to depress the consumption standard of the population even further, and to pursue an expansionist foreign policy even more forcefully. This Stalinist option is the option of political imperialism, which endeavors to extend Soviet-type political systems as far as USSR power can reach. Undoubtedly it is favored by sizable factions of the party apparatus and of the military-industrial complex. However, it offers no guarantees of increasing labor productivity; and the inevitable slowdown in economic growth will be accompanied, in all probability, by a fall in the standard of living.

It is important to note here that the changes in the interna-

tional terms of trade that have taken place since 1974, espe-
cially the rapid rise in the prices of fuel, gold, and raw mate-
rials, are very favorable to the Soviet regime.[110] As a result,
the Soviet leadership can pay less attention to internal reforms
designed to improve the system's efficiency and concentrate
instead on an expansionist foreign policy. The latter may, in
turn, be used to alter the sociopsychological climate within the
country and to infringe on workers' rights.

Now, at the close of the Brezhnev regime, the system of or-
ganized consensus is experiencing mounting pressures. Main-
tenance of the status quo and of stability without change — the
tack of Brezhnev's leadership — now seems exhausted. A
great many economic and political problems have accumulated
that all call for answers. Brezhnev's successors will have to
adopt a more resolute internal policy to protect the regime
from the threatening crisis. The character of this future policy
should, to a significant extent, determine the predominant type
of conflict in Soviet society in the years to come. If the lead-
ership chooses the path of reform and the liberalization of eco-
nomic life, such problems as the redistribution of investments
or a more efficient use of manpower in the national republics,
achieved through the organization of voluntary migration, may
be resolved without serious disturbances. The main contra-
dictions will, in this case, acquire primarily political and class
characteristics. Competition between the various sectors of
the economy, conflicts between planners and administrators
about planning objectives, and even class conflict between tech-
nocrats and workers may begin to assume a major role.

Nevertheless, one should not exclude the possibility — as the
invasion of Afghanistan has clearly demonstrated — that among
Brezhnev's successors a group will prevail which supports the
tightening of social discipline, a strengthening of the repres-
sive apparatus, and an intense militarization of society. To
succeed in such a policy, the governing group will have to ex-
tensively exploit the resources of Russian nationalism and
chauvinism. The policy of conquest may be presented to the
population for some time as a policy of defense against the

possibility of Chinese or American aggression. To ensure the success of such a policy, the propaganda apparatus will have to concentrate on the promotion of Soviet patriotism as a unifying factor in the face of external threats to the integrity of the country.

Yet, as Wlodzimierz Brus aptly notes, recourse to nationalism in the present situation in Eastern Europe is enormously conflict laden.[111] One might rather predict that under present conditions, an expansionist policy will be rapidly blocked. On the other hand, the militarist tendencies of the Soviet ruling group and the end of détente would leave little margin for internal economic liberalization. A new investment policy based on criteria no longer political but economic would inevitably worsen the economic situation of many Soviet republics, depriving them of important sources of social and economic benefits.

This policy could be enacted through administrative measures and should provoke more active opposition from ethnic minorities (Ukrainian, Georgian, etc.) that, because of their structural position in society, would be forced to develop particular nationalisms based to a considerable extent on anti-Russian sentiments. The intense preoccupation of many ethnic groups with their relations with the dominant Russian group would also have sources other than simply unequal economic treatment. While in the past Russian domination could have been perceived as providing both advantages and drawbacks, in the presence of strong Russian nationalism, cultural and linguistic subordination would imply the extinction of ethnic communities. In this case the intensification of ethnic conflicts appears increasingly probable.

NOTES

Note to Introduction

1. Will the Soviet Union Survive until 1984? (New York: Harper and Row, 1970), p. 22.

Notes to Chapter 1

1. H. Pachter, "On Being an Exile," Salmagundi, 10-11 (1969-70), p. 19.
2. Thus, for example, during the Union of Writers 1978 convention, ostensibly organized to celebrate Armed Forces Day but actually dedicated to the twenty-fifth anniversary of Stalin's death — a highly placed official from the Central Political Directorate of the Armed Forces delivered one such speech. Moreover, historians and sociologists still remember that the draft of one of the last volumes of the History of the CPSU was sharply criticized in the mid-'70s because of references to some incidents of Stalinist repressions during the 1947-49 period. On that occasion Sergei Trapeznikov, one of the chiefs of the ideological apparatus, reiterated that "Soviet history does not contain, and never has contained, negative pages."
3. Kommunist, 19 (1979), pp. 40, 42.
4. I. Stadniuk, Voina, part 2, Molodaia gvardiia, 5 (1974), p. 50.
5. Additional material on the rapid re-Stalinization can be obtained by comparing the first (midsixties) and second (late sixties and early seventies) editions of the memoirs of Soviet military leaders. See M. Geller, Kontsentratsionnyi mir i sovetskaia literatura (London: Overseas Publications, 1974), pp. 222-23.
6. Iu. Zhukov and R. Izmailova, "Nachalo goroda. Stranitsy iz khroniki 30-kh godov," Znamia, 2 (1977), p. 154.
7. S. Smirnov, "Svidetel'stvuiu sam," Moskva, 10 (1967), p. 29.
8. Iu. Bondarev, "Stranitsy iz zapisnoi knizhki," Znamia, 6 (1976), p. 115.
9. A. Kalinin, "Iz vospominanii syna," Znamia, 1-2 (1977).
10. T. Rigby, "Stalinism and Mono-Organizational Society," in R. Tucker (ed.), Stalinism: Essays in Historical Interpretation (New York: Norton, 1977), pp. 53-76.
11. C. Castoriadis, "The French Left," Telos, 34 (Winter 1977-78), p. 55.

165

12. R. Tucker, The Soviet Political Mind. Stalinism and Post-Stalin Change, 2nd rev. ed. (New York: Norton, 1971), p. 135.

13. V. Chalmaev, "Otbleski plameni," Moskva, 2 (1978), p. 187.

14. Preduprezhdenie pravonarushenii sredi nesovershennoletnikh (Minsk: Nauka-Tekhnika, 1969), p. 12.

15. The failure of Iurii Bukharin's (Larin) efforts to obtain his father's rehabilitation, for example, cannot be attributed to the ideological positions of the present Soviet leaders. In the eyes of today's population, Bukharin is not so much an ideologue as Stalin's principal political adversary. His rehabilitation would be in clear contrast to the policy of restoring the Stalin cult and was refused precisely for this reason.

16. N. Mandelstam, Hope Against Hope. A Memoir, translated by M. Hayward (New York: Atheneum, 1980), p. 147.

17. A. Zinoviev, Senza illusioni (Milan: Jaca Book, 1980), p. 107.

18. S. Cohen, "Bolshevism and Stalinism," in R. Tucker (ed.), Stalinism, p. 28.

19. V. Zaslavsky, "The Problem of Legitimation in Soviet Society," in A. Vidich and R. Glassman (eds.), Conflict and Control. Challenge to Legitimacy of Modern Governments (Beverly Hills-London: Sage, 1979), pp. 161-68.

20. See below, pp. 33-35.

21. H. Smith, The Russians (New York: Quadrangle, 1976), pp. 302-25.

22. Molodaia gvardiia, 12 (1968), p. 212.

23. V. Lenin, Polnoe sobranie sochinenii, 5th ed., vol. 41, p. 318.

24. A Levitin-Krasnov, "Pis'ma o russkoi molodezhi," in V. Belotserkovskii (ed.), SSSR. Demokraticheskie alternativy (Achberg: Achberger Verlaganstalt, 1976), p. 235.

25. See, for example, Politicheskii dnevnik. 1964-70 (Amsterdam: Fond Herzena, 1972), pp. 586-94.

26. L. Chukovskaia, Otkrytoe slovo (New York: Khronika, 1976), pp. 39-46.

27. M. Rutkevich and F. Filippov (eds.), Sotsial'naia struktura razvitogo sotsialisticheskogo obshchestva v SSSR (Moscow: Nauka, 1976), pp. 196-97.

28. A. Oberschall, Social Conflict and Social Movements (Englewood Cliffs: Prentice Hall, 1973), pp. 165-70.

29. M. Agurskii, "Dvulikii Stalin," Vremia i my, 18 (1977), p. 141.

30. N. Mandelstam, Hope Abandoned, translated by M. Hayward (New York: Atheneum, 1974), p. 585.

31. A. Nekrich, Otreshis' ot strakha. Vospominaniia istorika (London: Overseas, 1980).

32. L. Kopelev, "O novoi russkoi emigratsii," Samosoznanie. Sbornik statei (New York: Khronika, 1976), pp. 60-61.

Notes to Chapter 2

1. A. de Tocqueville, The Old Regime and the French Revolution (Garden City, N. Y.: Doubleday, 1955).

2. See John S. Reshetar, Jr., The Soviet Polity (New York-Toronto: Dodd, Mead, 1971); and Tibor Szamuely, The Russian Tradition (London: Seker and Warburg, 1974).

3. Stephen White, "The USSR: Patterns of Autocracy and Industrialism," in Archie Brown and Jack Gray (eds.), Political Culture and Political Change in Communist States (New York: Holmes and Meier, 1977), p. 56; Joseph LaPalombara, "Residues Under Revolution," Times Literary Supplement, December 2, 1977, p. 1405; Robert Conquest, "The Role of the Intellectuals in International Misunderstanding," Encounter, 51 (August 1978), p. 80.

4. Zbigniew Brzezinski, "Soviet Politics: From the Future to the Past?" in Paul Cocks, Robert V. Daniels, and Nancy Whittier Heer (eds.), The Dynamics of Soviet Politics (Cambridge, Mass.: Harvard University Press, 1976), pp. 337-51.

5. In our sample workers younger than 30 years old normally had seven or eight years of formal school education, while in the 31-40 group workers had five or six years. In the group over 40, workers with four years of schooling prevailed.

In discussing Soviet school and youth organization education, one should take into account that the legitimacy of party rule depends to a significant extent on the fact that Marxist doctrine is proclaimed as the dominant ideology of Soviet society and on the acceptance of the goals of classical Marxism as the final goals of Soviet societal development. (See also Jeffrey C. Goldfarb, "Social Bases of Independent Public Expression in Communist Societies," American Journal of Sociology, 4 [1978], pp. 920-39.) Schools are the foremost agents in disseminating and popularizing official Marxism which, however, represents only one, "idealistic," tier of the Soviet ideology as a whole. The illusory, special world created by this part of the Soviet ideology ought to be related to, and reconciled with, the everyday reality. The task of harmonizing ideal and real orders is subsequently accomplished by many other agents of socialization, among which the army and the closed enterprises play a prominent role.

6. Robert J. Brym, The Jewish Intelligentsia and Russian Marxism: A Sociological Study of Intellectual Radicalism and Ideological Divergence (London: Macmillan, 1978), pp. 35-72.

7. See. E. G. Antosenkov and Z. V. Kupriianova, Tendentsii v tekuchesti rabochikh kadrov (Novosibirsk: Nauka, 1977). Also see Note 22.

8. Marriage to a passport-bearer is for young female peasants one of the frequently used avenues of escape from the collective farm. This practice was widespread among our respondents, who still kept close family and friendship ties with people in the countryside.

9. Nikolai Bukharin, "Politicheskoe zaveshchanie Lenina," Pravda, January 24, 1929.

10. Erving Goffman, Asylums. Essays on the Social Situation of Mental Patients and Other Inmates (Garden City, N. Y.: Doubleday-Anchor, 1961).

Service in the rank and file is obligatory for every male citizen who reaches the age of 18 unless he is a student in an institution of higher education. In the period reported, the average length of military service was three to four years. Draconian discipline reigns in the Soviet army, and the only party organizations which have neither control over administration nor even the right to discuss the actions of superiors are those in the armed forces. The schedule is always planned to the smallest details. A member of the rank and file is always busy, even though often engaged in senseless activity, and never left to himself. From

the very first day each recruit knows the famous motto: "If you can't — we'll help you; if you don't like it — we'll force you." The day-to-day conditions are very poor, the soldier's allowance is merely symbolic (three rubles per month), and money orders from the family are not allowed. The soldier is completely cut off from relatives, friends, and the local population. According to the existing rules, a person born, say, near Vladivostok will serve somewhere near Leningrad and vice versa; leaves of absence are extremely rare. Members of the rank and file must wear only their uniform; their hair is closely cropped; they cannot wear a beard or moustache, and so on. In relating their army experience, many of our respondents asserted that "only in the army could one understand what real life is," or that "one came back a different man." Compare this with observations by Iosif Brodsky, who on the basis of his personal experience concludes: "Service in the Soviet army takes from three to four years, and I never met a person whose psyche wasn't mutilated by its mental straitjacket of obedience" ("Less than One," New York Review of Books, September 27, 1979, p. 45).

11. It is worth noting in passing that the main difference in social experience between a Soviet worker (or peasant) and a Soviet specialist (with university education) lies in the fact that the latter has never been subjected to the socializing effect of military service.

A specialist used to serve in the army only after graduation, i.e., normally after the age of 22, and as an officer. The length of his service was only six months. Recently, however, the government has changed the conditions of specialists' army service, bringing them closer to those of other social groups — evidence that some lessons have been learned in the struggle against the dissident movement.

12. Orville G. Brim, Jr., and Stanton Wheeler, Socialization After Childhood (New York: Wiley, 1966), pp. 35-37.

13. Stanislav Andreski, Military Organization and Society (Berkeley and Los Angeles: University of California Press, 1968), p. 186.

14. See also Iurii Chernichenko, "Rzhanoi khleb," Novy mir, November 1968, pp. 177-207.

15. It is noteworthy that today, the only social group in which cases of unwillingness to enter the party can be found is that of middle-aged semiskilled workers. Party membership for them may become an impediment to the utilization of their major resource — the right to change their job at will. And they are ineligible for the compensatory advantages of party membership.

16. For example, the right to buy a car or furniture without being waitlisted; the allotment of house and garden plots in southern parts of the country; earlier retirement and more beneficial pension plans, and so on. It is worth noting that workers will often be able to use these benefits only in the future, sometimes not until retirement.

17. In case an enterprise is shut down — not a rare event in the geological industry — a worker with security clearance will be transferred to another closed enterprise.

18. See N. A. Aitov, "Kariera. Zametki sotsiologa," Druzhba narodov, June 1975, pp. 225-33; and Vladimir Shubkin, "Nachalo puti," Novy mir, February 1976, pp. 188-219.

19. See Alexei Yakushev, "Are the Techniques of Sociological Surveys Applicable Under the Conditions of Soviet Society?" European Journal of Sociology, (1972), pp. 139-50. See also Walter D. Connor and Zvi Y. Gitelman, Public Opinion in European Socialist Systems (New York: Praeger, 1977).

20. G. G. Dadamian and D. B. Dondurei, "Problemy shkalirovaniia esteticheskikh otsenok v sotsiologicheskikh issledovaniiakh iskusstva," Sotsiologicheskie issledovaniia, 3 (1977), p. 195.

21. Yakushev, p. 144.

22. According to Soviet industrial regulations, any fixed rate of labor productivity that has been sustained during the previous six months should be raised, and the failure to sustain that rate entails a sharp reduction in workers' wages. Thus a secular growth of productivity is secured. This does not mean, however, that a Soviet worker is at the mercy of the factory administration. In 1956 Soviet workers regained the right to leave their job at will, and this has become their major bargaining resource. Due to a permanent lack of manpower, local factory administrations must somehow raise productivity without losing their labor force. But workers know that the intensification of productivity norms is not the result of initiatives by the local administration. Also, a change of job is sometimes associated with temporary material losses. This is why setting production norms in the Soviet Union ordinarily takes the shape of Simmel's "unifying conflict" (see G. Simmel, Conflict [Glencoe, Ill.: Free Press, 1955]): it becomes a form of collective bargaining in which workers actively help rate-fixers arrive at the average increase required with minimal losses for themselves.

23. Concerning the role of the passport system in the Soviet Union today, see Victor Zaslavsky and Yuri Luryi, "The Passport System in the USSR and Changes in Soviet Society," Soviet Union, 6 (1979), part 2, pp. 137-53.

24. According to Soviet statistics, in 1928 peasants made up 77.7 percent of the total Soviet population, while in 1970 they made up 20.7 percent ("Sotsial'noe razvitie rabochego klassa v SSSR v tsifrakh," Rabochii klass i sovremennyi mir, September-October 1975, p. 177).

25. C. A. Ferguson, "Diglossia," in Pier Paolo Giglioli (ed.), Language and Social Context (Harmondsworth: Penguin Education, 1959), pp. 194-203.

26. About the legitimizing role of this political code, see Claus Mueller, The Politics of Communication: A Study in the Political Sociology of Language, Socialization and Legitimation (New York: Oxford University Press, 1973); and Victor Zaslavsky, "The Problem of Legitimation in Soviet Society," in Arthur J. Vidich and Ronald M. Glassman (eds.), Conflict and Control, Challenge to Legitimacy of Modern Governments (Beverly Hills-London: Sage Publications, 1979), pp. 159-202.

27. Without access to personal files, we were unable to determine this more precisely.

Notes to Chapter 3

1. H. Arendt, The Origin of Totalitarianism (London: Allen & Unwin, 1951); C. J. Friedrich and Z. Brzezinski, Totalitarian Dictatorship and Autocracy (Cam-

bridge, Mass.: Harvard University Press, 1956).

2. V. Turchin, The Inertia of Fear and the Scientific Worldview, translated by G. Daniels (New York: Columbia University Press, 1981).

3. O. I. Shkaratan and V. O. Rukavishnikov, "Sotsial'nye sloi v klassovoi strukture sotsialisticheskogo obshchestva," Sotsiologicheskie issledovaniia, 2 (1977), pp. 62-73.

4. See, for example, Voprosy filosofii, 5 (1971), p. 24.

5. M. N. Rutkevich, "Dvizhenie sovetskogo naroda k sotsial'noi odnorodnosti," Kommunist, 7 (1977), p. 62.

6. N. I. Bukharin, Put' k sotsializmu v Rossii. Izbrannye proizvedeniia (New York: Omicron Books, 1967), pp. 117-18. See also A. Nove, "Socialism, Centralized Planning and the One-Party State," in T. H. Rigby, A. Brown, and P. Reddaway (eds.), Authority, Power and Policy in the USSR. Essays Dedicated to Leonard Shapiro (London: Macmillan, 1980), pp. 78-80.

7. Vedomosti Verkhovnogo Soveta SSSR, 52 (1940).

8. M. Feshbach, "Employment Trends and Policies in the USSR," Il Politico, 4 (1978), pp. 669-71; see also D. E. Powell, "Labour Turnover in the Soviet Union," Slavic Review, 2 (1977), pp. 268-85.

9. This essay was later published in Paris under the pseudonym of Bourgeois-demov and under the title Ocherki rastushchei ideologii (Paris: Echo, 1974), p. 168.

10. Pravda, January 12, 1980.

11. A. Katsenelinboigen, "Coloured Markets in the Soviet Union," Soviet Studies, 1 (1977), p. 62; see also D. Novoplianskii, "Vokrug ordera," Pravda, February 4, 1978.

12. W. Brus, "The Eastern European Reforms: What Happened to Them?" Soviet Studies, 2 (1979), pp. 257-67.

13. The reform is better known as the Shchekino method, which was first introduced at the Shchekino Chemical Combine in Tula Region in 1967. Today's Soviet press describes the Shchekino method as follows:

It was suggested to the collective that while producing the same output they manage with fewer people — the entire wage fund is yours, divide it among the remainder" (Sovetskaiia Rossiia, July 19, 1981, quoted in Soviet World Outlook, 9 [1981], p. 6).

14. See Ivan Khudenko's case in H. Smith, The Russians (New York: Quadrangle, 1976), pp. 213-14. Now, when a new economic reform is again on the Soviet agenda, the Soviet press is less reticent in explaining the reasons for abandoning the Shchekino method in the late 1960s. For example, Sovetskaiia Rossiia (July 22, 1981) accounts as follows for the failure of this method at the Omsk petrochemical plant:

The old enterprise was increasing labor productivity by 2 percent per year. Then, at the beginning of the Ninth 5-Year Plan, it was transformed to the Shchekino method, and in the 5 years it increased productivity right away by 48 percent. But all those years the ministry struggled against the Shchekino method at the enterprise. And in the end it won. At the beginning of the 10th

5-Year Plan the method was abolished at the plant, and now it is again producing increases of 2 percent a year. But the ministry is satisfied. Why? Because it can change the indicators every year ... (Quoted in Soviet World Outlook, 9 [1981], p. 6).

15. The existing "unreformed" economic system protects both workers' job security and workers' economic interests: "It is more advantageous even in economic terms for an enterprise to have a surplus rather than a shortage of manpower. The enterprise's grade (razriad) is determined according to numbers. The more people there are, the bigger the wage fund and likewise also of the bonus resources" (Sovetskaiia Rossiia, July 22, 1981, quoted in Soviet World Outlook, 9 [1981], p. 7).

16. This term, taken from Gogol's novel, in contemporary Soviet usage designates workers who exist only on the payroll and appear twice a month to collect their checks. Administrations "hire" these ghost workers because they may often need to fill employment quotas regardless of technical and/or economic need. The system also serves to increase the cash flow from the state budget and to distribute it between workers and manager.

17. Literaturnaia gazeta, September 13, 1978, p. 12.

18. P. G. Bunich, "Stimulirovanie truda v razvitom sotsialisticheskom obshchestve," Sotsiologicheskie issledovaniia, 2 (1981), p. 30.

19. W. Connor, "Generations and Politics in the USSR," Problems of Communism, 5 (1975), pp. 20-31.

20. P. Hollander, Soviet and American Societies: A Comparison (New York: Oxford University Press, 1973), pp. 388-92.

21. I. V. Stalin, Sochineniia, vol. 10 (Moscow: Politizdat, 1949), p. 232.

22. A. Krasikov, "Vodka: Commodity Number One," in R. Medvedev (ed.), The Samizdat Register (London: Merlin Press, 1977). For analogous developments in Poland, see H. Malinowska, "Extent and Effects of Alcoholism in People's Poland," Survey, 1 (1980), pp. 53-57.

23. S. G. Strumilin and M. Ia. Sonin, "Alkogol'nye poteri i bor'ba s nimi," Ekonomika i organizatsiia promyshlennogo proizvodstva (EKO), 4 (1974), p. 37.

24. V. Treml, "Production and Consumption of Alcoholic Beverages in the USSR: A Statistical Study," Journal of Studies in Alcohol (March 1975), pp. 285-320. According to official Soviet data, between 1970 and 1979 alcohol sales increased by 68 percent, (V. P. Voronin, "Sotsial'naia i ekonomicheskaia effektivnost' sfery obsluzhivaniia," Sotsiologicheskie issledovaniia, 2 [1981], p. 102).

25. "Ekonomika i alkogolizm," EKO, 4 (1974), pp. 35-68.

26. Literaturnaia gazeta, July 27, 1977.

27. Komsomol'skaia pravda, July 24, 1971; see also V. Dorofeev, "Chas volka," Literaturnaia gazeta, October 31, 1979.

28. A. G. Zdravomyslov, V. P. Rozhin, and V. A. Iadov, Man and His Work, translated by S. P. Dunn (White Plains, New York: International Arts and Sciences Press, 1970).

29. M. Matthews, Class and Society in Soviet Russia (London: Allen Lane, 1972), p. 141.

30. O. I. Shkaratan, "Problemy sotsial'noi struktury sovetskogo goroda," Filosofskie nauki, 5 (1970); O. I. Shkaratan and V. O. Rukavishnikov, "Sotsial'nye sloi."

31. B. M. Levin, Sotsial'no-ekonomicheskie potrebnosti: zakonomernost' formirovaniia i razvitia (Moscow: Mysl', 1974), p. 239. For very typical data on housing conditions in Leningrad, see V. M. Kiselev and N. F. Fedotova, "Zhilishchnye usloviia semii i rozhdaemost'," in Sotsial'nye problemy planirovaniia sotsialisticheskogo goroda (Leningrad: University of Leningrad Press, 1978), pp. 137-46.

32. A. G. Zdravomyslov, Zhiznennye potrebnosti trudiashchikhsia i ich udovletvorenie v usloviiakh razvitogo sotsializma (Moscow: Znanie, 1977), p. 38.

33. D. Lane, The Socialist Industrial State. Towards a Political Sociology of State Socialism (London: Allen & Unwin, 1976), pp. 198-99.

34. Planovoe khoziaistvo, 11 (1973), p. 17.

35. Bourgeoisdemov, Ocherki; Z. Katz, Patterns of Social Mobility in the USSR (Cambridge, Mass.: M. I. T., 1972); H. Seibel, "Problemlage und Schichtungsystem in der Sowjetunion," Kölner Zeitschrift fur Soziologie und Sozialpsychologie, 2 (1976), pp. 212-38.

36. M. I. Kulichenko, "Natsional'noe i internatsional'noe v zrelom sotsialisticheskom obshchestve," Voprosy filosofii, 5 (1979), p. 54.

37. F. R. Filippov, Sotsiologiia obrazovaniia (Moscow: Nauka, 1980), p. 57.

38. S. Mallet, "Socialism and the New Working Class," International Socialist Journal, 2 (1965), pp. 152-72; S. Mallet, Essays on the New Working Class (St. Louis: Telos, 1975); J. R. Tréanton, "Progrès des études empiriques sur la classe ouvrière," Revue française de Sociologie, 3 (1975), pp. 335-58; A. Touraine, La conscience ouvrière (Paris: Seuil, 1966).

39. Interesting information on the role of secrecy in Soviet science, which, according to Mark Popovsky, is "only a small part of the continent of the great Russian secrecy," can be found in M. Popovsky, Manipulated Science: The Crisis of Science and Scientists in the Soviet Union Today, translated by P. S. Falla (Garden City, N. Y.: Doubleday, 1979).

40. M. Ia. Sonin, "Effektivno ispol'zovat' trudovye rezervy," EKO, 4 (1977), p. 5.

41. Literaturnaia gazeta, September 5, 1979, p. 10; Ekonomicheskaia gazeta, 32, 33 (1979).

42. Vsesoiuznaia perepis' naseleniia 1970 goda, vol. 5 (Moscow: Statistika, 1973), p. 66.

43. E. Klopov, "Osnovnye predposyl'ki, napravleniia i itogi sotsial'nogo razvitiia rabochego klassa SSSR na sovremennom etape," paper presented at the Soviet-Italian Scientific Symposium, Institut Mezhdunarodnogo rabochego dvizheniia, Moscow, December 1980, p. 12.

44. Ibid., p. 13.

45. See, M. Yanowitch, Social and Economic Inequality in the Soviet Union. Six Studies (White Plains: M. E. Sharpe, 1977), pp. 74-77.

46. F. Filippov, Sotsiologiia obrazovaniia (Moscow: Nauka, 1980), p. 49.

47. M. Ia. Sonin, Razvitie narodonaseleniia. Ekonomicheskii aspekt (Moscow: Statistika, 1980), pp. 173-77.

48. For example, a survey of young workers' (under 30) attitudes to their work (conducted on the Baikal-Amur railway construction project) revealed that in 1975, 59.6 percent of the respondents saw their work as providing opportunities

for learning skills, allowing for personal growth, and promising promotion. In 1976 this figure had dropped to 39.3 percent (N. V. Poliakova, "Iz opyta izucheniia proizvodstvennoi adaptatsii rabochei molodezhi na stroitel'stve BAM," Sotsial'nye problemy stroitel'stva BAM [Novosibirsk: Sibirskoe otdelenie Akademii nauk, 1977], pp. 97-98).

49. D. Kaidalov, "Sotsial'nye faktory rosta ekonomiki," Pravda, April 22, 1981, p. 2.

50. See, for example, G. A. Kulagin, Rabochii-upravliaiushchii-uchenyi: zametki direktora (Moscow: Sovetskaia Rossiia, 1976); Voprosy istorii KPSS, 8 (1978); Kaidalov, "Sotsial'nye faktory."

51. R. E. Blackwell, Jr., "Cadres Policy in the Brezhnev Era," Problems of Communism, 2 (1979), pp. 29-42.

52. A. Levikov, "Chelovek kotoryi upravliaet," Znamia, 9 (1977), p. 193.

53. E. H. Carr and R. W. Davies, Foundations of a Planned Economy, vol. 1, part 2 (London: Macmillan, 1969), p. 455.

54. V. Perevedentsev, "Demography: The Situation, the Problems, and Policy," Soviet Law and Government, 4 (1976), pp. 40-51.

55. U. S. News and World Report, August 22, 1977, p. 21.

56. There are already indications of a turn in this direction, although they are still theoretical. The Soviet press often highlights and condemns the spreading practice of so-called "additional compensation" granted to anyone doing unpleasant and heavy manual labour. The authors recommend putting an end to wage increases, unreserved access to apartments, extra vacation time, and other privileges for unskilled workers and urge instead the use of these resources to improve working conditions by means of automation and mechanized labor. (See, for example, M. N. Rutkevich [ed.], Problemy sotsialisticheskogo obraza zhizni [Moscow: Nauka, 1977]).

57. V. Chalidze (ed.), SSSR — rabochee dvizhenie? (New York: Khronika Press, 1978).

58. A. Arato, "Civil Society Against the State," Telos, 47 (1981), pp. 23-47; Z. Bauman, "On the Maturation of Socialism," Telos, 47 (1981), pp. 48-54.

Notes to Chapter 4

1. T. Skocpol, States and Social Revolutions: A Comparative Analysis of France, Russia and China (Cambridge: Cambridge University Press, 1979), pp. 4-5. Skocpol's attempt to analyze the Russian Revolution from a "nonvoluntaristic, structural perspective," without taking into account the role of ideologically motivated revolutionaries, is, however, the least convincing part of her analysis. The reader is left with another iron law of social revolution whose realization in the Russian case leads to the inevitability of the Stalinist state.

2. Peter Wiles, Distribution of Income: East and West (Amsterdam: North-Holland Publishing Company, 1974), p. 25.

3. Hedrick Smith, The Russians (New York: Quadrangle, 1976); Robert G. Kaiser, Russia: The People and the Power (New York: Atheneum, 1976).

4. Jerry Hough, "The Brezhnev Era: The Man and the System," Problems of

Communism, 2 (1976), p. 12.

5. Among the publications in English, I would like to mention: Murray Yanowitch and Wesley Fisher (eds.), Social Stratification and Mobility in the USSR (White Plains, N. Y.: International Arts and Sciences Press, 1973); Seymour M. Lipset and Richard B. Dobson, "Social Stratification and Sociology in the Soviet Union," Survey, 19 (Summer 1973), pp. 114-84; Roy A. Medvedev, On Socialist Democracy, translated by Ellen de Kadt (New York: Knopf, 1976); Evelina K. Vasilieva, The Young People of Leningrad. School and Work Options and Attitudes, translated by A. Schultz and A. Smith (White Plains, N. Y.: International Arts and Sciences Press, 1975); David Lane, The Socialist Industrial State. Towards a Political Sociology of State Socialism (London: Allen & Unwin, 1976); Richard B. Dobson, "Social Status and Inequality of Access to Higher Education," in Jerome Karabel and A. H. Hulsey (eds.), Power and Ideology in Education (New York: Oxford University Press, 1977), pp. 254-75; Murray Yanowitch, Social and Economic Inequality in the Soviet Union. Six Studies (White Plains, N. Y.: M. E. Sharpe, Inc., 1977); Mervyn Matthews, Privilege in the Soviet Union. A Study of Elite Life-Styles Under Communism (London: Allen & Unwin, 1978); Alastair McAuley, Economic Welfare in the Soviet Union. Poverty, Living Standards, and Inequality (London: Allen & Unwin, 1979).

6. Rudolf Bahro, Die Alternative: Zur Kritik des realexistierenden Sozialismus (Frankfurt: Europäische Verlagsanstalt, 1977).

7. Wlodzimierz Brus, The Economics and Politics of Socialism (London: Routledge & Kegan Paul, 1973), p. 87.

8. T. M. Rigby, "Stalinism and the Mono-Organizational Society," in Robert C. Tucker (ed.), Stalinism. Essays in Historical Interpretation (New York: Norton, 1977), pp. 53-76.

9. Zygmunt Bauman, "Officialdom and Class: Bases of Inequality in Socialist Society," in Frank Parkin (ed.), The Social Analysis of Class Structure (London: Tavistock, 1974), p. 140.

10. Ibid., p. 141.

11. In turn, the legal income in some cases is composed of its formal and informal parts. The formal part of legal income is a salary officially established for a particular job. The informal part of income appears to be less permanent and officially fixed, consisting of additional payments and bonuses distributed by ad hoc decisions of the political authority and usually kept secret. The famous "envelopes" containing sums of money usually equal to a person's regular salary, which were distributed among members of the party apparatus and managers (see also Matthews, p. 37), serve as a good example of informal income.

Today the well-known "personal salaries" (see Yanowitch, pp. 38-40) and "personal pensions" represent a curious mixture of formal and informal incomes. The formal part of the personal salary corresponds to the established level of salary for a given position, while its informal part, the personal increment (personal'naia nadbavka), given for "outstanding merit," depends most on a person's connections with political authority. The informal part of the legal income is usually not taxed.

12. Gregory Grossman, "The 'Second Economy' of the USSR," Problems of

Communism, 5 (1977), p. 39.

13. Medvedev, p. 225.

14. Here I mean the system of so-called "certificates" ("with the yellow stripe," "with the blue stripe," "nonstriped," checks of the series "D"). The recent émigrés can provide an investigator with detailed information, including even the addresses of the certificate shops in the major cities. Any foreign visitor will be able to observe, at least from the outside, the actual operation of the system. Obtaining quantitative data will be a much more difficult task. To illustrate some of the difficulties in analyzing sociologically the inequality of rewards in a closed society, I would like to describe an unpublished study I am familiar with. Sociologist X decided to determine the number of beneficiaries of the system of certificate stores in Leningrad. After a year of direct observation of one store, he obtained reliable data on the number, sex, and approximate age distribution of customers per day. In order to estimate how often the same customer visited the shop and whether or not he used the other certificate shops available, X interviewed his acquaintances with access to certificates about their shopping practices and obtained some information from salesgirls about the frequency of the delivery of goods. Then he had to differentiate between the persons officially entitled to access to certificates and those who acquired them on the black market, between local residents and those from other cities, between regular and chance customers, and so forth. A panel of experts might provide us with more generalizable data on the subject, where X could only arrive at an estimation.

15. See Yanowitch, Matthews, and McAuley.

16. K. S. Karol, "Conversations in Russia," The New Statesman, January 1, 1971, pp. 8-10; Dimitri Simes, "The Soviet Parallel Market," Survey, 3 (1975), pp. 42-52; A. Katsenelinboigen, "Coloured Markets in the Soviet Union," Soviet Studies, 1 (1977), pp. 62-85; Gregory Grossman; Vladimir Bukovsky, To Build a Castle — My Life as a Dissenter (New York: Viking, 1979).

17. For information on the recent changes in the Soviet passport system and the role of this system for class formation, see V. Zaslavsky and Yu. Luryi, "The Passport System in the USSR and Changes in Soviet Society," Soviet Union 6, part 2 (1979), pp. 137-53; V. Zaslavsky, "La struttura di classe nella societa sovietica," Mondoperaio, 5 (1979), pp. 107-16.

18. For a discussion of the main channels open for leaving collective farms, see V. Zaslavsky and Yu. Luryi, pp. 140-41.

19. Pravda, July 4, 1978.

20. Hough, p. 12.

21. "On Adoption of the Statute on the Passport System in the USSR," Soviet Law and Government, 3 (1975-76), p. 68.

22. A practice of assigning special passports (with series and/or numbers whose meaning is easily recognizable by the officials concerned) to certain categories of the population (e.g., former prisoners) had been introduced under Stalin. Now passports for collective farmers are often issued on the same basis. Such documents are colloquially called "village passports" and, for all practical purposes, are useless. I am grateful to Professor Olimpiad S. Ioffe (formerly Civil Law Professor and Department Chairman at the University of Leningrad) for this information.

23. E. Klopov, V. Shubkin, and L. Gordon (eds.), Sotsial'noe razvitie rabo-chego classa SSSR (Moscow: Nauka, 1977), p. 226.

24. The system of "closed" cities needs special description and analysis. Briefly, it includes the most attractive cities and regions of the USSR, such as Moscow, Leningrad, Sverdlovsk, Novosibirsk, all capitals of the Soviet repub-lics, many regions of southern Russia, the Caucasus, the Crimea, some parts of the Baltic republics, and so forth. There is also a corresponding scale of categories of supply for food and consumer goods. Each city or region in the USSR is assigned a position on this scale, and "closed" cities occupy the top positions. For example, Moscow belongs to the highest category A, while Len-ingrad is placed one step below, in the I category. The endless queues in the stores which strike foreigners in Moscow are accounted for by the fact that the capital has become a department store for the rest of the country where com-modities inaccessible in other cities can be obtained.

25. Paul Hollander, Soviet and American Society: A Comparison (New York: Oxford University Press, 1973), p. 218.

26. Yanowitch, pp. 79-80.

27. N. Aitov, "Kariera. Zametki sotsiologa," Druzhba narodov, 6 (1975), p. 231.

28. N. Aitov, "Sotsial'nye aspekty polucheniia obrazovaniia v SSSR," Sotsial'-nye issledovaniia, 2 (1968), p. 191.

29. E. K. Vasilieva, Sotsial'no-professional'nyi uroven' gorodskoi molodezhi (Leningrad: University of Leningrad, 1973).

30. As A. Vel'sh has recently shown, "orientation on social status" can be considered as the most general motive and stable tendency in the Soviet engi-neer's behavior. The cardinal decisions of the Soviet technical specialists are based primarily on "career orientation" (A. Vel'sh, "Motivatsionnye orienta-tsii inzhenerov promyshlennogo predpriiatiia," Sotsiologicheskie issledovaniia, 3 [1975], pp. 100-11). The same "career orientation" forces the specialist to pull all strings possible to ensure the access of his children to higher education.

31. Many Soviet intellectuals, for example, Nobel prize winner Academician Petr Kapitsa, severely criticized the system of specialized schools, the num-ber of which is nevertheless growing.

32. Characteristically, the practice of private tutoring, which represents, in the eyes of the larger population, perhaps the most obvious example of an individual's access to special information, and which greatly and unjustly en-hances the chances for success in entrance examinations, cannot be ignored by the Soviet official press and has been discussed since the middle of the 1960s. There are data showing that up to 85 percent of first-year students in Moscow, Leningrad, and some other leading universities were prepared by private tu-toring. Private tutors (repetitory) are usually former or current university professors and are sometimes even members of the selection committees of their universities. This tells us where and for whom they are available. In a recent discussion of the problem in Pravda, a Moscow professor asks bluntly: "Whom do we examine? A high school graduate or his private tutor?" (Pravda, January 22, 1979, p. 3).

33. Marc Granovetter, Getting a Job (Cambridge, Mass.: Harvard Univer-sity Press, 1974).

34. The problem is so pronounced in Soviet society that even the leader of the Soviet official sociology, Academician Mikhail Rutkevich, is now suggesting that more attention be paid to territorial stratification in the USSR and its impact on inequality (M. N. Rutkevich, "O poniatii sotsial'noi struktury," Sotsiologicheskie issledovaniia, 4 [1978], p. 40).

35. Jonathan Kelley and Herbert S. Klein, "Revolution and the Rebirth of Inequality: A Theory of Stratification in Post Revolutionary Society," American Journal of Sociology, 1 (1977), p. 87.

36. M. Ellman, "A Note on the Distribution of Earnings in the USSR Under Brezhnev," Slavic Review, 4 (1980), pp. 669-71.

37. T. Zaslavskaia, "Ne v dengakh sut," Literaturnaia gazeta, December 5, 1979, p. 11.

38. Katsenelinboigen.

39. Alexandr Yanov describes "the broad and constantly expanding strata of the population that in the post-Stalin era have acquired a monopoly on travel to the West, so that they enjoy all the advantages of the Western way of life without experiencing any of its shortcomings (;) ... who obtained the exceptional privilege of living by Western standards in a country of semi-Asiatic poverty" (Detente After Brezhnev: The Domestic Roots of Soviet Foreign Policy, translated by R. Kessler [Berkeley: University of California Press, 1977], pp. 2-3).

40. Max Weber, The Theory of Social and Economic Organization, translated by A. M. Henderson and Talcott Parsons (New York: Free Press, 1964), pp. 185-86.

41. This argument is often offered by Soviet dissenters. See, for example, Yanov, p. 13.

42. This argument is often presented by the Western left-wing critics of Soviet and East European societies. See, for example, M. Holubenko, "The Soviet Working Class: Discontent and Opposition," Critique, 4 (1975), pp. 5-25; Chris Harman, Bureaucracy and Revolution in Eastern Europe (London: Pluto, 1974); Cornelis Castoriadis, "The Social Regime in Russia," Telos, 38 (1978-79), pp. 32-47.

43. Daniel Bell, The End of Ideology: On the Exhaustion of Political Ideas in the Fifties (New York: Free Press, 1962).

44. Robert C. Tucker, "The Deradicalization of Marxist Movements," American Political Science Review, 61 (1967), pp. 343-58.

45. Leszek Kolakowski, Toward a Marxist Humanism (New York: Grove Press, 1968), p. 174.

46. Barrington Moore, Jr., Soviet Politics — The Dilemma of Power, The Role of Ideas in Social Change (Cambridge, Mass.: Harvard University Press, 1950).

47. See, for example, Zbigniew Brzezinski, The Soviet Bloc, Unity and Conflict (Cambridge, Mass.: Harvard University Press, 1960); Zbigniew Brzezinski, Ideology and Power in Soviet Politics, rev. ed. (New York: Frederick Praeger, 1967).

48. Martin Seliger, Ideology and Politics (London: Allen & Unwin, 1976).

49. Peter Christian Ludz, Ideologiebergriff and Marxistische Theorie, Ansätze zu einer immanenten Kritik (Opladen: Westdeutscher Verlag, 1976), pp. 92-93.

50. Fred Goldner, Richard Ritti, and Thomas Ference refer to a somewhat similar process as the "production of cynical knowledge" (Fred Goldner, Richard Ritti, and Thomas Ference, "The Production of Cynical Knowledge," American Sociological Review, 4 [1977], pp. 539-51). About the process of ficticization, see also Valentin Turchin, The Inertia of Fear and the Scientific Worldview, translated by G. Daniels (New York: Columbia University Press, 1981), pp. 31-42; V. Zaslavsky and R. Brym, "The Functions of Elections in the USSR," Soviet Studies, 3 (1978), pp. 362-71.

51. S. V. Utechin, Russian Political Thought: A Concise History (New York: Praeger, 1963), pp. 242-43.

52. For example, in response to the popular American radio program "For Night-Birds," the Soviet program "After Midnight" was begun. Also, to increase the responsiveness of Soviet mass media to foreign propaganda, the Central Committee invented a profession previously unheard of in Soviet society — that of "commentator with the right of free comment," i.e., with authority to produce his own commentary rather than awaiting official reactions from the Ministry of Foreign Affairs. See also V. A. Medvedev, Razvitoi sotsializm: voprosy formirovaniia obshchestvennogo soznaniia (Moscow: Politizdat, 1980), pp. 111-23.

53. Claus Mueller, "Notes on the Repression of Communicative Behavior," in Hans Peter Dreitzel (ed.), Patterns of Communicative Behavior (New York: Macmillan, 1970), p. 106.

54. Pravda, March 5, 1978.

55. O. I. Shkaratan and V. O. Rukavishnikov, "The Social Structure of the Population of the Soviet City and Trends in Its Development," Soviet Sociology, (1978), p. 91.

56. James C. Scott, "Protest and Profanation: Agrarian Revolt and the Little Tradition," Theory and Society, 1-2 (1977); Alvin Gouldner, "Stalinism: A Study of Internal Colonialism," Telos, 34 (1977-78).

57. Robert E. Lane, Political Ideology, Why the American Common Man Believes What He Does (Glencoe: Free Press, 1962), p. 426.

58. Stanislaw Ossowski, Class Structure in the Social Consciousness (London: Routledge & Kegan Paul, 1963), pp. 110-13.

59. Yanowitch, p. 14.

60. Vladimir Shubkin, "Nachalo puti," Novy mir, 2 (1976), pp. 201-2.

61. As Roy Medvedev has pointed out: "There is also a disturbing new trend toward special advantages in access to higher education — sometimes more than half of the nominally available places are reserved even before the examinations take place. This means that certain selected pupils are admitted to an institute whatever their examination results, which leads to a decline in the quality of our officials in such fields as the foreign service and facilitates the rise of a hereditary bureaucracy" (Medvedev, p. 228).

62. Barrington Moore, p. 224.

Notes to Chapter 5

1. In what follows the terms "ethnic" and "national" will be used interchangeably.

2. The titles of two recent authoritative Soviet monographs are character-
istic enough: S. T. Kaltakhchian, Leninizm o sushchnosti natsii i puti obrazo-
vaniia internatsional'noi obshchchnosti liudei (Leninism on the Nature of the
Nation and the Formation of an International Community of People) (Moscow:
Moscow University Press, 1976); M. T. Iovchuk (ed.), Proletarskii sotsialisti-
cheskii internatsionalizm: traditsia, sovremennyi opyt, tvorcheskoe razvitie
(Proletarian Socialist Internationalism: Traditions, Contemporary Experience,
Creative Development) (Moscow: Politizdat, 1978). Compare these to G. W.
Simmonds (ed.), Nationalism in the USSR and Eastern Europe in the Era of
Brezhnev and Kosygin (Detroit: University of Detroit Press, 1977); H. Carrère
d'Encausse, L'empire éclaté: la révolte des nations en URSS (Paris: Flam-
marion, 1978).

3. As Valerie Bunce and John Echols have pointed out, students of the Soviet
system "still tend to oversimplify politics in a manner we would not dream of
when analyzing American or Western European systems," and "Western biases
continue to creep into many of our studies" (V. Bunce and T. M. Echols, "From
Soviet Studies to Comparative Politics: The Unfinished Revolution," Soviet
Studies, 1 [1979], p. 48).

4. I interviewed these people in 1972-73 in the USSR.

5. For example, Edward Allworth does not even mention the passport sys-
tem among the main group support factors bearing on the nationality question.
See E. Allworth (ed.), Nationality Group Survival in Multi-Ethnic States (New
York: Praeger, 1977), pp. 3-10.

6. V. I. Kozlov, Natsional'nosti SSSR. Etnodemograficheskii obzor (Moscow:
Statistika, 1975), p. 256.

7. Ibid.

8. Another case is presented by Soviet Jews. The 1979 census showed
1,811,000 Jews in the country, although many experts believe that the number
should be closer to three million. R. Anderson, "Jews Leader Says Stiffer So-
viet Rules Cut Emigration," New York Times, June 8, 1980, p. 3.

9. Itogi Vsesoiuznoi perepisi naseleniia 1970 g., vol. 7 (Moscow: Statistika,
1974).

10. "On Adoption of the Statute on the Passport System in the USSR," Soviet
Law and Government, 3 (Winter 1975-76) p. 70.

11. Kozlov, p. 231.

12. G. V. Starovoitova, "A Contribution to the Study of the Ethnopsychology
of Urban Populations (From Data of a Survey of the Population of Three Cities
in the Tatar ASSR)," Soviet Sociology, 4 (Spring 1977), p. 5.

13. L. I. Maksimov, "Kak byt' s natsional'nostiu Andreiki?" Literaturnaia
gazeta, August 15, 1973.

14. M. I. Kulichenko, Natsional'nye otnosheniia v SSSR i tendentsii ikh raz-
vitiia (Moscow: Politizdat, 1972), p. 424.

15. The Jewish Autonomous Province created in the 1930s in the Far East
on the Chinese Border is a fictitious, bureaucratic formation. Fewer than
0.5 percent of all Soviet Jews live on its territory.

16. H. Seton-Watson, Nations and States. An Inquiry into the Origins of Na-
tions and the Politics of Nationalism (Boulder: Westview Press, 1977), p. 312.

17. A. A. Susokolov, "Vliianie razlichii v urovne obrazovaniia i chislennosti kontaktiruiushchikh etnicheskikh grup na mezhetnicheskie otnosheniia," Sovetskaia etnografiia, 1 (1976), p. 103.

18. Kozlov, p. 240.

19. L. N. Terent'eva, "Ethnic Self-Identification by Adolescents in Ethnically Mixed Families," Soviet Sociology, 1 (Summer 1973), pp. 34-51.

20. Ibid., p. 50.

21. M. Rywkin, "Central Asia and Soviet Manpower," Problems of Communism, 1, (1979), pp. 1-13.

22. M. I. Kulichenko, Ukreplenie internatsional'nogo edinstva sovetskogo obshchestva (Kiev: Politizdat, 1976), p. 54.

23. According to the prevalent theory of internationalization, some smaller ethnic groups may undergo assimilation in two stages: first merging with a larger non-Russian nationality and then ultimately assimilating with Russians.

24. V. I. Lenin, Polnoe sobranie sochinenii, 5th ed., vol. 24, pp. 125 ff.

25. Ibid., vol. 23, p. 318.

26. T. H. Rigby, "Conceptual Approach to Authority, Power and Policy," in T. H. Rigby, A. Brown, and P. Reddaway (eds.), Authority, Power and Policy in the USSR. Essays Dedicated to Leonard Shapiro (London: Macmillan, 1980), p. 21.

27. Iu. V. Bromlei, "Towards a Typology of Ethnic Processes," British Journal of Sociology, 3 (1979), pp. 341-48.

28. A. N. Kholmogorov, Internatsional'nye cherty sovetskikh natsii (Moscow: Mysl', 1970), p. 141. Some ethnographers also affirm that national awareness is often preserved even after the complete loss of language and culture (I. S. Gurvich, "Nekotorye problemy etnicheskogo razvitiia narodov SSSR," Sovetskaia etnografiia, 5 (1967), pp. 62-77). They quote as examples Russified Germans and Jews. However, in these cases nationality registered in the passport and discriminatory practices function as external forces evoking national self-awareness.

29. E. Glyn Lewis, Multilingualism in the Soviet Union. Aspects of Language Policy and its Implementation (The Hague: Mouton, 1972), p. 62.

30. The case of the Kirghiz language is typical. After the revolution the Arabic alphabet, which according to experts did not reflect the features of the Kirghiz language, was replaced by a Latinized alphabet. The population accepted this change. Then, after fewer than fifteen years, the Latinized alphabet was replaced with the Cyrillic alphabet by a Moscow provision. The central authorities thereby sought to facilitate the teaching of the Russian language to Kirghiz, to increase the difference between Kirghiz and the other languages belonging to the same linguistic group, and thus to isolate the Central Asian people from Turkey and other foreign countries.

31. M. I. Kulichenko, "Natsional'noe i internatsional'noe v zrelom sotsialisticheskom obshchestve," Voprosy filosofii, 5 (1979), p. 55.

32. See I. Dzyuba, Internationalism or Russification? A Study in the Soviet Nationalities Problem, 2nd ed. (London: Weidenfeld and Nicolson, 1970), pp. 164-65. In the twenties, for example, the Ukrainian mass media were often better and more rapidly informed than the Moscow press because RATAU

(radio-telegraphic agency of the Ukraine) had its own correspondents in differ-
ent parts of the world.

33. S. I. Bruk and M. N. Guboglo, "Dvuiazychie i sblizhenie natsii v SSSR.
Po materialam perepisi naseleniia 1970 g.," Sovetskaia etnografiia, 4 (1975),
p. 25.

34. See the English translation in R. Solchanyk, " 'Russification' to be
Stepped Up," Soviet Analyst, 1 (1980), pp. 7-8. This quotation illustrates the
campaign in the Soviet press that preceded the decree: "In recent years, how-
ever, there has been a marked intensification of the sincere, objective, and vol-
untary desire — indeed, a burning wish — of parents for their children to begin
to receive instruction in the Russian language long before they enter school"
(S. Shermukhamedov, "Unfaltering Attention to the Study of the Russian Lan-
guage," Soviet Education, 7 [May 1976], p. 55).

35. B. D. Silver, "Language Policy and the Linguistic Russification of Soviet
Nationalities," in J. R. Azrael (ed.), Soviet Nationality Policies and Practices
(New York: Praeger, 1978), p. 300.

36. Barbara Anderson calls "ethnic reidentification" the process whereby
during the censuses persons declared themselves Russians regardless of the
nationality recorded on their passports. If applied to linguistic and cultural
Russification, ethnic reidentification can be helpful in explaining higher levels
of Russification among members of nationalities lacking the status of national
republic as compared to republic-level nationalities. Anderson implies, how-
ever, that ethnic reidentification may also happen practically and even officially:
"If a person wanted to reidentify because of some perceived advantage to be
gained, the late teens or early twenties would be an optimum time to do so, be-
fore one was firmly established in a job where others knew one's nationality"
(B. A. Anderson, "Some Factors Related to Ethnic Reidentification in the Rus-
sian Republic," in Azrael, p. 317). This assertion is based on a misunderstand-
ing of how the passport system functions.

37. Opyt etnosotsiologicheskogo issledovaniia obraza zhizni. Po materialam
Moldavskoi SSR) (Moscow: Nauka, 1980), p. 106.

38. H. Kohn, "Nationalism," in International Encyclopedia of the Social Sci-
ences (New York: Macmillan and Free Press), vol. 11, p. 65; H. Kohn, "Soviet
Communism and Nationalism," in E. Allworth (ed.), Soviet Nationality Problems
(New York: Columbia University Press, 1971), pp. 43-71.

39. I. Berlin, "Nationalism: Past Neglect and Present Power," Partisan
Review, 3 (1979), p. 349.

40. Lenin, vol. 36, p. 607.

41. T. Rakowska-Harmstone, "The Dialectics of Nationalism in the USSR,"
Problems of Communism, 3 (1974), pp. 1-22; T. Rakowska-Harmstone, "The
Study of Ethnic Politics in the USSR," in Simmonds, pp. 21-22.

42. Iu. V. Arutiunian, "A Concrete Sociological Study of Ethnic Relations,"
Soviet Sociology, 3-4 (Winter-Spring 1972-73), pp. 328-48.

43. M. S. Dzhunusov, "Sblizhenie natsii v usloviiakh razvitogo sotsializma,"
Sotsiologicheskie issledovaniia, 4 (1976), pp. 47-48.

44. Iu. V. Arutiunian, "Ethnosocial Aspects of the Internationalization of
Way of Life," Soviet Sociology, 2 (Fall 1979), pp. 18-19.

45. A. McAuley, Economic Welfare in the Soviet Union. Poverty, Living Standards, and Inequality (London: Allen & Unwin, 1979), p. 109. See also A. I. Levin, Nauchno-technicheskii progress i lichnoe potreblenie (Moscow: Mysl, 1979), pp. 105-6.

46. P. Zwick, "Ethnoregional Socio-Economic Fragmentation and Soviet Budgetary Policy," Soviet Studies, 3 (1979), p. 392.

47. Ibid., p. 395.

48. Even a casual observer of everyday life in the USSR will notice that the Central Asian or Moldavian collective farmer is often better off than the Russian. In fact, Russian nationalist samizdat derives much of its popular appeal from its harping on the theme of the undeniably lower living standards of the Russian population in comparison to those of the populations of the non-Russian republics.

49. Z. Bauman, "Officialdom and Class: Bases of Inequality in Socialist Society," in F. Parkin (ed.), The Social Analysis of Class Structure (London: Tavistock, 1974).

50. J. F. Hough, Soviet Leadership in Transition (Washington, D. C.: Brookings Institution, 1980), p. 68.

51. L. I. Brezhnev, "Doklad na 26 s"ezde KPSS," Pravda, February 24, 1981, p. 7.

52. V. O. Rukavishnikov, Naselenie goroda. Sotsial'nyi sostav, rasselenie, otsenka gorodskoi sredy (Moscow: Statistika, 1980), p. 86.

53. A. Katsenelinboigen, Studies in Soviet Economic Planning (White Plains: M. E. Sharpe, 1978), p. 150.

54. The activities of the local party apparatus are effectively controlled, for example, by the institution of second secretaries. The first secretaries of union or autonomous republics are always representatives of local nationalities, while second secretaries are very often Russians sent in by the central power. The second secretary "functions as an institutionalized check on the first secretary," being in control of personnel and the local KGB apparatus (see T. H. Miller, "Cadres Policy in Nationality Areas. Recruitment of CPSU First and Second Secretaries in non-Russian Republics of the USSR," Soviet Studies, 1 [1977], pp. 3-36).

55. One of the most recent examples is that of the downfall of the first secretary of the Ukrainian Communist Party, Petr Shelest, accused of "lyric nationalism."

56. Kulichenko, "Natsional'noe," p. 53.

57. Lewis, p. 80.

58. Z. Brzezinski, "Political Implications of Soviet Nationality Problems," in Allworth, p. 74.

59. Zwick, pp. 392-95.

60. Z. Medvedev, Soviet Science (New York: Norton, 1978), p. 197.

61. Opyt etnosotsiologicheskogo issledovaniia obraza zhizni, p. 221.

62. One Soviet sociologist who was involved in research on ethnic relations in the USSR told me about his talk with a Ukrainian worker with whom he was on friendly terms and could speak openly. Asked what he thought about a possible separation of the Ukraine from the USSR, the worker answered: "Unless

we have democracy, we will not be able to separate. And if we had it, why separate?"

63. Katsenelinboigen, p. 96.

64. Kulichenko, "Natsional'noe," p. 54.

65. M. Hechter, "Group Formation and Cultural Division of Labor," American Journal of Sociology, 2 (1978), p. 308; see also S. Lieberson, "Stratification and Ethnic Groups," Sociological Inquiry, 40 (Spring 1970), pp. 172-81.

66. V. S. Vardys, "Modernization and Baltic Nationalism," Problems of Communism, 5 (1975), pp. 32-48.

67. Thus in the Politburo of the Latvian Communist Party there were, in 1970, only two members out of thirteen with non-Latvian names; only three of the latter, however, were born in Latvia. As Juris Dreifelds ("Latvian National Demands and Group Consciousness Since 1959," in Simmonds, p. 144) has justifiably pointed out, "many party and government positions in the seventies have retained an apparently high representation of Latvians," but "all these statistics are misleading if they are used to assess the degree of Latvian political clout or representation of their interests in the republic. Many of the above positions have been filled by people whose only connection to Latvia is their family name" (and, one should add, the inscription "Latvian" in the nationality entry of their passports).

68. See Vestnik statistiki, 2 (1975), p. 85; Rukavishnikov, pp. 67-68.

69. Allworth, p. 16.

70. But the term itself is questionable if we consider the real situation of religion in the Soviet Union.

71. See J. Amalric, "The Soviet Union: A Crumbling Monolith," in The Guardian, February 11, 1979. The claim that the Soviet regime is opposed to Khomeiny's regime because it fears the contagious example of the "Islamic revolution" may spread to the Central Asiatic republics is very naive in the same way that, for example, the claim that the defection to the West by Soviet ballet dancers will serve as an example for the defection to Moscow of Western ballet dancers. Contrary examples of the Soviet Turkic nationalities influencing other Muslims abroad may be rather numerous. Thus Jeremy Azrael points to China's persecuted Turkic minorities, who "have fled across the border into the USSR in large numbers in recent years and whose express conviction that their Soviet kinsmen enjoy a relatively satisfactory life makes them not only receptive subjects and useful objects of Soviet propaganda (including domestic propaganda and counter-propaganda) but also makes them promising intelligence targets and potential fifth column allies whose presence on the Sino-Soviet border is a deterrent to Chinese 'adventurism.' In addition, Soviet efforts to penetrate the Middle East rely heavily on Turkic personnel, a disproportionate number of whom can be found in nearly every Soviet embassy, aid office, and military mission" (J. Azrael, "The 'Nationality Problem' in the USSR: Domestic Pressures and Foreign Policy Constraints," in S. Bialer, The Domestic Context of Soviet Foreign Policy [Boulder: Westview, 1980], p. 147).

72. Arutiunian, "Ethnosocial Aspects," p. 25.

73. It should be pointed out that many Soviet experts do not consider Jews a truly ethnic group but, rather, "a heterogeneous conglomerate of various ethnic

groups and nationalities, kept together partly by a common religion and partly by a certain historical inertia of ethnic self-consciousness" (see Sovetskaia etnografiia, 4 [1973], p. 45).

74. The precarious situation of ethnic groups lacking their own territory can be further illustrated by the example of the Gypsies. In 1956, the year of the Twentieth Congress, the Supreme Soviet approved a decree containing the following article: "To forbid Gypsies to practice nomadism and induce them to shift to a sedentary and laborious way of life" (in Vedomosti Verkhovnogo Soveta SSSR, 21 [1956], cited by V. Chalidze, Prava cheloveka i Sovetskii Soiuz [New York: Khronika, 1974], p. 185). The Gypsies who did not obey this decree were condemned to five years in exile. Later this penalty was abolished. For further discussion of the disadvantageous ethnic groups, see V. Zaslavsky and R. Brym, Soviet-Jewish Emigration and Soviet Nationality Policy (forthcoming).

75. A. M. Nekrich, The Punished People: The Deportation and Fate of Soviet Minorities at the End of the Second World War (New York: Norton, 1978).

76. After all, except for the Germans and the Crimean Tatars, all other ethnic groups accused by Stalin of treason and later rehabilitated have been allowed to return to their respective territories.

77. V. Zaslavsky, "The Problem of Legitimation in Soviet Society," in A. J. Vidich and R. M. Glassman (eds.), Conflict and Control. Challenge to Legitimacy of Modern Governments (Beverly Hills — London: Sage, 1979), pp. 180-96.

78. See A. M. Kovalev, "Razvitoe sotsialisticheskoe obshchestvo — zakonomernyi etap kommunisticheskoi formatsii," Voprosy filosofii, 6 (1979), p. 50.

79. Katsenelinboigen, pp. 147-48; I. Birman, "The Financial Crisis in the USSR," Soviet Studies, 1 (January 1980), pp. 84-105.

80. Ibid., p. 86.

81. N. Penkaitis, Der Finanzausgleich in der Sowjetunion und seine Bedeutung für die Wirtschaftsentwicklung der Unionsrepubliken (Berlin, 1977), p. 191, cited in Osteuropa, 6 (1979), p. 451.

82. See, for example, T. K. Koichuev, Ekonomicheskoe razvitie Kirgizii i faktory ego uskoreniia (Frunze: Kirgizistan, 1973); S. I. Kirke, Tempy i proportsii ekonomicheskogo razvitiia soiuznoi respubliki (Kishinev: Karta Moldaveniaska, 1973).

83. Voprosy filosofii, 5 (1979), p. 53.

84. It is worth noting that such Russian derogatory terms as "chernozhopye" (black asses), used in the past to refer to people of Central Asian origin, are now used also for those from the Caucasian republics and from Moldavia.

85. T. Rakowska-Harmstone, "The Study of Ethnic Politics in the USSR," in Simmonds, p. 22.

86. A. Yanov, The Russian New Right: Right-Wing Ideologies in the Contemporary USSR (Berkeley: University of California Press, 1978); A. Sinyavsky, "Solzhenitsyn and Russian Nationalism," in The New York Review of Books, November 22, 1979; A. Ulam, "Russian Nationalism" in Bialer; E. Allworth (ed.), Ethnic Russia in the USSR: The Dilemma of Dominance (New York: Pergamon, 1979).

87. Thus since the early 1970s, some institutions of higher education in Leningrad, following a secret circular, have stopped accepting Georgians

as students. This measure was justified in terms of the need to react to the practice of bribing the members of the selection commissions for admission exams. In reality it was an obvious response to the popular myth about rich Southerners corrupting morally unstable Russian officials.

88. Berlin, p. 349.

89. A. Yanov, "Ideal'noe gosudarstvo Gennadiia Shimanova," Sintaksis, 1 (1978), p. 34.

90. A. Agurskii, "Neonatsizm v SSSR," Novyi zhurnal, 118 (1978), pp. 213-14.

91. Here one might note the recent grandiose exhibit of paintings by Ilia Glazunov in Moscow, or browse through the pages of Aleksandr Chakovskii's latest novel Victory, or look at the innumerable photographs and reproductions in the mass media portraying Russian troops, military victories, Orthodox churches, and monasteries — all major stereotypes of Russian nationalism.

92. Characteristically, two influential members of the Politburo, Dmitrii Polianskii and Aleksandr Shelepin, considered closely tied to the nationalist faction, have been removed. Also, the editor of the journal Molodaia gvardiia has been replaced by someone more moderate.

93. When, at the beginning of the 1970s, a decision had to be made as to who would occupy the important post of chief of propaganda for the Central Committee, the then assistant director, A. Iakovlev, representing the ideas of the internationalist wing of the apparatus, published a long article severely critical of the Russian nationalists' position ("Against Anti-Historicism," Literaturnaia gazeta, November 15, 1972). Iakovlev lost his post in the apparatus of the Central Committee. The former first secretary of the Central Committee of the Komsomol, Tiazhel'nikov, noted for his Stalinist sympathies, was appointed chief of propaganda.

94. See, for example, E. R. Sarukhanov, Sotsial'no-ekonomicheskie problemy upravleniia rabochei siloi pri sotsializme (Leningrad: Leningrad University Press, 1981), p. 26.

95. Pravda, September 6, 1981.

96. Let me take, for example, provisions favoring a broader diffusion of the Russian language. The central administration, not satisfied with the results achieved, insists on a further dissemination of the Russian language and limitations on non-Russian language instruction in the schools. There might be two reasons for this policy: first, for the next fifteen to twenty years, one out of three soldiers in the Soviet Army — where Russian is spoken almost exclusively — will come from Central Asia; second is the need to organize massive migrations toward the territory of the RSFSR. However, the reactions of many ethnic groups demonstrate that this policy came to be interpreted not as an attempt to prepare society for the tasks which were set for the 1980s, but rather as the determination of the Russian national group to utilize their language as an instrument of control over access to the most prestigious positions and professions. Thus in 1978 demonstrations took place in protest against proposals in the draft of the Georgian constitution that would have omitted the provisions making Georgian the official language of the republic (Khronika tekushchikh sobytii, 49 [1978]; Zaria Vostoka, April 15-16, 1978). There is considerable evidence that Georgian schoolteachers were among the prime organizers of the

demonstrations. As a result, the provisions declaring Georgian the official language of the republic were retained. Similar provisions were retained in the constitutions of other Caucasian republics.

97. S. Bialer, Stalin's Successors. Leadership, Stability, and Change in the Soviet Union (Cambridge: Cambridge University Press, 1980), p. 216.

Notes to Chapter 6

1. B. Ts. Urlanis, Istoriia odnogo pokoleniia. Sotsial'no-demograficheskii ocherk (Moscow: Mysl', 1968).

2. V. Bunce, "The Political Consumption Cycle: A Comparative Analysis," Soviet Studies, 2 (1980), pp. 280-90.

3. The term "social structure" is used here in the widest sense, i.e., class, ethnic, demographic, and territorial structures are seen as directly interrelated and as comprising the substructures of the social structure of Soviet society (see E. K. Vasil'eva, Sotsial'no-ekonomicheskaia struktura naseleniia SSSR [Moscow: Statistika, 1978], p. 38).

4. R. A. Medvedev and Z. A. Medvedev, Khrushchev. The Years in Power, translated by A. R. Durkin (New York: Columbia University Press, 1976), pp. 143-79.

5. R. Pipes, "Militarism and the Soviet State," Daedalus, 4 (1980), p. 7.

6. A recent article by a well-known poet and dissident, Naum Korzhavin, demonstrates the degree of propaganda with respect to the "yellow threat" to which the Soviet population is subjected. Even this staunch critic of the Soviet regime accepts completely one of the central theses of the Soviet propaganda, that of the inevitability of Chinese aggression. Once this thesis is accepted, support of unrelenting military buildup follows logically (see Naum Korzhavin "Only Fifteen Years from Now!...." Russia, 1 [1981], pp. 50-58).

7. C. Castoriadis, Devant la guerre (Paris: Fayard, 1981), p. 131.

8. Z. Bauman, "Officialdom and Class: Bases of Inequality in Socialist Society," in F. Parkin (ed.), The Social Analysis of Class Structure (London: Tavistock, 1974), p. 136.

9. S. Bialer, Stalin's Successors, Leadership, Stability, and Change in the Soviet Union (Cambridge: Cambridge University Press, 1980), p. 141.

10. A. Sozykin, "Gosudarstvennyi kontrol' za ispol'zovaniem rabochei sily na proizvodstve," Sotsialisticheskii trud, 8 (1978), p. 38.

11. A. I. Solzhenitsyn, The Gulag Archipelago, 1918-1956; An Experiment in Literary Investigation, vol. 5-7, translated by H. Willetts (New York: Harper & Row, 1978), pp. 507-14.

12. M. Baglai, "Profsoiuzy v usloviiakh sotsialisticheskogo obshchestva," Pravda, December 26, 1980, p. 3.

13. See T. H. Goldthorpe, "Social Stratification in Industrial Society," in R. Bendix and S. M. Lipset (eds.), Class, Status, and Power: Social Stratification in Comparative Perspective, 2nd ed. (New York: Free Press, 1966), pp. 648-59; Z. Bauman, pp. 129-48; W. D. Connor, Socialism, Politics, and Equality. Hierarchy and Change in Eastern Europe and the USSR, (New York:

Columbia University Press, 1979).

14. Looking at the individual-society interaction from another angle, we can discuss here alternative channels of individual effort rather than the various types of individual activity.

15. For example, marriage constitutes one of the main migratory channels to gain entrance to closed cities (see T. Fedotovskaia, "Regulirovanie chislennosti naseleniia — opyt Moskvy," in O naselenii Moskvy [Moscow: Statistika, 1980], p. 57).

16. Connor, p. 110.

17. Cited in ibid., p. 106.

18. See A. Zinoviev, Bez illuzii (Lausanne: L'Age d'Homme, 1980).

19. Itogi Vsesoiuznoi perepisi naseleniia 1970 g., vol. 7, (Moscow: Statistika, 1974), p. 7.

20. V. P. Tomin, Uroven' obrazovaniia naseleniia v SSSR (Moscow: Statistika i finansy, 1981), p. 181.

21. J. R. Logan, "Growth, Politics, and the Stratification of Places," American Journal of Sociology, 2 (1978), p. 414.

22. Ibid., p. 404.

23. V. B. Ostrovskii, Novyi etap v razvitii kolkhoznogo stroia (Moscow: Politizdat, 1977), p. 255.

24. B. S. Khorev (ed.), Problemy rasseleniia v SSSR. Sotsial'no-demograficheskii analyz seti poselenii i zadachi upravleniia (Moscow: Statistika, 1980), p. 34.

25. V. O. Rukavishnikov, Naselenie goroda. Sotsial'nyi sostav, rasselenie, otsenka gorodskoi sredy (Moscow: Statistika, 1980), p. 234.

26. Khorev, pp. 46-47.

27. Vasil'eva, p. 141.

28. They are closed from the point of view of the Soviet citizen, insofar as the right to move to one of them permanently or even temporarily requires special permission from the authorities. There are also cities and regions "closed to foreigners," of which Gorki, where Academician Sakharov is exiled, is an example. Discussion of this category of closed cities, however, is beyond the scope of this article.

29. Vestnik statistiki, 5 (1979), pp. 73-74.

30. B. S. Khorev and V. M. Moiseenko, Sdvigi v razmeshchenii naseleniia SSSR (Moscow: Statistika, 1976), p. 68.

31. Khorev, p. 199.

32. N. A. Aitov and N. G. Kharitonov, "Zhizn' i trud v molodom gorode," Druzhba narodov, 12 (1977), pp. 233-41.

33. Khorev, p. 197.

34. E. R. Sarukhanov, Sotsial'no-ekonomicheskie problemy upravleniia rabochei siloi pri sotsializme (Leningrad: Leningrad University Press, 1981), p. 25.

35. Naselenie SSSR 1973. Statisticheskii sbornik (Moscow: Statistika, 1975), pp. 84-85.

36. A Soviet researcher's data show that in districts of Vilnius populated by recent migrants from the countryside, the incidence of criminal activity is 2.5

times higher, and the incidence of psychiatric illness 6.4 times higher than in districts of fully urbanized dwellers (see, Rukavishnikov, pp. 20-21).

37. A. Ia. Kvasha, Problemy ekonomiko-demograficheskogo razvitiia SSSR (Moscow: Statistika, 1974), p. 121.

38. Rukavishnikov, p. 70; see also A. P. Soloviov and G. M. Romanenkova, Ekonomicheskaia i sotsial'naia effektivnost' ispol'zovaniia trudovykh resursov (Leningrad: Leningrad University Press, 1979).

39. Vasil'eva, p. 163.

40. E. Klopov, "Osnovnye predposylki, napravleniia i itogi sotsial'nogo razvitiia rabochego klassa SSSR na sovremennom etape," paper presented at the Soviet-Italian Scientific Symposium, Institut mezhdunarodnogo rabochego dvizheniia, Moscow, December 1980, p. 21.

41. V. Perevedentsev, "Urbanizatsiia v trekh rakursakh," Druzhba narodov, 9 (1976), p. 216.

42. Ibid.

43. To reside in an area without a propiska is illegal, but the authorities will tolerate the interloper as long as his enterprise protects him. A worker aware of his precarious position has every reason to remain obedient and hardworking.

44. Klopov, pp. 21-22.

45. To cite a characteristic example from a Soviet study on new workers of the "Elektrostal" plant (Moscow region): the authors of the study note, in passing, that "women, most of whom arrived recently from other regions, were offered limitchik jobs. Among the metal polishers these women numbered 60 percent in 1959 and 54 percent in 1974" (see Metodologicheskie i metodicheskie problemy izucheniia rabochego classa sotsialisticheskogo obshchestva [Moscow: Institut mezhdunarodnogo rabochego dvizheniia, 1979], p. 156).

46. For example, a study by the Central Statistical Agency indicates that on May 14, 1975, 15 percent of machines did not operate in heavy industry due to lack of workers, and in addition, 40 percent of the lost working time was caused by undermanned shifts.

47. The word exists in two variants: limitchik and limitnik, of which the first seems to be more widely used. The word is a common Sovietism rarely seen in print and not included in dictionaries.

48. It is instructive to see how the introduction of squad labor (the brigade method) proceeds (see pp. 59-60). This form of work organization "permits a sharp increase in production output without a corresponding increase in the workforce" (A. Levikov and A. Nikitin, "Logika dvizheniia," Literaturnaia gazeta, November 12, 1980, p. 10) and therefore often involves greater exploitation of workers. Attempts to propagate this method meet with determined opposition by cadre workers. The only industry where the brigade method has been introduced to a noticeable extent is construction, where most of the workforce is made up of limitchiks.

49. Perevedentsev, p. 217.

50. The few sociological studies of limitchiks completed in the Soviet Union were never published. However, some published articles contain references to this social group. For example, V. Komarovskii, in his study of Moscow workers, singled out a group of young unmarried people, so-called limitniks, who

made up 17 percent of all respondents (V. Komarovskii, "Rabochie opytno-eksperimental'nogo proizvodstva: nekotorye cherty sotsial'nogo oblika," paper presented at the Soviet-Italian Scientific Symposium, Institut mezhdunarodnogo rabochego dvizheniia, Moscow, December 1980).

51. I am grateful to Professor Olimpiad S. Ioffe who has drawn my attention to this fact.

52. In 1974 the author of this book participated in an unofficial seminar in Leningrad in which a small group of social scientists and architects attempted to calculate the number of limitchiks. Based on an analysis of statistical data, familiarity with the instructions of local authorities, and personal observation, the participants estimated that limitchiks make up at least 15 percent of the work force in closed cities.

53. In addition to the economic and demographic arguments of official experts, samizdat literature advances political and moral criticisms: the closed cities system is branded as utterly undemocratic and in direct contradiction to the officially proclaimed ideology (see, for example, R. A. Medvedev, On Socialist Democracy, translated by E. de Kadt [New York: Knopf, 1976], pp. 210-14).

54. Khorev, pp. 233-34.

55. Fedotovskaia, p. 55.

56. Perevedentsev, pp. 216-17.

57. V. A. Iadov, Sotsial'no-psikhologicheskii portret inzhenera (Moscow: Mysl', 1977), p. 10.

58. Ibid., p. 11.

59. See Pravda, January 22, 1977; January 28, 1978; January 20, 1979; January 26, 1980. However, vocational schools that provide specialized training off the job are quite a recent development and continue expanding (W. E. Eason, "Demographic Trends and Soviet Foreign Policy: The Underlying Imperatives of Labor Supply," in S. Bialer (ed.), The Domestic Context of Soviet Foreign Policy [Boulder: Westview, 1980], pp. 218-21).

60. G. Kulagin, "Do trudovoi knizhki," Literaturnaia gazeta, February 21, 1979, p. 10. See also P. G. Bunich, "Stimulirovanie truda v razvitom sotsialisticheskom obshchestve," Sotsiologicheskie issledovaniia, 2 (1981), pp. 30-31.

61. M. Ia. Sonin, Razvitie narodonaseleniia. Ekonomicheskii aspekt (Moscow: Statistika, 1980), p. 157.

62. Sarukhanov, p. 58; Kommunist, 11 (1979), p. 6.

63. In the past years the refusal of young specialists to accept their assigned job placement became common; in some of the southern universities, the proportion of graduates who do not take up their assigned jobs reaches 20 percent. Many of these graduates, having gained a foothold in a closed city, give up their profession and enter the "second economy." In Azerbaidzhan, for example, the authorities were compelled to create a new agency whose only function is control over distribution of graduates.

64. Sonin, p. 157.

65. N. A. Aitov, Tekhnicheskii progress i dvizhenie rabochikh kadrov (Moscow: Ekonomika, 1972), p. 67.

66. Sarukhanov, p. 38.

67. The special role performed by Soviet university policy in the absorption

of the ethnic middle class has already been discussed in the previous chapter.

68. M. A. Ivanova and I. A. Samarina, Tekhnicheskii progress i struktura NTR i sluzhashchikh (Moscow: Nauka, 1970), p. 55.

69. See V. I. Belousov, "Pochemu novatsii ne vstrechaiut ovatsii," EKO, 8 (1980), pp. 197-207.

70. See also V. Zaslavsky and R. Brym, Soviet-Jewish Emigration and Soviet Nationality Policy (forthcoming).

71. G. Konrad and I. Szelenyi, The Intellectuals on the Road to Class Power. A Sociological Study of the Role of the Intelligentsia in Socialism, translated by A. Arato and R. Allen (New York: Harcourt, Brace, Jovanovich, 1979), pp. 220-25.

72. A. W. Gouldner, The Future of Intellectuals and the Rise of the New Class: A Frame of Reference, Theses, Conjectures, Arguments and an Historical Perspective on the Role of Intellectuals and Intelligentsia in the International Class Contest of the Modern Era (New York: Seabury, 1979).

73. Connor, p. 344.

74. An analysis of the 1970s administrative reforms and, in particular, the new passport system, in full effect since 1981, demonstrates that the coercive apparatus is in full control of the situation.

75. Goldthorpe, pp. 648-49.

76. Bialer, p. 147.

77. Vasil'eva, p. 38.

78. T. I. Zaslavskaia, "K metodologii sistemnogo izucheniia derevni," Sotsiologicheskie issledovaniia, 3 (1975), p. 31.

79. Vasil'eva, pp. 163-64.

80. Medvedev, p. 213.

81. For example, by 1975 in Moscow and Leningrad women made up 56 percent of the total work force (Sarukhanov, p. 24).

82. Analyzing current demographic trends in three Slavic (Russian, Ukrainian, Belorussian) and three Baltic (Estonian, Latvian, Lithuanian) republics, which together contain 83 percent of the USSR's urban population, Soviet researchers point to the impending decrease in the population of these republics. "Since these populations are the ones with the highest levels of education, professional experience, and scientific potential, this decrease will entail many undesirable social, economic, and other consequences" (Khorev, p. 195).

83. A. Aganbegian, "Gde iskat' rezervy?" Trud, January 19, 1980, p. 2.

84. Rukavishnikov's research in Kazan indicated that more than 70 percent of the respondents were dissatisfied with the state of services and food supply in the city (Rukavishnikov, pp. 218, 230-31).

85. D. M. Nuti, "Socialism on Earth," Cambridge Journal of Economics, 5:4 (1981), p. 399.

86. Sarukhanov, p. 66.

87. A. I. Levin, Nauchno-tekhnicheskii progress i lichnoe potreblenie (Moscow: Mysl', 1979), p. 197.

88. V. I. Lenin, Polnoe sobranie sochinenii, 5th ed., vol. 4 (Moscow: Politizdat), p. 70. See also I. V. Stalin, Ekonomicheskie problemy sotsializma v SSSR (Moscow: Politizdat, 1952), p. 46.

89. G. E. Glezerman, Zakony obshchestvennogo razvitiia: ikh kharakter i

ispol'zovanie (Moscow: Politizdat, 1979), p. 169.

90. A. Yanov, Detente After Brezhnev: The Domestic Roots of Soviet For-
eign Policy, translated by R. Kessler (Berkeley: University of California Press,
1977), pp. 17-19; I. Birman, "Protivorechivye protivorechiia," in V. Chalidze
(ed.), SSSR: vnutrennie protivorechiia, 1 (New York: Chalidze Publications
1981), pp. 15-16.

91. To cite a typical example from the Soviet press: in 1979 a chemical
plant fulfilled only 15 percent of its planned quota. "Now the plan, reduced
sharply and several times, is 100 percent fulfilled," writes the journalist
(A. Vaksberg, "Proryv," Literaturnaia gazeta, June 3, 1981, p. 12). What com-
pelled the central planners to correct the plan target so drastically? Workers,
whose wages are docked if the plan quota is not achieved, began quitting their
jobs. Consequently, the central planners were forced either to accept the plan
target suggested by the local administration or close the plant.

92. I. Birman, "From the Achieved Level," Soviet Studies, 2 (1978),
pp. 153-72.

93. A. Miasnikov, "Alternativa," Literaturnaia gazeta, June 20, 1979, p. 10.

94. In the past ten years the actual income of the population has grown at
an annual rate of 5.1 percent, while saving deposits increased, on the average,
by 16 percent a year (V. F. Maer, Uroven' zhizni naseleniia SSSR [Moscow:
Mysl', 1977], p. 245). Birman has called this situation a "financial crisis in
the USSR" (I. Birman, "The Financial Crisis in the USSR," Soviet Studies, 1
[1980], pp. 84-105). This situation is best illustrated by the Soviet press itself.
Literaturnaia gazeta (March 25, 1981, p. 12) printed an account of the following
"experiment": A Moscow journalist travels to Krasnodar, a resort town with
a population of more than 500,000. According to the conditions of the experi-
ment, he cannot take with him soap, razor blades, a change of underwear,
toothpaste, detergent, and so on; instead, he must obtain his toiletry and other
personal effects in Krasnodar. The journalist spends two fruitless days look-
ing for them in the state stores and then, "unshaven, unwashed, and irate,"
heads for the city of Novorossiisk. There he easily obtains everything on the
black market, but at prices three to five times higher than those set by the
government.

95. P. Hollander, Soviet and American Society: A Comparison (New York:
Oxford University Press, 1973), p. 388.

96. Bialer, p. 158.

97. As Aitov has pointed out, the possibility of a more interesting and pres-
tigious job provides a much more powerful incentive to migrate than simple
monetary gains (N. A. Aitov, NTR i sotsial'noe planirovanie [Moscow: Profiz-
dat, 1978], p. 21).

98. Levin, pp. 197-98.

99. M. Vajda, "Is Kadarism an Alternative?" Telos, 39 (1979), p. 176.

100. A. Nove, "The Soviet Economy: Problems and Prospects," New Left
Review, 119 (1980), p. 17.

101. D. M. Kazakevich, "Khozraschetnaia predpriimchivost': politekonomi-
cheskii aspekt," EKO, 2 (1980), p. 47.

102. Nove, p. 17.

103. V. Seliunin, "Den'gi liubiat tovar," Pravda, January 7, 1981, p. 3.

104. September 25, 1978, p. 10.

105. A. I. Kuzminykh, "K letunam i tuneiadtsam nuzhny zhestkie mery," EKO, 11 (1980), p. 169.

106. Ibid., pp. 169-72.

107. L. Goldin, "Sotsial'nyi aspekt shchekinskogo opyta," Pravda, April 2, 1981, p. 3. See also "Automation and Incentives as Solutions for Tight Labor Market," Soviet World Outlook, 9 (1981), pp. 6-7.

108. G. Popov, "Tvoe rabochee mesto," Pravda, December 27, 1980, p. 3.

109. For the connection between political pluralism and economic liberalization in Soviet-type societies, see W. Brus, "Political Pluralism and Markets in Communist Systems" (forthcoming).

110. W. Gumpel, "Entspannungspolitik und wirtschaftliche Entwicklung — die Grenzen des internationalen Aktionsradius der UdSSR" (forthcoming).

111. W. Brus, "Political System and Economic Efficiency: The East European Context," Journal of Comparative Economics, 4 (1980), p. 54.

Victor Zaslavsky was born in Leningrad in 1937. He graduated from the Mining University there and worked for ten years in geology throughout the Soviet Union. He later took degrees in philosophy and history from Leningrad University and taught sociology in that city.

In 1974 he was dismissed from all positions and black-listed for "political unreliability." He emigrated in 1975 to Canada, where, since 1976, he has taught sociology at the Memorial University of Newfoundland in St. John's. Zaslavsky is the author of articles published in Espresso, Listy, Mondo-peraio, Social Research, Society, Sociology, Soviet Studies, Soviet Union, Telos, Theory and Society, and other journals, and of Il consenso organizzato. La società sovietica negli anni di Brezhnev, published in 1981 in Italy. A German translation of The Neo-Stalinist State has just been pub-lished in Berlin.